TWO WOMEN PATRONS OF THE RUSSIAN AVANT-GARDE
NADEZHDA DOBYCHINA AND KLAVDIA MIKHAILOVA

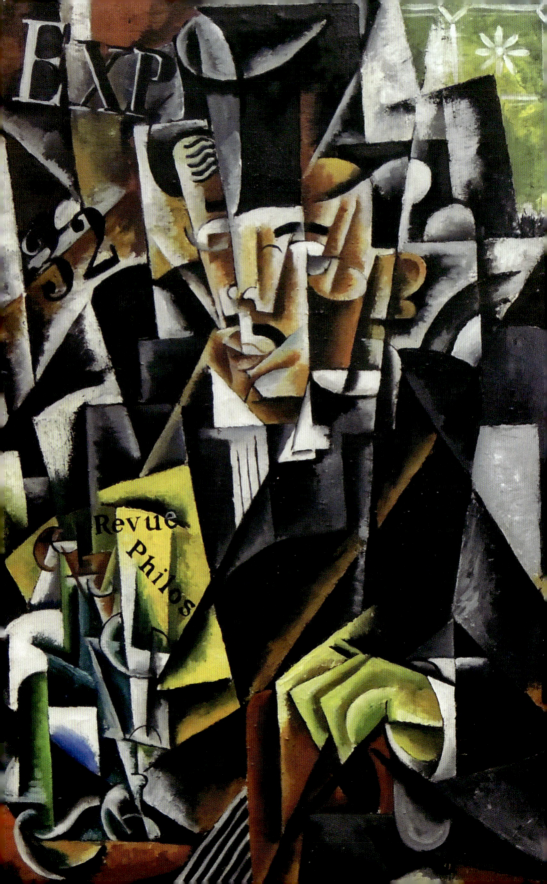

TWO WOMEN PATRONS OF THE RUSSIAN AVANT-GARDE
NADEZHDA DOBYCHINA AND KLAVDIA MIKHAILOVA

Natalia Budanova
Natalia Murray

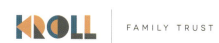

Published in 2021 by
Unicorn, an imprint of Unicorn Publishing Group LLP
5 Newburgh Street
London
W1F 7RG
www.unicornpublishing.org

Published in collaboration with Kroll Family Trust
www.krolltrust.com

© N. Budanova and N. Murray

All rights reserved. No part of the contents of this book may be reproduced, stored in or introduced into a retrieval system, or transmitted, in any form or by any means (electronic, mechanical, photocopying, recording or otherwise), without the prior written permission of the copyright holder and the above publisher of this book.

Every effort has been made to trace copyright holders and to obtain their permission for the use of copyrighted material. The publisher apologises for any errors or omissions and would be grateful to be notified of any corrections that should be incorporated in future reprints or editions of this book.

ISBN 978 1 913491 27 7
10 9 8 7 6 5 4 3 2 1

Design by newtonworks.uk

Printed by Fine Tone Ltd

Contents

Foreword — *vii*

Acknowledgements — *ix*

Notes on transliteration and convention — *ix*

Introduction — *1*

CHAPTER 1
Paths to the Art Business — *4*

 1.1. Klavdia Mikhailova — *8*

 1.2. Nadezhda Dobychina — *16*

CHAPTER 2
Launching the Gallery Business — *26*

 2.1. An emerging art market in the Russian capital — *30*

 2.2. The foundation of Dobychina's Art Bureau — *33*

 2.3. Artistic life in Moscow in the 1910s — *36*

 2.4. The opening of Mikhailova's Art Salon — *41*

CHAPTER 3
From Convention to Hooliganism — *50*

 3.1. The opening season of 1912–13 in Mikhailova's Art Salon — *50*

 3.2. Nadezhda Dobychina: the Russian 'Durand-Ruel in a skirt' — *70*

 3.3. The Art Salon's second season: on the verge of an international cataclysm — *80*

 3.4. Breaking the ice: Natalia Goncharova's exhibition at Dobychina's Art Bureau — *99*

CHAPTER 4

'Who has time for art now, when human life is in danger?' *107*

4.1. Mikhailova's shattered plans *110*
4.2. The Art Salon in wartime *121*
4.3. Dobychina's Art Bureau and exhibitions in Petrograd during the First World War *133*

CHAPTER 5

Last act: the beginning of the end *170*

5.1. A storm approaching: the 1916–17 season at the Art Salon *174*
5.2. Dobychina's Art Bureau in the revolutionary 1917 *189*
5.3. The Art Salon after the October Revolution: the closing chapter *196*
5.4. Facing up to new realities: Dobychina *206*

Picture Credits *224*
Index *225*

Foreword

by Daniel Kroll, Managing Director, Kroll Family Trust

The Kroll Family Trust is actively engaged in fostering cultural activities and publications in order to promote 20th-century art, including our vast collections of fine art, to broader audiences.

Following eight decades of art collecting, I am a third-generation collector and entrepreneur who shares a passion for Modern art that began with my grandfather and has been passed on to me by my father, Michael Kroll. Both my grandfather and father spent considerable time learning and enriching their curiosity for art and embraced different movements and styles. Above all, they were captured by, and felt connected to, European and Russian art of the early 20th-century. The colours, bold shapes and strength of the works simply dazzled them.

Naturally, growing up with such art and with such a passionate father, an innate appreciation of art was in my blood. It is therefore a great honour for me to present such a unique and important publication which reveals the story of the lives of two pioneering women, and their influence on some of the greatest artists of Modern art, whose works form an integral part of my family collection.

Our publication uncovers unknown or forgotten facts about the inventive enterprises and ground-breaking activities of Nadezhda Dobychina and Klavdia Mikhailova who organised innovative exhibitions in their private art galleries in Russia during the decade of 1910.

That it breaks new ground by bringing a scholarly eye to a previously under-studied aspect on art dealership and patronage is an added benefit; it fits neatly into our objective to not only share knowledge and objects with an international audience but also to encourage pioneering thinking and innovative scholarship in areas previously not thoroughly researched.

We are therefore most grateful to Natalia Budanova and Natalia Murray for their initiative, collaborative work and dedication that brought this important scholarship to light, and I congratulate the entire team at Unicorn Publishing Group and especially its chairman Lord Strathcarron who brought this endeavour to fruition.

The Kroll Family Trust has also played an active role in fostering cultural relations between Israeli and Russian Museums, especially the State Hermitage

Museum, St. Petersburg and the Israel Museum, Jerusalem through exchanges of collections and exhibitions.

Our commitment to empowering educational support for young students was recently manifested through collaboration with the Jacobs University Bremen for a three-year programme in supporting the Russian Art & Culture Group activities including workshops, subsidy for young scholars, online presence and publications.

As we look to the future, we hope to continue the model of cooperative ventures that have allowed us to grow from our modest origins as a family trust into one that can have a significant impact on the international cultural landscape.

Acknowledgements

Throughout the research and the writing of this book, many friends and colleagues have been enormously supportive and helpful to us, but we would particularly like to thank the Francis Haskell Memorial Fund for its travel grant that allowed us to carry out extensive research in the archives in Moscow and St Petersburg.

We would also like to express our special gratitude to Lord Strathcarron of Unicorn Publishing and Daniel Kroll and the Kroll Family Trust, who both believed in our book from the start and without whose generous support it would have never been realised.

Many friends and colleagues discussed and shared ideas with us. We owe a major debt of gratitude to Thea Polancic, who kindly shared her PhD research, materials from the interview with Daniil Dobychin and vital images from his family archive which have been used in this book. We are immensely grateful to Natalia Polenova, John Milner, John Bowlt and Natalia Semenova for their support and inspiration, as well as all the valuable information which they generously shared with us.

This book benefits greatly from exhaustive research in archives, museums and libraries in St Petersburg and Moscow, all of which would have been much more difficult without the continuous assistance of Anna Zakharova.

Notes on transliteration and convention

This book spans the pre- and post-revolutionary years, and so encompasses a change in the Russian calendar. All dates before February 1918 are given according to the Old Style (Julian) calendar. After that time, they follow the New Style (Gregorian) calendar, in line with western Europe, which was adopted by the Bolsheviks on 14 February 1918.

The city of St Petersburg was re-named Petrograd on 1 September 1914 to make it sound less Germanic in the wake of the First World War, and Leningrad after the death of Lenin (21 January 1924), until post-Soviet times when it resumed its original name. In this book, references employ the name in use at the time under discussion.

The Modified Library of Congress transliteration system has been used, with the alteration that single or double diacritical marks denoting the Russian hard and soft signs have been omitted from people's names and surnames. In order to establish consistency with the spelling of more well-known and established names, adjectival endings – 'ii' and 'iy' have been simplified to – 'y' (e.g., Lunacharsky rather than Lunacharskii; Trotsky rather than Trotskii; Mayakovsky rather than Maiakovskii).

Where names have a recognised westernised form (Marc Chagall, Feodor Chaliapin, Alexandre Benois, for example), these have been retained.

Throughout this book, translations from Russian sources are by these authors unless otherwise indicated.

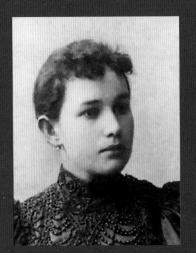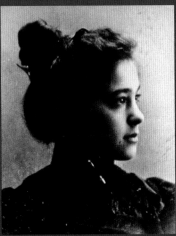

Introduction

Women dealers and gallery owners represent a notable and integral part of the present day international art scene. However, this active female engagement with fine art is a relatively recent phenomenon. In fact, the activities of well-established and prominent women gallerists, including Peggy Guggenheim, Halima Nalech and Annely Juda, in managing the art market and promoting diverse art styles did not occur before the 1930s–40s.

In the patriarchal culture of Imperial Russia, just as in the other European countries, collecting, exhibiting and trading art works were historically men's business. Nevertheless, in the second half of the nineteenth century, a new phenomenon emerged. Women, both in the capital cities of St Petersburg and then Moscow, as well as in the provinces, started to play an important role in managing and promoting folk arts and crafts and traditional dress. This important gender-related change, which would soon lead to a strong presence of women in all fields of Russian visual art, was prompted by a profound remodelling of the economic, political and cultural tissue of the country following the emancipation of the serfs and democratic reforms of 1860s.

In the course of European history there were, of course, some isolated incidents of women's involvement in art business. The earliest cases were recorded in the Netherlands, where women from the families of members of the artists' guilds, especially wives and widows, had participated in the process of selling their spouses' works of art since the fifteenth century. Although their business activities were mostly on a small scale and limited to their families' art production, some particularly energetic and entrepreneurial women even managed to establish a business enterprise, buying and selling art works on the national and international market. Lysebetten Lambrechts of Antwerp exported Dutch art to England in the first decades of the sixteenth century, while a century later Judith Leyster, a member of the Haarlem artists' guild of St Luke and a painter in her own right, became actively involved in the art trade after marrying the prominent art dealer Jan Miense Molenaer.

It must be stressed, however, that these Dutch women's involvement in the art trade appears to have been far ahead of other European countries. For instance,

in the UK it was not until 1877 that a woman – the wealthy aristocrat, artist, musician and writer Lady Lindsay (née Caroline Blanche Elizabeth FitzRoy) – became directly involved in the art gallery business. Together with her husband, Sir Coutts Lindsay, they founded the Grosvenor Gallery, which soon became a leading art enterprise and a pivot for the Aesthetic Movement of the early 1880s. Lady Lindsay graciously played the role of the hostess of this establishment, which was founded mostly with her own money and modelled on the interior of an aristocratic home, with its elegant space embellished with antique furniture and oriental rugs. This was the beginning of the reinvention of contemporary painting as a luxury object. Yet, despite all her active participation in the gallery's business, Lady Lindsay could hardly be considered a professional gallerist or an art dealer. Although her excellent social skills and her wealth were essential for setting up and for the day-to-day running of the enterprise, this whole project was no more than one of many other ventures in which a high-society lady elected to invest part of her bustling energy, creative zeal and large inheritance. The Lindsays' divorce in 1882 ultimately led to the closure of the Grosvenor Gallery in 1890.

The advent of Modernism did not change gender imbalance in the field of gallery business and dealership, from which women remained virtually excluded. At the beginning of the twentieth century, the only female dealer in Europe to pursue

Unknown artist, *Poster advertising the first one-man show of Modigliani at Berthe Weill gallery*, 1917.

an explicit trade line in her art business ventures was Berthe Weill. As a risk-taker, Weill aimed to promote new artists and their daring visual experiments. The exhibitions she mounted at her Gallery B. Weill, which opened in December 1901 at 25 rue Victor Massé in Paris, included works of young pioneering painters now considered to be the forerunners of Modernism. Weill was one of the first art dealers to advocate Fauvism, promoting work by Henri Matisse, André Derain, Georges Braque and Albert Marquet as early as 1908/09. She had also recognised Picasso's enormous creative potential and became his first dealer in 1900, even before the artist moved permanently to Paris. She enthusiastically endorsed Cubist artists, displaying in her gallery works by major champions of this new ground-breaking style, including not only Picasso but also Braque, Albert Gleizes, Jean Metzinger and Fernand Léger. Finally, in 1917 she hosted the only one-man show of Amedeo Modigliani in his lifetime – a scandalous exhibition which was famously closed by the police on the grounds of nudity.

Considering Weill's ground-breaking activities, it is not surprising that in present-day literature on art dealership and patronage she is generally referred to as the first and the only female art dealer who promoted Avant-garde painting in the first two decades of the twentieth century. However, this assertion is not historically correct, as innovative exhibitions organised in Russia during the decade of 1910 by Nadezhda Dobychina and Klavdia Mikhailova in their private art galleries in St Petersburg and Moscow occurred at the same time as Weill's endeavours in France. The story of the lives and inventive enterprises of these two pioneering women has been long overdue and this book is the first step in that direction.

CHAPTER 1

Paths to the Art Business

Nadezhda Dobychina and Klavdia Mikhailova were born in the last decades of the nineteenth century, when the idea of gender equality naturally fitted in with general aspirations for social renewal. Following the emancipation of the serfs in 1861 and important economic and social reforms of the 1860s, the patriarchal culture of Imperial Russia underwent significant changes. The woman question became one of the key points on the agenda for national renewal. Gender egalitarianism was forcefully championed by the philosopher, writer and political activist Nikolai Chernyshevsky in his seminal novel *What is to Be Done?* (*Chto delat?*), written in 1863 and published in the same year in the journal *The Contemporary* (*Sovremennik*). Its main heroine, Vera Pavlovna Rozal'skaia, marries the medical student Lopukhov to escape the oppressive environment of her patriarchal family, and achieves economic independence through founding a seamstress workshop for women. Here, Vera Pavlovna and her fellow workers hold common values of female emancipation while also sharing profits of their business enterprise. Soon banned by the censors, the novel was disseminated in handwritten copies and was widely read by the Russian democratic elite who strove to change the rigid rules of patriarchy by embracing a new type of relationship between the genders based on companionship, equality and personal freedom. By the end of the nineteenth century a new type of forward-thinking, enlightened and dynamic young woman had emerged. In 1883, Gleb Uspensky, an influential left-wing publicist and writer, paid tribute to the 'new' woman who came to be seen as the incarnation of an 'ideal of self-sufficiency, a new intellectual and spiritual beauty, the prototype of … the new generation who would bring about far-reaching social changes'.[1]

Dobychina and Mikhailova belonged precisely to this up-and-coming new generation envisaged by Uspensky. They happened to be living during a period of radical gender reshuffling, when Russian women were stepping out of the shadows, claiming for themselves a new role within their country's social, professional and cultural contexts. The gender democratisation of the national higher

1 G. Uspensky, 'In relation to one little painting' (*Po povodu odnoi malen'koi kartinki*'), *Otechestvennye zapiski*, 1883, no. 2, Moscow, pp. 557–8.

education system, including art studies, opened new professional opportunities for women. In 1878, they obtained the right to a university level education through the establishment of the Bestuzhev Higher Courses for Women (*Bestuzhevskie kursy*), which secured women professional training in history, medicine, natural sciences and mathematics. Although universities still resisted women's rights to higher education (before the October Revolution of 1917, Russian universities lifted the ban on women only for two years, in 1906–08), medical institutes began to admit women in the 1870s. At the same time, special advanced courses were offered to women, first in Moscow and St Petersburg and by 1910 in ten other cities. In 1911, female graduates in St Petersburg, Moscow, Kiev and Kazan were allowed to sit state examinations and by 1914 women accounted for 30 per cent of students in institutions of higher education. As a result, the empire experienced a quick rise of professional working women: totalling about 40 per cent of Moscow's professionals and semi-professionals, according to the 1902 city census.

In the first decades of the twentieth century, Russian visual arts were one of the major fields in which women occupied a prominent position. Without doubt, this phenomenon rested in the early availability of artistic education to women. The Imperial Academy of Arts in St Petersburg became one of the first in Europe to give women access to its full curriculum from 1873, and in 1891 it abolished all restrictions against the admission of female students.[2] As a result, the first generation of professional women artists was already formed in Russia by the 1890s. They became eligible to receive the title of first-class artist, a status that gave them an equal professional standing to men and the opportunity to receive academy-funded training abroad.

Equally important was the fact that many talented women in Russia, inspired by Chernyshevky's ideas, considered art not only as an outlet for one's own creativity and self-fulfilment, but also as important means of social improvement and women's emancipation. Such was, for instance, the moral creed embraced by Elena Polenova, a prominent figure in the Russian Arts and Crafts Movement. The very decision to become a practising artist came to her whilst she was volunteering as a nurse and caring for wounded soldiers in Kiev during the Russo-Turkish war of 1877–8. In addition to intense artistic endeavours, Polenova also engaged in entrepreneurship. Her remarkable career in the art business began in the Abramtsevo estate near Moscow, in partnership with its owner's wife Elizaveta Mamontova. Elizaveta's husband, Savva Mamontov (1841–1918), a wealthy industrialist, was an amateur painter and playwright as well as an enthusiastic supporter of many

2 By the 1850s women in Russia were allowed to attend drawing classes at the Imperial Academy of Arts as auditors. In France, women gained full admission to the École des Beaux-Arts in 1897, while in Britain female students' access to professional training was subject to special regulations until 1893.

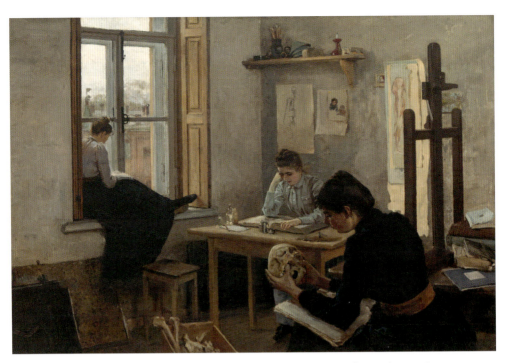

Elena Polenova, *Anatomy students*, c.1880, oil on canvas, 81.5 × 124 cm. Polenovo Museum Reserve, Polenovo.

Ilya Repin, *Portrait of Elizaveta Grigorievna Mamontova*, 1879, oil on canvas, 83.5 × 59 cm. Abramtsevo Museum Reserve, Abramtsevo.

Savva Mamontov in Abramtsevo.
Photograph, 1880s. Abramtsevo Museum Reserve, Abramtsevo.

Russian artists. Elizaveta also supported the cause of art patronage, albeit in a different way to her spouse. A fervent promoter of cottage industries in Russia, she established a number of workshops which aimed to resurrect the peasant crafts that had come under threat from the efficiencies and standard models of industrialisation. From 1876, workshops in joinery and carpentry were duly established on the Abramtsevo estate, where locals could learn essential technical skills and reap financial rewards. In 1885, Elizaveta employed Polenova as the workshops' creative director. It was a brilliantly strategic move. In the following decade Polenova developed innovative designs, making traditional craft objects more appealing to the modern, urban clientele. Soon wares produced by Abramtsevo workshops became sought-after artefacts sold in commercial outlets and displayed in the prestigious exhibitions.

Close collaboration between the two like-minded women initiated the establishment of other art colonies all over the European part of the Russian Empire, in which women played leading roles as sponsors, organisers and creative leaders. In fact, the overwhelming majority of Arts and Crafts centres in Russia were managed by women, who worked in a variety of different media to the benefit of local communities. Much like the Arts and Crafts Movement elsewhere in Europe and America, their creative endeavours managed to erase the boundaries between the fine and applied arts.

This trend was largely facilitated by the considerable economic independence enjoyed by Russian women, especially those from aristocratic and merchant families. According to the latest research, in the eighteenth century women in the Russian Empire were more financially independent than their counterparts in Europe. The legislation of 1753 introduced the law of separate property for married couples of the landowning classes, according to which women gained full control over their own possessions, capital and assets. Women were also entitled to inherit their parents' property, while those from the merchant classes had the right to become guild members. By the 1850s women had the same private property rights as men and were actively engaged in economic activities, in some cases even directing the large trades and leading important family businesses. This special economic context, rather rare across the other European countries, secured a relatively high level of female self-determination and self-reliance in Russia. Women's prominent role in the country's cultural life, including art education, art patronage and art business, continued to grow, allowing many ambitious personalities to develop into influential, prominent and fully-fledged professionals.

Klavdia Mikhailova and Nadezhda Dobychina fully benefitted from the opportunities available to women at the time. Their biographies include several corresponding points. Both women were able to access higher education, both managed to balance their married life with their business activities, both had sufficient financial means to establish and successfully run the two most influential private galleries in pre-revolutionary Russia, both had to close their buoyant businesses soon after the advent of Bolshevik power and both went on to adapt to the new harsh conditions of life in the newly founded Soviet State. As time passed, their names as well as their endeavours seemed to have been erased from the story of Russian visual art. Yet, their remarkable lives and deeds deserve to be rescued from this historical oblivion.

1.1. Klavdia Mikhailova

Klavdia Ivanovna Mikhailova (née Suvirova) was born in 1875 to a wealthy merchant family. Apart from her sister Olga, who was five years her senior, there is no information on her other siblings. The Suvirov family achieved financial prosperity just three decades before Klavdia's birth. Her paternal grandfather, Nikandr Petrovich Suvirov, was a humble serf who managed to obtain emancipation in 1840 at the age of thirty-one. Nikandr must have had exceptionally good entrepreneurial skills, as in a matter of just a few years he managed to establish a prosperous textile business. In the 1870s both his sons – Vladimir and Ivan (Klavdia's father) – belonged to the First and Second Guild of Merchants, respectively, confirming that by then the family had risen to prominence and had entered the respectable upper middle class.

Ivan owned a large textile factory near Bratsevo village, on the outskirts of Moscow, which employed around 600 people. Apparently, he was a rather stern boss: historical records contain information about a number of strike actions organised by his workers from the 1880s to the 1900s. He might have been indeed a tough master, but he also comes across – quite surprisingly – as a considerate and liberal parent, who spared no effort in giving his daughters an excellent education. In accordance with a widespread contemporary practice, girls from upper middle-class families would go to private schools called 'female gymnasiums'. In all probability, Klavdia and Olga received their formal education in one such establishment in Moscow. The Suvirov sisters also had an obvious flair for the arts, as in 1891 they both applied to become students at the prestigious Moscow School of Painting, Sculpture and Architecture. At that point Olga was twenty-one, while Klavdia was no more than a teenager. Both were accepted, which confirms that their parents provided them with considerable preliminary art training, for it was an indispensable condition to be admitted to the school. Ivan Suvirov did not oppose his daughters' decision. He supplied them with the duly signed permission forms and paid their fees.

Klavdia began her high art education at the Moscow School of Painting, Sculpture and Architecture in autumn 1891, at the tender age of sixteen. Nothing is known about her five years of studies. A popular alternative to the stiff traditionalism of the Imperial Academy, the school counted among its teaching staff some

Klavdia Mikhailova. Photograph, early 1890s.
Russian State Archive of Literature and Art
RGALI, Moscow.

of the most renowned masters of Russian art, among which were Vasily Polenov, Vladimir Makovsky, Isaak Levitan and Abram Arkhipov. During Klavdia's time there, the school's curriculum and teaching body was influenced by the ideology and aesthetic legacy of the *Peredvizhniki* (the Wanderers group). Established in 1863, the association followed the ideology of Russian democratic and liberal thinkers of the 1860s–70s who viewed art through the lens of moral and social responsibility. The *Peredvizhniki* aspired to represent an unidealised picture of contemporary life at the same time as popularising art by bringing their exhibitions to various provincial towns of the Russian Empire, hence their name. By the 1890s, however, the group's focus shifted from social critique to a more moderate ground, widening the range of their subjects to include landscapes, portraits and genre scenes, as well as revivalist historical and mythological painting. In the field of painterly technique, the *Peredvizhniki* also moved towards a freer manner, showing interest in works *en plein* air and experimenting with colour and light. Once a group of young rebels, by the 1890s the *Peredvizhniki* became the most established and influential art society in Russia. At the same time, their artistic approach was increasingly viewed as outdated by the new generation of Russian artists.

The last ten years of the nineteenth century proved to be a decade of intensive re-evaluation of previous concepts in the visual arts. Klavdia, whose years of art studies coincided with this significant historic moment, undoubtedly was exposed to its conflicts, clashes and debates. In the absence of documented evidence, there is no way of establishing her own views on the matter. However, the broadness of her social and professional contacts suggests an open-minded and liberal personality prepared to respect different opinions. Despite her own paintings revealing a deeply rooted connection with the aesthetics of the late *Peredvizhniki* and fascination with Symbolism, in her capacity as a gallery owner she was able to appreciate the creative radicalism of the Avant-garde and forge fruitful collaborations with a wide range of various artistic associations.

Years spent within the walls of the school also shaped the Suvirov sisters' personal life, as it was there that they met their future husbands. It seems that once more the parents met their daughters' life choices with no apparent resistance, although their fiancés came from petty bourgeoisie families, which meant relative poverty and lower social status. Most likely both the sisters tied the knot during their studies. At least that was definitely the case with Klavdia, who married fellow student Ivan Mikhailov, seven years her senior, in 1896. Olga and her future husband, Vitold Byalynitsky-Birulya, were classmates. Mikhailov and Birulya were faithful followers of realism in art and after graduation they both gravitated towards the *Peredvizhniki* group's sphere of influence. Birulya forged a solid career as a successful landscape artist. His paintings were acquired by private collectors and prestigious museums, including the Tretyakov Gallery, which made its first

purchase of his work while he was still a student. In the early 1900s, Birulya was elected a full member of the *Peredvizhniki* group, having consolidated his distinguished status within the Russian artistic world. Olga and he lodged in the central area of Moscow, in the Suvirovs' residence on Malaia Dmitrovka Street that runs in close proximity to Bolshaia Dmitrovka Street where Klavdia would later open her Art Salon in 1912. The young couple kept an 'open house', which quickly acquired a good reputation in cultural circles close to the *Peredvizhniki* and Russian Arts and Crafts Movement, attracting visitors that ranged from illustrious artists such as Ilia Repin, Isaak Levitan and Vasily Polenov to the influential art patron Savva Mamontov.

Klavdia and Ivan Mikhailov did not share the parental house with Olga and Vitold, but they did share the same circle of acquaintances. Quite soon Ivan came to the realisation that he was more a successful entrepreneur than an artist. In 1909 he was appointed the exhibition commissioner responsible for organising the *Peredvizhniki* annual events, while Klavdia started to participate regularly in the group's shows as an artist. Despite all these professional achievements, the sisters' personal lives were far from serene. In the early 1900s Olga's mental health deteriorated: she developed a bipolar condition accompanied by bouts of nervous breakdowns. Her husband was devastated. During her recurring crises he would often appeal to Klavdia and Ivan for their assistance in taking care of his ailing wife.

As if caring for her sister's wellbeing was not enough, Klavdia had her own family troubles. From her private correspondence it emerges that Ivan had a rather difficult character and was inclined to hypochondria, which probably accounts for the fact that his relationships with Klavdia's parents did not work out well. Despite it, she proved to be a devoted and loyal wife and they remained married until Ivan's death in the summer of 1940. According to the recollections of one of their common acquaintances, in the 1910s Mikhailova 'had a very difficult life because of Ivan Ivanovich's character. Yet, I would have never guessed it for she always treated him with loving consideration. … Klavdia Ivanovna insisted that he was more talented than she, but I have never seen him paint a picture.' These already unhappy circumstances were exacerbated by problems with the couple's only child. In 1896, while they were both still at the school, their daughter Natalia was born. However, for some reason the young parents relied on Klavdia's family to take care of the baby. As it turned out, Natalia remained with her maternal grandparents until they died in the early 1910s. Only then did the girl – already a teenager – finally return to live with Klavdia and Ivan, and it took time and effort from all of them to develop a proper family bond.

This dramatic private context did not prevent Mikhailova from successfully launching her artistic career in 1897. At the age of twenty-two she participated in her first exhibition, thus confirming her professional standing. She then regularly

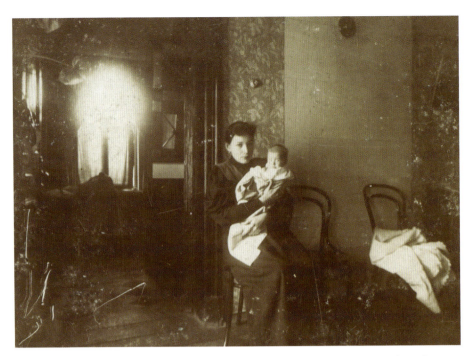

Klavdia Mikhailova with her daughter Natalia. Photograph, c.1896. Russian State Archive of Literature and Art RGALI, Moscow.

took part in various art shows every season until 1912, when her main efforts switched to running the Art Salon. However, she would never completely give up on painting and participated in various exhibitions from time to time. Coming from a well-off family, Mikhailova hardly needed a job to make ends meet, yet an idle existence seems was not to have been to her liking. Until 1912 painting was her true vocation, for which she spared no time or effort. One of her contemporaries remembered Mikhailova as being totally absorbed in the creative process during her frequent visits to countryside: 'She would relentlessly walk around the park, flower garden and close neighbourhood carrying with her either a sketchbook or a wide-angle-lens camera. She was always making studies or exquisitely artistic photos.'

Mikhailova was careful in selecting the societies with whom to display her paintings, exhibiting with only a few, but distinguished, groups. Her first major commitment was to the Moscow Association of Artists (*Moskovskoie Tovarishchestvo Khudozhnikov*), one of the most prominent art societies of *fin de siècle* Russia. She contributed to their annual exhibition for seven consecutive years without, however, becoming a full member. The association, founded in 1893 by a group of alumni of the Moscow School of Painting, Sculpture and Architecture, was only formally registered as an exhibition body in 1896, which was just a year before

Mikhailova's involvement. According to its statute, it had the objective of 'ensuring success and promoting further development of Russian visual arts'. To achieve this goal, it aimed at freeing the arts from both the stultified classicism of the Imperial Academy and the didactic realism of the *Peresvizhniki*. The members and associates engaged with the latest developments of western European art with the intention of reinvigorating Russian painterly culture, broadening contemporary tastes and recasting public opinion on the nature of art and creativity. Their main stylistic directions embraced Symbolism, Impressionism and Post-Impressionism.

The period from 1907 to 1912 was particularly fruitful in Mikhailova's artistic career, as the range of societies with whom she exhibited widened to include other acclaimed groups. For two seasons in 1907 and 1908 she participated in the annual show at the Imperial Academy of Arts in St Petersburg. For almost a decade from 1908, she became a regular contributor to Moscow shows of the *Peredvizhniki*. However, perhaps the most consequential move was her decision to join endeavours of a newly founded society called the Independent Ones (*Nezavisimye*). The sudden emergence of this society was a result of an open conflict between the Moscow Association of Artists and the young aspirants whose works were rejected by its selection committee. In its issue of 9 April 1907, the *Moscow Journal* (*Moskovskaia Gazeta*) reported:

> Today the Moscow Association of Artists opened its annual exhibition of paintings in the new building of the Stroganov School on Myasnitskaya. Out of a thousand paintings offered for display 750 were turned down by the jury. Then, door to door to this exhibition, i.e. in the same building and even on the same staircase, the outcast artists decided to arrange their own exhibition calling it 'The exhibition of the Independent Ones'.

The clash took place against the dramatic background of the First Russian Revolution of 1905–07 and to a certain degree reflected ethics of confrontation between the establishment and the revolutionaries.

Mikhailova's decision to side with the rebels might seem odd. After all, her long-lasting collaboration with the Moscow Association of Artists seemingly commanded loyalty to this prominent organisation, especially considering she was on friendly terms with many artists who formed its core. Yet, her relationship with the association had already been put on hold for two years during which she did not take part in its exhibitions. Perhaps she grew dissatisfied with the group's aesthetic strategy or perhaps the association rejected her works for its display. Whatever the case, in 1907 Mikhailova opted to join the dissidents, among which were the two future leaders of the early Russian Avant-garde – the inseparable couple Mikhail Larionov and Natalia Goncharova. It is more than probable that it was in the context of this spontaneously organised event that Mikhailova first met

this non-conformist energetic pair. Her acquaintance with them would have far-reaching consequences for the history of Mikhailova's Art Salon.

Mikhailova remained involved in the exhibition activities of the Independent Ones until 1909. The society did not last long anyway, disintegrating in 1912. Nonetheless, her three-year participation in this alternative venture bore fruit: her works attracted favourable attention of art critics and were discussed in the press. Especially successful was the season of 1908–09, when Mikhailova's landscapes and paintings, inspired by Russian folklore tales, were singled out by a number of commentators. By this time her artistic capacity was in full bloom. Judging by the reviews, her paintings stood out by virtue of a special experimental technique based on strong colour effects and the unorthodox use of metallic pigments.

A pale image of Mikhailova's artistic trials can be conjured up from a few black-and-white postcards that reproduce her works, displayed at the 1909 exhibition of the Independents Ones. Darkened by age, these poor-quality images do not allow one to appreciate the finesse of her painting style, but her technique appears reminiscent of Post-Impressionist pointillism. Some of her pictures were constructed following classical conventions of a three-dimensional illusion, while in others she

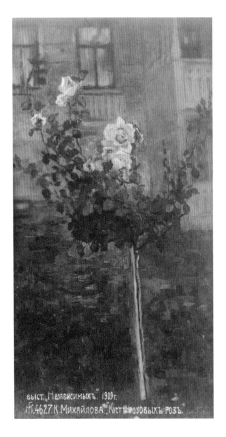

Klavdia Mikhailova, *Rose bush*, c.1909, oil on canvas, size and whereabouts unknown.

engaged in a more Modernist approach, flattening the pictorial space and shifting angles of view. Landscapes were one of her favourite genres. As one can judge by the existing imperfect reproductions, her visions were imbued with a subtle sense of melancholy and underlying mystery, achieved by representing nature at its borderline state: at dawn or at dusk when colours and shapes blur under the uncertain feeble light.

The strongest appeal for Mikhailova as an artist lay in the motifs taken from Russian folk tales. Decades later, in a letter to the famous writer Maxim Gorky, she eloquently explained the reason of her professional fascination with that kind of subject matter:

> In a Russian fairy tale I was always attracted by something different than all other artists. What I am particularly interested in are ancient myths and pagan beliefs hidden in them. And as an artist I am enticed first of all by the alluring splendour of their imagery for, I think, nothing else can offer such picturesque and colourful possibilities. For me, the entire Russian epic represents a struggle between light and darkness, good and evil, life and death. But what fascinates me most is that the light, goodness and life always win.

Two things can be distilled from this short passage. First, Mikhailova comes across as an idealist whose world view was based on the pursuit of perfection and the belief in the power of good. Undoubtedly, such a disposition made her particularly susceptible to the aesthetics of Symbolism without, however, being seduced by its darker, decadent side. Secondly, by her artistic nature she was a colourist, enchanted by the interplay of hues and eager to experiment with a multitude of pigments. The press reviews published after the 1909 exhibition of the Independent Ones corroborate this assumption. Although some commentators found her colour schemes a bit garish, they all agreed that her paintings were 'the display's real pride and joy'. Critics particularly commended two of her fairy tale compositions called *The Golden Kingdom* and *The Silver Kingdom*. The most complimentary was the well-established art critic (and the son of the renowned art patron Savva Mamontov), Sergey Mamontov, who wrote:

> It has been a long time since I had seen anything that can be compared to Mrs Mikhailova's paintings. Only a woman is capable of such creations, a woman who is both gifted and bold. Not everyone succeeds in bringing gold and silver pigments into landscape painting so successfully. This exhibition boasts two undoubtedly outstanding works, or, should I say, poems, by Mrs Mikhailova called *The Golden Kingdom* and *The Silver Kingdom*. Autumn and winter. Against the background of bright yellow trees, a small Russian wooden house, painted with golden metallic paints, stands out – a colour

Klavdia Mikhailova. *The Silver Kingdom*, c.1909, oil and metallic powder on canvas, size and whereabouts unknown.

combination that is surprisingly beautiful and unexpected. In front of the house stands a prince clad in dark red. Another pairing painting represents the same vista in winter where the silver house stands against a white background of frost. All is so amazingly simple and beautiful that one could not help but marvel.

Despite considerable success following her participation in the 1909 show of the Independent Ones, Mikhailova ended her collaboration with the group and from the next season exhibited exclusively with the *Peredvizhniki*. The reasons as to why in 1912 she committed herself to gallery business at the expense of her artistic career remain obscure. Without doubt her husband's example, as well as the considerable inheritance she received following her father's death, played a certain role in her decision. Whatever the case, she managed to integrate her creative potential into her entrepreneurial endeavours. Two decades spent within Moscow's artistic milieu equipped her with many useful contacts and experiences to launch a buoyant gallery venture. By 1912, the thirty-seven-year-old artist was about to open a new chapter in her professional life.

1.2. Nadezhda Dobychina

Nadezhda Evseevna Dobychina was born Ginda-Neka Shyevna Fishman on 28 October 1884 to a Jewish family in Orel, a picturesque town just over 200 miles south of Moscow. She changed her first and patronymic names (and after marriage

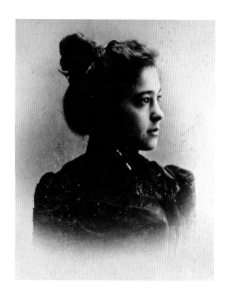

Nadezhda Dobychina, photograph taken in Orel, 1902.

her surname, too) due to the hardships and persecutions suffered by the Jews in the Russian Empire. In the mid-eighteenth century, Catherine the Great had taken measures aimed at restricting the Jews' freedom of movement and started the process of preventing them from settling in other regions of the empire. These measures, reaffirmed by successive monarchs between 1804 and 1825, gave birth to what was called the 'residential zone', inside which Jews were forced to live; it stretched across the entire western edge of the empire, from the Baltic Sea to the Black Sea – the area presently occupied by Lithuania, Poland, Belarus and Ukraine. Forbidden from working the land, Jews survived as merchants and artisans concentrated in small rural towns, or *shtetlach*.

In the mid-nineteenth century, these restrictions began to soften: permission to live beyond the residential zone was granted in 1859 to 'merchants of the first guild', in 1860 to tenured professors at major universities, in 1865 to certain trades people, in 1867 to military veterans and in 1879 to those with a higher education. Since Nadezhda's father served in tsar's army, he and his family were allowed to live outside Jewish residential zone.

In her diary written in August 1918, Nadezhda remembered her father as a stooped man of medium height with straight dark hair with side-locks that came down to his curly beard:

> I often asked my father why he had straight soft hair on his head and curly coarse hair in his beard. He had a straight Greek nose, wide-opened green-brown eyes and beautiful eyebrows and eyelashes. His best features were his eyes and his mouth. When he was content there was an expression of mournful kindness in his eyes; when he was excited, his eyes were filled with

the rampant fire, as if all the Jewish songs were reflected in his eyes; when he was angry his eyes would fill up with sparks of lightening. He was famous for his love of animals and treated the feeding of cows as the holy act. He never said much but he expressed all his feelings and emotions with his eyes.

The family was relatively poor but Nadezhda received a good education, first at home and later at the gymnasium, where she met her future husband, Petr Dobychin. He came from nobility and his social status and inheritance helped Nadezhda to become a successful businesswoman.

Nadezhda's first letters to Petr were written in May 1904 while she was undergoing treatment for tuberculosis in Das Kurhaus in Meran. At the time she was worried that she would be forced to marry a rich Jewish man, as her parents could not afford to pay for further treatment. However, Petr managed to make a good impression on her parents and even changed his religion from Russian Orthodox to Judaism in order to marry the love of his life.

In 1903 Dobychina travelled over 600 miles to St Petersburg from her native Orel to study biology at Lesgaft's Part-time Courses for Training Women Instructors of Physical Exercises and Games. It was a brave choice, since at the time Jews were forbidden to settle in Moscow and St Petersburg. Marc Chagall, who was a student at the Imperial Society for the Protection of the Arts in the Russian capital, wrote in his memoires, *My Life*: 'But in order to live in St Petersburg, one needs not only money, but also a special permit. I am a Jew. And the Tzar has set aside a

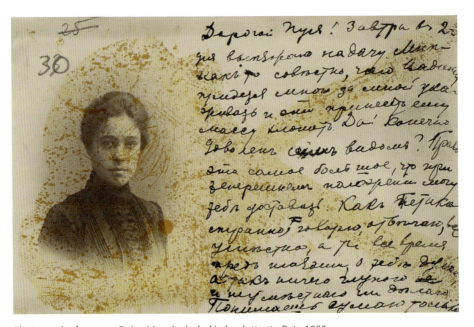

Photograph of a young Dobychina, included in her letter to Petr, 1905.

special zone of residence for the Jews, which they are not allowed to leave.' At the time, Jewish students in the capital could constitute no more than 5 per cent of the whole cohort in all places of higher education (with the only exception of the Conservatoire).

Admission of women to professional training in the field of sport was also still novel: the official view in Russia had long been that vigorous physical exercise was the preserve of men and that women were not suited to it, due to their social status and anatomical structure. During her studies Dobychina met students with radical views which probably led to her short imprisonment in 1904 for propaganda among Kronshtadt sailors. Petr Lesgaft, a prominent physician and social reformer, was famous for his revolutionary views and for his strong support of female emancipation. He founded the Part-time Courses for Training Women Instructors of Physical Exercises and Games to encourage women's participation in sport, which he considered as a means to social liberation:

> Social slavery has left its degrading imprint on women. Our task is to free the maidenly body of its fetters, conventions and drooping posture, and return to our pupils their freedom and suppleness which have been stolen from them. We must develop in them firmness, initiative and independence, teach them to think and take decisions, give them knowledge of life and make physical educationalists out of them.

Lesgaft provided courses in physical education and anatomy to female students at his home, and from 1896 at the part-time courses which were opened at the house of philanthropist Innokenty Sibiriakov, who donated 200,000 roubles and his house in St Petersburg to Lesgaft's courses for women. In the first year, one hundred women students attended the course and 166 in the second year. They studied physiology, the theory of movement, hygiene and the history of physical education, and were assigned to practical work in nurseries and orphanages where they could study children's development, particularly through games and exercises. They were also encouraged to attend fencing classes four times a week, to play team games, skate and engage in gymnastics.

It was at the Lesgaft courses that Dobychina met Nikolay Kulbin, who at the time taught her biology but soon changed the course of her life. Kulbin was a medical doctor who in the first decade of the twentieth century became the major supporter and promoter of the Russian Avant-garde. He combined his job as a surgeon at the Russian Army headquarters with an interest in contemporary art and music, describing his main aspiration as the 'liberation of art, literature and music from conventional patterns'. A fellow artist described Kulbin as 'the brightest representative of bohemia, who was a military man, a chief doctor in the military headquarters – a very important position at the time! He would usually wear a battered

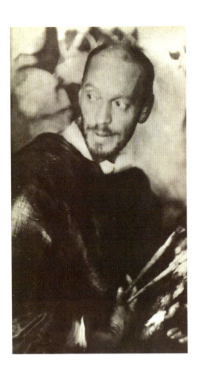

Nikolay Kulbin, 1909.

trench coat of the officer of tsar's army, complete with spurs on his galoshes; and he resembled an officer as much as me or Akhmatova did. ... Outside, soldiers would salute him, but when he came in and took off his trench coat, he would stop being a military man and would become a man of art. ... He was a friend of poets and artists, a patron. Although he did not have much money, he supported us more than anybody else.'

In 1907 he founded the Triangle: The Art and Psychology Group that held four exhibitions between 1908 and 1910 in St Petersburg and Vilna (Vilnius) and gave many young artists their first opportunity to exhibit their work. Kulbin believed that artists should use pure unmixed colours and by choosing 'Triangle' as the name of his new group, he indicated the importance of the three primary colours. Thus, the emblem of the group was a triangle with yellow, blue and red sides.

Between 1908 and 1910 Kulbin was at the centre of the Avant-garde scene in St Petersburg, following the *Exhibition of Modern Trends in Art* (*Sovremennye techeniia v iskusstve*) which he organised, and which became the first ever show of Avant-garde art in the capital. It opened on 25 April 1908 in the department store, Passazh, on Nevsky Prospect in St Petersburg, and included 400 works by the representatives of all trends in art – from the academic artist Nikolay Bogdanov-Bel'sky to the leader of the World of Art (an art movement and magazine), Alexandre Benois, and the rising star of the Russian Avant-garde Aleksandra Ekster. One of the leaders of the Russian Futurism, David Burliuk, explained in his memoires that

Kulbin believed that it was possible to connect academic and Avant-garde art and present it in one exhibition. Burliuk tried to encourage Moscow-based figureheads of the Avant-garde, Mikhail Larionov and his partner Natalia Goncharova, to send their works to this important exhibition but they decided to refrain from showing their works with less known (to them) artists from St Petersburg.

Conservative St Petersburg art critics struggled to accept the new art but admitted that Kulbin's paintings, in which only pure primary colours were used, were interesting and quite effective. The more progressive commentator, Konstantin L'dov, in his article, 'Artists-revolutionaries' ('*Khudozhniki-revolutsionery*'), wrote that the exhibition has shown 'art of the future; art of the brave and inevitable search for the novelty in art'. 1908 was celebrated by the first signs in the development of the upcoming Russian Avant-garde. In his memoires Burliuk lamented:

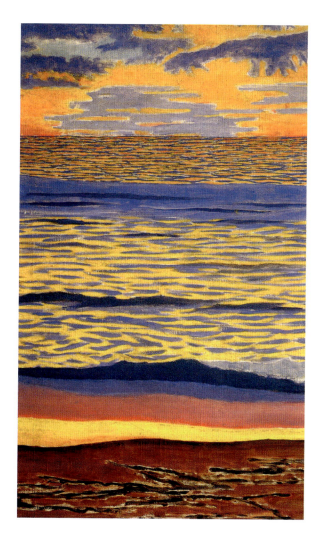

Nikolay Kulbin, *Sea View (Sunset)*, c.1916, oil on canvas, 97 × 62 cm. The State Russian Museum, St Petersburg.

We cheerfully came forward; young and kind, ready to embrace the whole world. But wherever we went ... we were either not accepted at all or allowed in microscopic doses, which were safe for the old. At the time we still did not understand that we were 'magpie children', who were born in the nest of old art out of the eggs, planted there by the pre-revolutionary times.

Nevertheless, at this important time the Russian Avant-garde was born and for the first time announced itself at the brave and still unprecedented exhibitions.

Nadezhda Dobychina took an active part in these developments and soon became the 'secretary of expositional and financial activities' for Kulbin's exhibitions – *Impressionisty* (Impressionists) in March–April 1909 and *Treugol'nik* (Triangle) in April 1910. Her responsibilities included applying for the necessary permits from the city council and finding venues for the exhibitions; a challenging

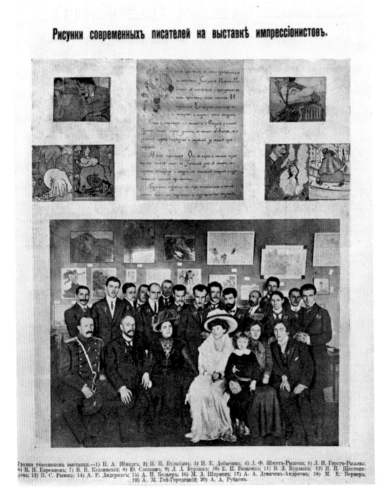

Dobychina and Kulbin with the participants of the *Impressionisty* exhibition, 1909.

task in a city without commercial galleries (see Chapter 2). Thus, the *Impressionisty* took place in an unused shop and the *Treugol'nik* was held in the basement of the Hotel Aurora.

Critics remarked on the unusual venue for the *Impressionisty* exhibition, which was decorated in a deliberately primitivist and rough manner: 'The walls of the three-four rooms are covered with crude sackcloth (the cheapest one); and on this dirty-grey background equally rough, dirty-grey "paintings" are displayed.' The cover of the exhibition catalogue was made from the same sackcloth, which was supposed to stress the artists' interest in primitive peasant culture. The interior strived to challenge the established image of the exhibition hall and to democratise consumers of the new art.

However, neither the critics nor the general public were quite ready for this new approach. Most reviews called the exhibition a fraud or madness and concluded that psychiatrists should review such exhibition rather than art critics.

Despite the negative reviews and the novelty of exhibits, *Impressionisty* was attended by 8,000 people and around fifty works were sold.

Dr Kulbin strived to give scientific interpretation to the new art, explaining its principles in lectures organised with Dobychina's assistance at the opening of each exhibition of his new group, Triangle. In the lecture he presented at the private view of the *Impressionisty* exhibition, Kulbin lamented:

> You would be wrong to assume that these artists can't draw according to general academic rules: all of them are great artists, they have graduated from the art schools and are professional artists, but they are not satisfied with the accepted norms and demands of the art establishment. They find everything cheesy in art – disgusting. … The favourite colour of these artists is blue. They deny all the academic rules of painting, all systems, and follow exclusively their own impressions.

Kulbin even included a special section in *Impressionisty* which was supposed to illustrate his theory of psychological unity between words and visual art.

This scientific approach helped critics to take him and his new art more seriously. Thus, the newspaper *Birzhevye Vedomosti* published a rather positive review of *Impressionisty*:

> It is a group of nice people who happen to be the artists. They are not charlatans …, they are fanatics, enthusiasts, seekers, often grown-up children. Anything but charlatans. Their symbol – a mystical triangle. As if they are some mysterious corporation or a sect.
>
> Triangles are everywhere – on the exhibition poster, on the catalogue, on the cloakroom tickets and even on the ceiling of the exhibition venue.

An interesting person – the leader of these impressionists. A very curious phenomenon. He is a military doctor Kulbin. A young man with the look of a maths teacher, with epaulets of the State Councillor, with endless love to art and youthful eyes of excited confirmed fanatic.

Kulbin manages to be at the same time a brilliant specialist, a doctor, an artist and to give speeches and lectures on the new developments in art.

Impressionist … This scary word immediately recalls an image of a dishevelled figure with a pale face and restlessly darting eyes, who is rather spaced out.

And suddenly … the State Councillor in the uniform of a military doctor. We have not seen such impressionists before. Such surprises can only happen in Russia – rich and absurd, profound and rebellious.

… Everywhere at the exhibition one can feel the conductor's baton of the State Councillor Kulbin.

As a scientist, doctor-psychiatrist, he is trying to find in art solutions to psychological problems.

The respectable job and status of Kulbin forced critics to take him and the artists whom he exhibited seriously, and even the most established artist at the time, Ilya Repin, who was famously against new trends in art, told Kulbin: 'Although we

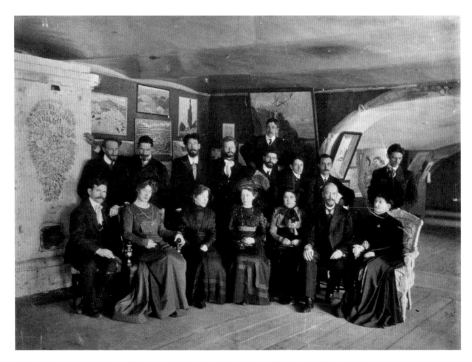

Dobychina and Kulbin with the participants of the *Treugol'nik* exhibition, 1910.

represent two opposite camps, I understand you. … You are looking for something and succeed in your strives, while others are just laughing at the general public.'

Repin's support opened many doors in Russia at the time. Not only did it encourage Kulbin but it soon helped Dobychina – who probably met Repin for the first time at this exhibition – in her new business venture. Three years after the foundation of Triangle, Kulbin concluded that they brought to Russia Post-Impressionism combined with their own discoveries, which later made the foundations of the Futurism in the Russian Avant-garde.

Following the first exhibitions of Triangle, Dobychina assisted Kulbin in the organisation of lectures and concerts for the Society of People's Universities (*Obshchestvo Narodnykh Universitetov*). She was also taking acting lessons from the theatre director Nikolay Yevreinov, with whom Kulbin had a particularly close working relationship and who was a member of the Triangle group. For Dobychina it was a great opportunity to develop her acting skills, since Jews were prohibited from entering the Imperial Theatrical College at the time.

Known among artists as 'crazy doctor', Nikolay Kulbin worked as a stage designer for Vsevolod Meyerkhold's Terioki summer theatre (1912) and the Queen of Spades Theatre (December 1913 to January 1914), helped Boris Pronin establish the Stray Dog Café (*Brodiachaia Sobaka*), founded the groups ARS Alliance (1911) and the Spectator (1912–13) and illustrated Futurist books. He was also running a salon, an informal gathering that included most Russian Avant-garde artists, composers, poets and scholars. He collaborated with the future leading artists of the Russian Avant-garde – Kazimir Malevich, Olga Rozanova, the Burliuk brothers (David and Vladimir) and Mikhail Matyushin – and helped them to get established in St Petersburg. While Wassily Kandinsky was living in Germany, he relied on Kulbin to keep him up-to-date with cultural developments in Russia and to supply him with popular prints, *lubki*, which provided a great source of inspiration to Kandinsky in his experiments with non-objectivity. When one of his most admired composers, Arnold Schoenberg, set off for St Petersburg in 1912, Kandinsky arranged for his friend, Kulbin, to meet him at the train station. 'Kulbin knows everything, that is, he knows all the artists of importance,' Kandinsky wrote in a letter to Schoenberg. He was in the centre of all the debate on the nature of the new art and in 1913–14 gave lectures on Futurism. In February 1914 Kulbin organised an unprecedented visit of the leader of Italian Futurism, Filippo Tommaso Marinetti, to Moscow and St Petersburg.

Meeting with Nikolay Kulbin changed Dobychina's destiny and inspired her to leave biology behind and dedicate herself to contemporary art and young artists, who would soon depend on her and her Art Bureau for commissions and sales.

CHAPTER 2

Launching the Gallery Business

At the beginning of the twentieth century, private commercial art galleries were still a novelty in Russia. Collectors and art lovers acquired fine art at auctions, in antique shops, at the exhibitions organised by the Imperial Academy of Arts in St Petersburg and by various art societies or directly from the artists' studios.

The first prototype of the commercial gallery was opened in Moscow in 1909 by Karl Lemercier (or Lemersie). Attached to the popular and best art retail store in the city, Avanzo (or Avantso), the Lemercier Gallery might be considered the first enterprise of this sort in Russia. It grew out of a small display room, selling various kinds of painting pigments, varnishes, brushes, canvases and other artistic materials. The shop successfully operated in the old capital from the 1850s. In the 1870s its owner, Ivan Avanzo, extended his main line of business by selling paintings as well. After Avanzo's death in 1909, his company came into possession of Karl Lemercier, a Belgian, who had moved to Moscow some decades before and worked as a salesman in the shop. It seems that he had no particular aesthetic ambition for his gallery, putting instead the main focus on its commercial success and following conventional tastes in his range of art works for sale. Although Lemercier organised a number of minor exhibitions between 1909 and 1912, his place did not play any special role in the artistic life of Moscow. However, in autumn 1912 the profile of the Lemercier Gallery started to change. Karl died and his business was inherited by his widow Klara. She was determined to transform her gallery into a more sophisticated and influential space. However, for the next three years it struggled to develop a coherent exhibition policy and remained a minor segment of the art market, marginalised and underrated due to its explicitly commercial orientation. In the meantime, the national press continued to complain about the absence of well-appointed private exhibition spaces in Moscow and St Petersburg able to showcase independent displays of contemporary art and to enlighten the public about the latest trends. The situation changed in 1912 when Dobychina and Mikhailova launched their galleries that soon became both integral parts and important influencers of the Russian art market.

The decade embracing the 1910s represented a period of intense fermentation in Russian art history. During that short timespan the life of the artistic

communities of both Moscow and St Petersburg was characterised by fierce battles between various art groups and associations about the intrinsic nature of artistic practice. After the turbulent years of the First Russian Revolution of 1905, the intellectual and artistic circles of the empire were striving to remodel cultural life in a more progressive way, fighting against conservatism and the rigid conventions of the Imperial Academy. Many artists of the new generation grew dissatisfied with the classical concept of the painting as a window on the world. Instead, they were advocating freedom to treat the painting not as a mere reflection of nature but as the means to express artists' unrestrained creativity and subjective vision.

The new concept of the nature of painting brought its formal qualities and subjectivity to the fore while gradually devaluing the importance of the subject matter. This tectonic shift was well perceived by contemporaries and became one of the central points of debate at the first All-Russian Congress of Artists convened in December 1911 in St Petersburg, shortly after the official opening of the Dobychina's Art Bureau and less than a year before the inauguration of Mikhailova's Art Salon. The renowned art historian, Professor Dmitry Ainalov, summarised the kernel of the situation in his opening remarks to congress participants:

> The world of the artist has been experiencing a differentiation, a stratification staggering in its diversity. The phenomenon has been erroneously interpreted as a complete absence of discipline, or else as an unprincipled freedom splitting artists into groups to which some ascribed the role of art movements. … It seems that Russian art in its advancement has lost its collective orientation and tempo, while no one has the courage to acknowledge that it is in fact just proceeding along the general European route.

Ainalov rightly pointed out the connection between Modernist tendencies in Russian art and radical shifts taking place in western Europe, especially in France and Germany. However, the decade of the 1910s was also a period when the vivid interest of Russian artists in the latest western European trends transformed into a contest for leadership. Within just a few years the new generation of Russian artists would compete with each other and with their western European contemporaries in inventing the most ground-breaking styles. Thus, the modernising slant of the Jack of Diamonds group, inspired by Cézanne, was quickly superseded by yet more radical movements: Neo-Primitivism, Cubism, Futurism and Rayism, all of which drastically revamped the formal characteristics and subject matter of painting. Finally, the Suprematism of Malevich and Constructivism of Tatlin in 1915 introduced an entirely new direction of non-figurative painting, eliminating the didactic nature of the academic art.

Dobychina and Mikhailova managed to find their own place in this complex cultural environment, as they became active and influential participants of these

turbulent and exciting developments. They worked hard to build a solid reputation for their business ventures, transforming them into the prestigious centres of innovation. This was a hazardous quest, given that in Russia there were no established models which they could follow. Both women had to prove promptly their ability to manage pioneering enterprises, starting from virtually zero. As a result, their strategies were based on a trial-and-error approach as they tested ways to run their businesses.

The challenge to establish a successful art gallery involved a variety of duties. They had to find exhibition spaces capable of hosting art events for a wider public, followed by finding skilful curators and designers of catalogues and posters for the exhibitions. They also had to establish reliable contacts with promising artists, leading art critics and influential press outlets. Their undertakings and experience-based strategies ultimately contributed to the development of the most effective models of commercial gallery business.

Dobychina and Mikhailova opened their galleries in the two major cities of the Russian Empire: St Petersburg and Moscow, respectively. Longstanding rivals contesting the role of custodian of the Russian national spirit, each city was distinct in its flavour and lifestyle. St Petersburg, also referred to as 'the Venice of the North' or 'Northern Palmyra', was founded by Peter the Great in 1703, who envisaged it as the capital city of a modernised Europe-orientated Russia. Built on the banks

View of St Petersburg. Photochrom postcard, *c.*1890–1900.

of the Neva River, which provided a vital link to the Baltic Sea, the city was built by the leading European architects. It quickly grew into a busy metropolis accommodating all central branches of the Imperial administrative and cultural power. It also provided the seat for the tsar's court. Its lifestyle, fashions and artistic tastes were largely shaped by the aesthetic standards of aristocracy. By the same token, its artistic life was dominated by the Imperial Academy of Art, established in St Petersburg in 1757. Until the end of the nineteenth century the academy continued to represent a stronghold of the classical conservative tradition.

By contrast, Moscow – the 'old capital' of Russia – was less exposed to immediate autocratic domination. As a result, it had a rather laid-back lifestyle, while also cherishing the remnants of the ancient pre-Petrine Muscovy. First recorded in 1147 as a tiny hamlet, by the fifteenth century Moscow had become the capital of the Grand Principality, which eventually grew into the vast Russian state. Peter the Great, born there in 1670, strongly disliked the city as a symbol of an archaic and anachronistic way of life. Frustrated by unsuccessful attempts to transform the land-locked city into a European centre, the tsar built a new capital – St Petersburg – from scratch, thus stripping Moscow of its role of the capital city. At the turn of the twentieth century, life in Moscow – in contrast to aristocratic St Petersburg – was largely dominated by economic and social activities of affluent merchant families, who also acted as major influencers of taste in the field of fine arts.

View of Moscow. Photochrom postcard, c.1890–1900.

Striking differences between the old and the new capital's lifestyles were often described by contemporaries. For instance, Anna Tiutcheva, a lady-in-waiting to the Empress Maria Aleksandrovna and daughter of the prominent diplomat and celebrated poet Fedor Tiutchev, observed in her memoirs:

> People in Petersburg belong either to the army, or to the bureaucracy. … All people here are wearing a uniform, all are constantly busy, all would like to be employed by somebody, all obey somebody else's orders. Moscow, on the contrary, is the city of the greatest freedom and carelessness. No one here likes to feel inhibited, but all cherish their comfort. This transpires in every instant of local life. It is evident in the colourful multitude of the crowd; in a wide variety of styles and colours of people's clothes; in the outmoded fashion of ladies' dresses; in the whimsical and peculiar harness of their carriages. It resounds in the street noise and movement. … Moscow is the city of the ultimate leisure. Everyone here lives for himself according to his own comfort.

2.1. An emerging art market in the Russian capital

Until the middle of the nineteenth century art life in the capital was controlled and run by the Imperial Academy of Arts. In 1820, the Society for the Encouragement of Artists was founded. The society enjoyed the emperor's patronage and boasted members of the Imperial family at the head of the committee and members of aristocracy as members. The society gave grants to students from the Academy of Arts, sending some of its graduates to study abroad, held annual competitions in painting and applied arts, published art journals and arranged exhibitions first at the hired premises of the Dutch Church at 20 Nevsky Prospect and from 1870 at the former chief policeman's residence at 38 Bolshaya Morskaya Street, which was given to the society by the state.

In December 1863, following the students' revolt against the Imperial Academy of Arts, the first artists' cooperative was created in St Petersburg. It aimed to give artists a chance to sell their works directly to the public, avoiding the middlemen and committees. It accepted art commissions and organised small exhibitions at the rented apartment in the house which was later turned into the famous Hotel Angleterre. This first business venture, entirely run by artists, inspired the emergence of the famous *Peredvizhniki* (the Wanderers group of artists), which was founded on 2 November 1870 in Moscow. Now the temporary selling exhibitions toured around Russia.

However, until Dobychina's Art Bureau was opened, most exhibitions in St Petersburg were organised by various societies of artists in order to give their members an opportunity to sell their works. Apart from the Imperial Society for the Encouragement

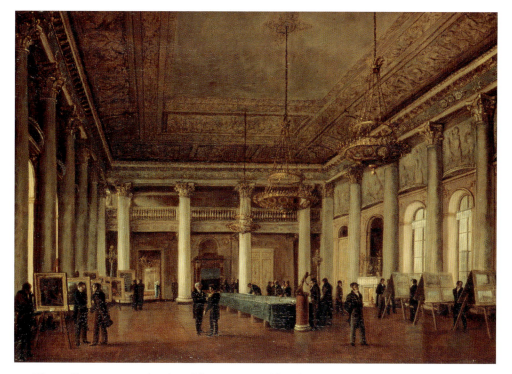

Nikanor Chernetsov, *Interior view of the Dmitry Naryshkin's house during a meeting of the Society for the Encouragement of Artists*, 1825, oil on canvas, 62.1 × 84.6 cm. The State Tretyakov Gallery, Moscow.

of the Arts (the former 'Society for the Encouragement of Artists') artists' societies did not have their own galleries. Instead, they rented exhibition rooms at the Imperial Academy of Arts, the Academy of Science, the Stroganov, Yusupov and Tauride palaces, the Armenian Church and the department store, Passazh, and several other similar premises in the centre of the city. Most of these premises had unsuitable lighting for exhibitions and charged unaffordable rent for young artists.

The first professional exhibition in St Petersburg was organised by the Russian art patron, ballet impresario and founder of the Ballets Russes, Sergey Diaghilev, who in 1905 put together a huge exhibition of Russian portrait painting at the Tauride Palace. He was the first Russian curator, in the modern sense of this word, who managed to connect the aesthetic qualities of exhibiting works of art (accompanied by professional lighting and a scrupulously developed plan of the exhibition, where sculpture and applied arts were in dialogue with the paintings) with a thoroughly developed business strategy.

Another experiment in the history of commercial exhibitions in St Petersburg was the Contemporary Art Salon founded in 1902–03 by Prince Sergey Shcherbatov and Baron Vladimir von Meck, with the participation of several artists from the

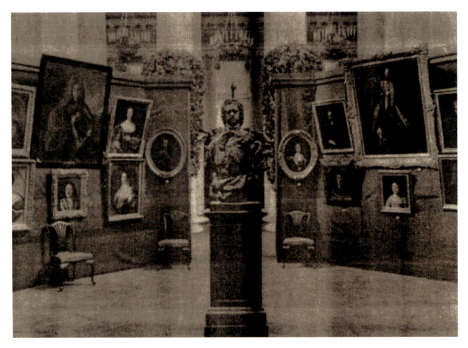

Installation view of the 1905 Tauride Palace exhibition, 1905.

World of Art group. The salon was opened in lavish rooms at the premises situated on the same street as the Imperial Society for the Encouragement of the Arts. It staged a permanent exhibition of paintings, furniture and applied art, influenced by the aesthetic principles of the Art Nouveau. Here, temporary exhibitions of the World of Art artists, Konstantin Somov and Nikolay Roerich, blended in with exhibitions of Japanese prints and French jewellery. The salon was opened to a select audience from the high strata of society and was attended by the members of the aristocracy and Tsar Nicholas II himself. Nevertheless, it was not financially successful and soon had to close down.

In January 1909, the largest exhibition in St Petersburg to date opened at the Cadet Military School. It was organised by the Salon of Sergey Makovsky, ambitiously promising to show the most important art created not only in Russia but in the rest of the world. More than 500 works by eighty artists were shown in not very well lit rooms of the military school. This ambitious exhibition became an important milestone in the development of the new exhibition culture in twentieth-century Russia. However, it was not a commercial success, which encouraged Makovsky to concentrate on his new journal, *Apollon*, instead. Along with this, he still organised much smaller exhibitions, such as *Modern Russian Women's Portraits* or works by students of Léon Bakst in the premises occupied by his editorial office (Moika Embankment, 24).

In April 1910, the even larger *International Exhibition of Paintings, Sculpture and Engravings* was opened at the Armenian Church on Nevsky Prospect. It became known as the Salon of Izdebsky, after the name of the organiser, the sculptor from Odessa, Vladimir Izdebsky. This exhibition, which was staged in Kiev and Odessa before arriving in the capital, included more than one thousand works of art by artists from different groups and societies. However, rather like Salon of Makovsky, the exhibition was a commercial failure, which discouraged Izdebsky from his original plan of organising the second salon in St Petersburg.

2.2. The foundation of Dobychina's Art Bureau

On 28 October 1911, the day of her twenty-seventh birthday, Nadezhda Dobychina opened the Art Bureau in her apartment in St Petersburg. The official announcement of the opening of this new venture proclaimed that its main aim was to facilitate a 'vital mediation between artists and public for the sale of works of art and the execution of such art commissions as paintings, theatre decorations and costume designs, all kinds of applied art, artistic interior design and so on; help with the choice and staging of theatrical productions, organisation of concerts, operas, musical evenings, poetry recitals and so on; consultations on various questions of art'. It also stated that the bureau only accepted original works of art. The announcement included the full address and the phone number of this new business venture and was signed by Dobychina.

Dobychina's apartment was in a wooden house on Divenskaia Street,[3] a rather scruffy neighbourhood in St Petersburg's Petrogradsky district (just off Kamennoostrovsky Prospect), where merchants and artisans traditionally lived. Initially,

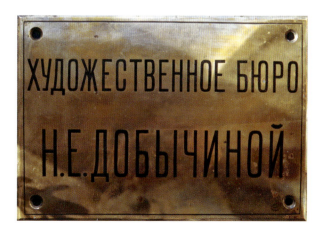

A plaque from the Art Bureau, c.1913.

3 House no. 9 was demolished in 1913 and replaced by a modern apartment block for the workers of the first St Petersburg multi-storey car park next door.

the Art Bureau was a business venture rather than an art gallery. 'Finally, we will also have a European-style shop,' wrote Alexandre Benois about the bureau shortly after it opened, 'and hopefully soon other so-called "art stores", which for many years have corrupted the tastes of St Petersburg passers-by through their shop windows on Morskaia Street and Nevsky Prospect, will follow suit.'

At the time there was a dearth of places in St Petersburg for contemporary artists to exhibit and sell their works. Lack of commercial success and often negative reviews of the first art salons may explain why in October 1911 Nadezhda Dobychina decided to call her new business venture 'Art Bureau' instead of the more traditionally used name 'Salon'. In 1913, the newspaper *Sankt-Peterburgskie Vedomosti* explained that it was 'a sort of permanent commission bureau for artists'. In her extensive research of the Art Bureau, Thea Polancic suggested that this unusual name for an art gallery could have been proposed by Nikolay Kulbin, who at the time was a member of the Society of Intimate Theatre. On 23 September 1911, the *Sunday Evening Gazette* reported the opening of an exhibition of Kulbin's works, organised by the 'art bureau' of the Society of Intimate Theatre. On 31 December 1911, the society founded the famous Stray Dog Café, which soon became the most popular cultural club in St Petersburg, where evenings of Futurist poetry and numerous scandalous disputes took place. The posters which advertised the opening of this new café, announced: 'Those who wish to be in costumes by Sergey Sudeikin are requested to contact the *art bureau* "The Stray Dog" (N.I. Kulbin, B.K. Pronin, V. Belkin).'

Kulbin was a great influence on Dobychina and her bureau, so it is possible that he had advised her on the name of her new business venture, which was generally well received. Thus, the artist and art critic, Gerasim Magula, wrote a review of the bureau:

> The need in the establishment which would become a 'middleman' and would still pursue its moral duties, is long overdue. Without a doubt, the Academy should have stepped into this role by organising a permanent commercial exhibition on a grand scale. A small shop which sells students' works at the Academy and the Society for the Encouragement of the Arts, does not make much difference: most artists have no idea how they can sell their works. In St Petersburg on Divenskaia Street the Art Bureau has been organised. Its goal is to become the middleman between artist and the public – to sell works and to take commissions for various artistic tasks. It has just opened, but it seems to have a sincere desire not to exploit the artists, but to help them. … One can't not welcome this useful initiative.

The newspaper *Sankt-Peterburgskie Vedomosti* explained that Dobychina opened 'a sort of permanent commissioning bureau for artists.' In her autobiography

Nadezhda explained that the main aim of her new venture was 'to promote and to give an opportunity for young talents and established artists from the older generation to exhibit their works'. In 1912, the *Permanent Exhibition of Contemporary Art* was opened at the bureau and in March 1913 the journal *Apollon* announced that more than sixty paintings had been sold and numerous commissions received. A month later the same journal reported that Dobychina's bureau was going from strength to strength and the permanent exhibition was growing, with new paintings added straight from the artists' workshops. *Apollon* concluded that 'such an important and useful mediation between artists and collectors is becoming more and more popular'.

The leading graphic artist, Vladimir Milashevsky remarked in his memoires that one cannot fully understand the artistic life of St Petersburg in the first decades of the twentieth century without knowing about Dobychina – an 'energetic, enterprising woman, who was the first person to realise that Russia was mature enough and ready to recognise that selling of paintings and management of artists' lives was a real "affair"!' Milashevsky explained that he did not want to call this new venture a 'business', since it was a much more gentle collaboration with artists than a dry money exercise. He mentioned that it was a proper, lucrative affair rather than prodigality of the millionaire Tretyakov.[4]

When Dobychina opened her bureau, she was certainly not wealthy. In her reminiscences about the poet Vladimir Mayakovsky (who was staying in her flat for a few months from December 1912), Nadezhda recalled how her financial situation was rather challenging at the time – she was on her own with a small child while her husband was studying for the state exams at Kazan University (almost 1,000 miles from St Petersburg). She did not have boots to wear in winter and often could not even afford to buy soap. Nevertheless, not only did she give shelter to one of Russia's most scandalous poets but from December 1912 she started staging evening recitals of his brave poems. She recalled that these recitals were organised by Mayakovsky himself, together with the 'father of Russian Futurism', David Burliuk, and attended by the Avant-garde artist and composer Mikhail Matuishin and his wife and artist in her own right, Elena Guro, poet Benedikt Livshitz (one of the leading artists of the World of Art group), Mstislav Dobuzhinsky and others. Nadezhda was amazed at how much attention these artists paid to the young rebellious poet. She described how in the discussion which followed the recital, Dobuzhinsky said: 'Perhaps, it is very talented, but it is hard to understand anything in these poems.' Mayakovsky replied: 'And you think your provincial landscapes are easy to understand?' Dobuzhinsky remarked: 'Perhaps not but they have a scent ...'

4 Pavel Mikhailovich Tretyakov (1832–98) was a Russian businessman, patron of art, collector and philanthropist who gave his collection and his mansion to the city of Moscow – now the Tretyakov Gallery – the major collection of Russian art.

Vladimir Mayakovsky and the Russian Futurists. Sitting from left to right: Velimir Khlebnikov, Leonid Kuzmin, Sergey Dolinskii; standing: Nikolai Burliuk, David Burliuk, Vladimir Mayakovsky, 1912.

These confrontations would be at the essence of exhibitions, concerts and poetry recitals of Dobychina's bureau for the next seven years. Although she favoured the restrained elegance of the World of Art artists to the scandalous extremism of the Avant-garde, in 1913–15 she organised the most important exhibitions of the Russian Futurists.

2.3. Artistic life in Moscow in the 1910s

Despite an apparent commitment to its retrospective lifestyle, Moscow turned out to be the engine of innovation in Russian fine arts in the first two decades of the twentieth century. The process was in great part due to the initiatives of some rich and influential Moscow merchants. Savva Mamontov, Pavel Tretyakov, Ivan Morozov and Sergey Shchukin did not merely limit their support for the arts to generous financial contributions, they assumed the role of masterminds of its major developments. The daughter of a prosperous textile manufacturer, Klavdia Mikhailova must have drawn much of her inspiration from their deeds when setting up her Art Salon.

Mamontov and Tretyakov put their energy into boosting the prestige and importance of national artistic heritage. In the 1870s, Mamontov established and patronised an art circle headquartered in his Abramtzevo country estate. The core

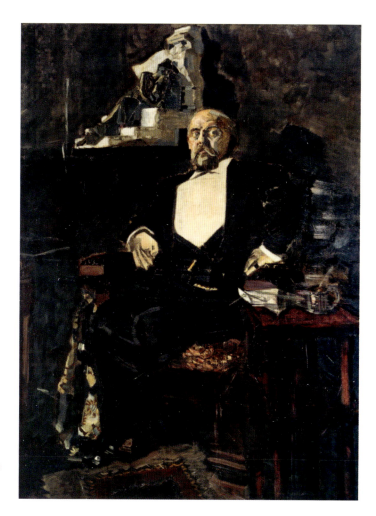

Mikhail Vrubel, *Portrait of Savva Mamontov*, 1897, oil on canvas, 187 × 142.5 cm. The State Tretyakov Gallery, Moscow.

of this informal alliance was formed by the most talented artists from the *Peredvizhniki* association, while its artistic pursuits focused on the revival of traditional folk and religious art. At the same time, Mamontov also advocated the search for new forms of artistic expression; for years he lent his keen and loyal support to Mikhail Vrubel, the uniquely idiosyncratic artist whose daring pictorial experimentations paved the way for the Russian Avant-garde.

Tretyakov inaugurated the foundation of the major national museum of Russian art – now known as the Tretyakov Gallery – by donating his rich collection of ancient and contemporary Russian art to the city in 1892. This generous gift also included a building to host the permanent display, as well as a considerable amount of money to be spent on its day-to-day running.

If Mamontov's and Tretyakov's endeavours increased interest in native Russian art, two textile magnates and shrewd collectors – Ivan Morozov and Sergey

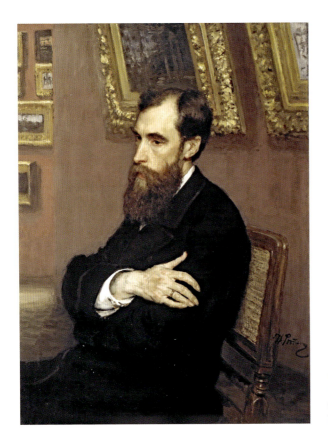

Ilia Repin, *Portrait of Pavel Tretyakov*, 1883, oil on canvas, 97 × 75.5 cm. The State Tretyakov Gallery, Moscow.

Shchukin – turned Moscow into 'the city of Gauguin, Cézanne and Matisse', as they managed to amass two of the most stunning collections of contemporary French painting in the world. Morozov was interested in pioneering French and Russian art, acquiring major works by Cézanne, Gauguin, Van Gogh, Sisley and the Nabis group, together with paintings by the most accomplished and talented contemporary Russian artists, ranging from virtuoso Realist artists Valentin Serov and Isaak Levitan to iconoclastic Modernist Mikhail Vrubel and radical Avant-gardists Natalia Goncharova and Marc Chagall. Displayed over the two upper floors of his spacious mansion on Prechistenka Street, Morozov's gallery became a private museum of modern and contemporary art, to which only a chosen few were invited by the owner.

Unlike Morozov, Shchukin focused exclusively on western European art, virtually ignoring the oeuvre of his fellow Russians. His rich collection encompassed all the important stages of French modern art, ranging from the Impressionists and Post-Impressionists to the newest radical discoveries of Matisse and Picasso. Works in Shchukin's mansion in the centre of Moscow were arranged in a special visual display, including the assemblage of sixteen paintings known as the 'Gauguin

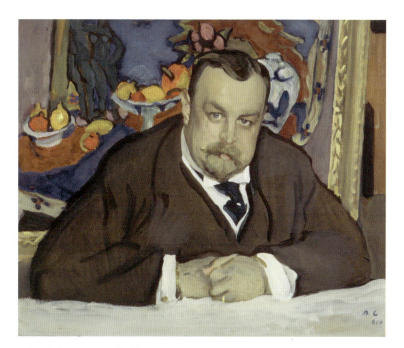

Valentin Serov, *Portrait of Ivan Morozov*, 1910, tempera on cardboard, 215 × 80 cm. The State Tretyakov Gallery, Moscow.

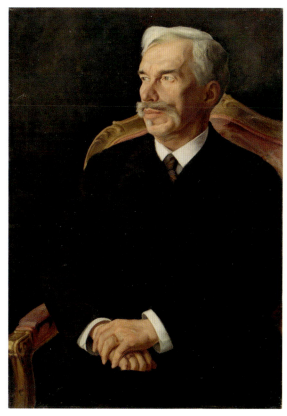

Dmitry Melnikov, *Portrait of Sergey Shchukin*, 1915, oil on canvas, 91 × 64 cm. Pushkin State Museum of Fine Arts, Moscow.

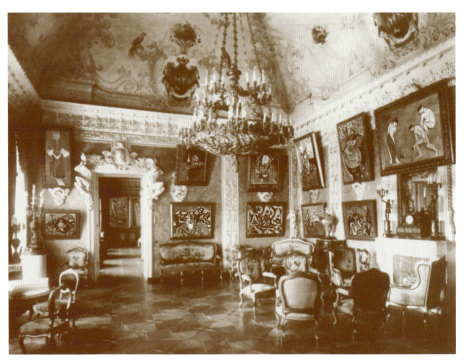
Pink dining room (known as Matisse Room) in Shchukin's house. Photograph, 1910s.

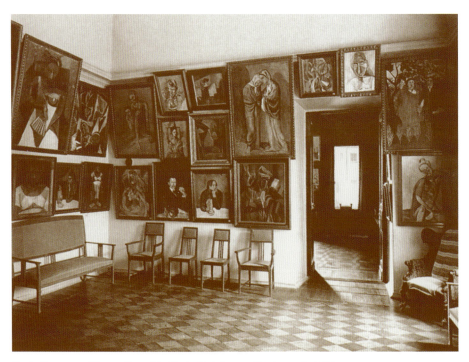
Study (known as Picasso Room) in Shchukin's house. Photograph, 1910s.

altar' and a study room tightly covered by fifty canvases by Picasso. From 1909, Shchukin's treasures became accessible not only to the Moscow cultural elite, painters and art students, but also to any genuinely interested members of the general public who were able to visit on Sundays.

Shchukin's and Morozov's collections radically affected emerging painters of younger generations, stimulating their appetite for artistic innovation. According to Boris Ternovets, the future first director of the State Museum of New Western Art in Soviet times: 'Moscow collections, which reflected the major currents of French painting of the last decades with an unprecedented completeness, represented for painters a sort of "trip to Paris".' It was especially true in relation to Shchukin's gallery, as it grew to represent a sort of 'academy' of the new art. Kuz'ma Petrov-Vodkin asserted ironically, looking back to the years of his youth in the autobiographic book *Khlynovsk. Euclidean Space*: 'The contagion spread from Znamensky Lane' [i.e. Shchukin's address].

Particularly powerful was the impact on students of the Moscow School of Painting, Sculpture and Architecture, where Mikhailova had studied a decade earlier. Contemporary reviewers of the school's annual two-week-long graduation exhibitions of the 1910s promptly noticed the 'new style' of the students' works on display, pouring scorn on the simplification of drawing and the dreariness of colour schemes.

Mikhailova apparently never cut ties with her alma mater, so much so that many participants in the most sensational Avant-garde exhibitions which would soon take place in her Art Salon came from that very institution. Living up to their reputation of troublemakers and iconoclasts, they would carry on with their daring artistic experimentations, adopting the tactic of ruffling the public's feathers and making scandal an integral part of their promotional policy.

2.4. The opening of Mikhailova's Art Salon

Klavdia Mikhailova launched her Art Salon in early November 1912. By that time, she enjoyed the reputation of a professional artist whose paintings regularly appeared in prestigious exhibitions and received positive reviews from the press. Her father, the industrialist Ivan Suvirov, died in *c.*1911–12. A short article published in December 1912 in one of the central Russian newspapers *Novoe Vremia* (*New Times*) informed that the late Suvirov had bequeathed to the city of Moscow a capital sum of 200,000 roubles to be used in support of the poor. It was a generous donation, considering that an average annual salary of a workman was approximately 250 roubles, while a government minister would earn 26,000 roubles per annum. Without doubt, Suvirov also left a substantial patrimony to his heirs, even if the exact size of it remains unknown.

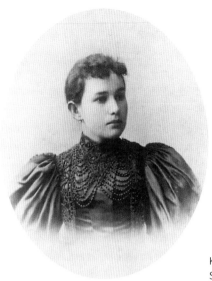

Klavdia Mikhailova. Photograph, late 1890s. Russian State Archive of Literature and Art RGALI, Moscow.

According to Russian law, Klavdia Mikhailova received full control over her share of inheritance. She could dispose of it as she pleased. Now she had sufficient financial means to put it into a venture of her choice. The idea of establishing a private art gallery must have seemed both appealing and feasible. After all, Mikhailova belonged to the social stratum of Moscow merchants whose involvement with the visual arts had been particularly intense and effective over the last decades.

She was a person whose background conveniently encompassed both commercial and artistic outlooks. On the one hand, Mikhailova was acquainted with essential business practicalities. The daughter of an industrialist in charge of a large and prosperous textile company, she must have witnessed at close range a useful set of rules on how to run a private enterprise. In addition, her husband, Ivan, had been for many years closely engaged in organising the exhibitions of the *Peredvizhniki*, one of the most influential and buoyant Russian art associations. Over the years he had accumulated valuable knowledge in the field. Klavdia could confidently put his recommendations into practice and rely on his expertise when in doubt. (It is worth mentioning, though, that Ivan Mikhailov's participation in his wife's business, if it indeed had taken place, remained extremely discreet and private, as no one had ever mentioned his name in connection to the salon). On the other hand, Mikhailova must have learned at her own expense the trials and tribulations of being a professional artist, including the problem of getting her works accepted into an art exhibition, as well as the endless heavy struggle for public recognition and financial success. Having launched the gallery, she did not stop her art practice so that her creative endeavours coexisted with her business activities. Therefore, it would not be far-fetched to suppose that in founding the

Art Salon she aspired – maybe somewhat idealistically – to balance profitability with more noble purposes such as, for instance, offering an artist-friendly exhibition space to her fellow painters and improving public taste in visual arts. The motto she chose for her gallery – '*Vita brevis, ars longa est*' (Life is short, art is eternal) – at least lends substance to this conjecture.

The Art Salon's main *raison d'être* was surprisingly reiterated some fifteen years later in 1927, when Mikhailova appealed to the Bolshevik government to grant her a personal pension on the grounds of her valuable contribution to the promotion of national art. In her petition she stated:

> In 1912 I founded the Art Salon on Bolshaia Dmitrovka Street. A specially appointed exhibition space was equipped at my personal expense. On these premises I organised a number of exhibitions and lectures on art which all had one and sole target – to raise the level of artistic culture in Russia. I was making a loss on my business, which I can prove if need be, by the account books in my possession.

One must, of course, take into consideration the historical background and Mikhailova's reasons for producing such a declaration. Yet, it definitely contained a degree of truth, especially if we pay regard to the significant number of painters who supported her by adding their signatures under her application. Some of them went even further. Igor Grabar, a well-known Post-Impressionist painter, icon restorer and art historian, who became a high-ranking manager of Soviet cultural projects after the revolution, fully endorsed Mikhailova's petition in a letter attached to hers: 'I know very well her [Mikhailova's] blameless activity in the field of the fine arts and that warm help, both moral and financial, which she gave to numerous poverty-stricken artists.' Another wholehearted recommendation came from Yakov Tugendkhold, a prominent art critic who had collaborated with Mikhailova on her salon's international projects. He wrote:

> Over a number of years Mikhailova's salon was probably the unique place in Moscow where one was able to engage in cultural and educational work popularising arts, giving lectures and papers and looking at trends proposed by the new generation of artists. In this sense, the Art Salon directed by Mikhailova was very different from the other exhibition spaces which were engaged primarily in the pursuit of profit.

It took Mikhailova much time and effort to set up her business. Apart from finding the appropriate site for the gallery, she had to obtain the city council's permission and present the authorities with recommendations from esteemed Moscow citizens confirming her reliability. One such letter of recommendation survives. It was written by Prince Nikolai Shcherbatov, the Vice-President of the Imperial

Historical Museum in Moscow, one of the major cultural institutions of the old capital whose imposing red-brick palace erected in 1881 still stands opposite St Basil's Cathedral on the Red Square. Prince Shcherbatov's country residence in Bratsevo, on the northwest outskirts of Moscow, neighboured Mikhailova's father's house and textile factory. In his letter of recommendation, he attested that he had known Mme Mikhailova well for a long time both as an artist who had taken part in several exhibitions in his museum and at a personal level as a neighbour to his country estate. 'I consider her a completely decent and trustworthy person,' he wrote in conclusion.

Mikhailova selected the location for her venture with care. The Art Salon was established at a prestigious address, 11 Bolshaia Dmitrovka Street, a long and broad road in the central area of Moscow, running from the Boulevard Ring towards the Kremlin. Once an exclusive residential area for the Moscow aristocracy, in Mikhailova's time almost all of its noble mansions changed hands, becoming the property of rich merchants and industrialists. In the 1910s, the street possessed a fresh and modern feel, as many of its buildings had been recently constructed or remodelled following the latest architectural fashion to host expensive apartments, private mansions and luxury shops. The first Moscow power station, which supplied electricity to city dwellers, was also located there, as well as two popular private theatres. In short, the area, which offered both commercial and cultural attractions, was bustling with the public, day and night.

Façade of the Art Salon with the posters advertising Valentin Serov's posthumous exhibition. Photograph, 1914.

On Bolshaia Dmitrovka there already existed other venues where prestigious art exhibitions were regularly held. Therefore, the street was well-known to Moscow art lovers. One such place was a three-storey building situated at number 15, that is, practically next door to Mikhailova's future gallery. Owned by the Vostriakovs, a merchant family, from 1904 it was held on lease by the literary and artistic circle under the leadership of the renowned Symbolist poet Valery Briusov. This informal body ran a library, a restaurant and a concert hall on site. It also set up an art gallery, where a number of exhibitions took place in the 1910s. The most acclaimed were the annual displays of two major centrist art groups, the Union of Russian Artists and the Association of Moscow Painters.

At number 32 stood the Levisson House, a brand new three-storey building in the Art Nouveau style. It was erected by the sought-after architect Adolf Erikhson for the affluent furniture merchant Rafail Levisson, who used it as a retail store and a block of rented apartments. Levisson belonged to the same energetic cohort of Moscow upper middle-class art patrons as Tretyakov, Mamontov, Morozov and Shchukin, and was a member of the Moscow Society of Friends of Fine Arts, which was actually based in his house. The society regularly provided a venue for exhibitions organised by art groups of various directions.

However, the most relevant neighbour was the Lemercier Gallery located within five-minutes' walking distance from Mikhailova's Art Salon. Lemercier's was, 'de facto', the first Russian commercial art gallery. It occupied the ground floor of the two-storey building in the short Saltykovsky Lane. Inaugurated in October 1909, it was a close predecessor and potential rival of Mikhailova's enterprise. Yet, the Lemercier Gallery was still gathering its momentum and did not seem to be a serious busines competitor in this area. In fact, in 1912 commentators still complained about Moscow's lack of the appropriate space for independent art exhibitions. So much so that when Mikhailova's salon opened its doors in November 1912, art critic Aleksandr Koiransky happily reported that Moscow life was 'finally enhanced by the establishment of a venture, the need for which has long been felt. Art circles have repeatedly voiced the necessity of an exhibition place for small-scale displays of individual artists or small art groups. The Lemercier Gallery, the only enterprise of this kind until now, was far from fulfilling this purpose, given that its owners paid too much attention to the market taste, arranging sales of mostly low-standard pictorial works.'

The name chosen for the new gallery – the Art Salon (*Khudozhestvenny Salon*) – was hardly an original one. Indeed, the noun 'salon', borrowed from the French in the eighteenth century to designate exclusive gatherings of polite society or intellectuals at the invitation of a high-class host or hostess, by 1912 was more often used (following again the French custom) for exhibitions of contemporary art. In the few years preceding the establishment of Mikhailova's gallery, several art

ventures called salons had already taken place in Moscow, St Petersburg and some other major cities in the Russian Empire. The most significant and momentous were three salons of the Golden Fleece, organised in Moscow in a short span of two years (1908–09) by Nikolai Riabushnsky, an energetic scion of a wealthy merchant family. These were followed by two salons put together by Vladimir Izdebsky in 1909 and 1910 in large Ukrainian cities, including Kiev, Odessa, Kherson and Nikolaev, before arriving finally in St Petersburg.

Riabushinsky and Izdebsky kept to the trend established by the French salons, as they exhibited works by diverse artists of various directions and styles to give the public a panoramic view of the newest artistic tendencies. Both organisers also aspired to represent bigger international perspectives, as they brought together Russian artists and the exponents of the most prominent French groups of the last decades. While Riabushinsky's and Izdebsky's salons collaborated with different artists, their exhibitions together covered virtually all the significant names of the modern French and Russian art, featuring works by Paul Cézanne, Paul Gauguin, Henri Matisse, Kees van Dongen, André Derain, Georges Braque, Giacomo Balla, Marianne von Verefkina, Wassily Kandinsky, Mikhail Larionov, Natalia Goncharova, Ilya Mashkov, Petr Konchalovsky and many others. Although both initiatives were short-lived, nonetheless they aroused strong public interest and exercised a considerable influence on Russian artistic life, setting Modernist trends and disseminating new aesthetic ideals.

Riabushinsky's and Izdebsky's curatorial endeavours might have served as a powerful source of inspiration for Mikhailova, considering that she would follow up their policy of representing the latest artistic discoveries – both French and Russian. Indeed, although having been fully assimilated into the Russian language of the time, the word 'salon' still preserved a subtle reference to its French cultural legacy. All considered, Mikhailova's decision to call her gallery the Art Salon might have been a shrewd promotional move, a way to capitalise on the already well-established definition of the salon as a place for the display of all kinds of contemporary art styles.

The designation of the gallery as Mikhailova's Art Salon had rarely, if ever, been used in the new establishment's advertising posters. Instead, it became commonly known as the Art Salon on Bolshaia Dmitrovka (*Khudozhestvenny Salon na Bolshoi Dmitrovke*), referring to its location. Klavdia Mikhailova was seldom mentioned in the press in connection to her gallery. Why that was the case is difficult to explain. It happened perhaps spontaneously, or else Mikhailova herself preferred to preserve a certain degree of privacy. Or it might have been connected to an attempt to distinguish her gallery from other merchants' enterprises, which often had the owners' surnames on their company trademarks. Only in its last years of existence would the gallery sometimes be defined as Mikhailova's Salon (*Salon Mikhailovoi*)

in its exhibition catalogues and in press reviews. This fact seems to suggest the rise in public visibility and confidence of the salon's owner.

Mikhailova hired the entire unit of the substantial two-storey house, built in 1903–05 by the same architect, Adolf Erikhson, who constructed the neighbouring Levisson's House, mentioned above. This two-storey property in the neoclassical style belonged to Nikolai Mikhailov, son and business partner of the affluent merchant Aleksandr Mikhailov, whose flourishing fur trade boasted the title of 'Supplier of his Imperial Majesty's Court'. Mikhailova's husband, Ivan, whose name she took upon her marriage, was only a namesake with no direct connection to that family.

In his own line of business, Aleksandr Mikhailov, the father of Mikhailova's actual landlord, was a sort of a ground-breaker. In the previous decade he had pioneered an exclusive method of preserving fur and precious rugs using low temperatures. In the inner courtyard of Erikhson's house, Mikhailov constructed a multi-storey building to accommodate his 'First and only Refrigerator for the secure conservation of fur items, cloths and rugs', as it was announced in a newspaper advertisement. Astonishingly, that unique structure survived all the dramatic perturbations of Russian twentieth-century history and still functions as a fur storehouse today. The 'Fur fridge' opened the same year as Mikhailova's Art Salon. It occupied the backyard side of the property, opposite Erikhson's building, where the gallery rooms were located. Thus, the premises at 11 Bolshaia Dmitrovka Street hosted contemporarily two pioneering ventures: an innovative storehouse for luxury goods and one of the first private art galleries in Russia.

Mikhailova used the rented space exclusively for the purposes of her business. She and her husband lodged in an apartment in the prestigious Nastasin Lane, just off Tverskaya Street, fifteen minutes' walking distance from the gallery. The salon had six generous, high-ceilinged rooms on the first floor and a number of service rooms designated for various household and management purposes on the ground floor. According to the agreement between Mikhailova and her landlord, her employees were allowed to take residence on the premises as long as they had all necessary documents and a permit to sojourn in Moscow. Once she took possession of the rented place, Mikhailova reorganised and refurbished the set of rooms on the ground floor to accommodate living quarters and a kitchen for her members of staff.

The gallery's space on the first floor was generous and airy, its windows glazed with mirror glass. Nineteen of them faced the street and seventeen others looked on to the inner courtyard. Two of its largest rooms had parquet floors, while the other floors were of solid, unvarnished wood. The salon had a main porch that opened on to the street and a private side entrance from the inner courtyard for service purposes. The premises were also provided with all contemporary

modern conveniences, including a telephone, electrical light, water supply, insulated window frames for winter, a sewage system, and male and female toilets for visitors.

The layout of the property had good potential for adaptation to the needs of an art gallery. Mikhailova took special care to transform the place into the optimal site for exhibition of art. A three-flight staircase was added to the lobby. The doors between the four front rooms running one after another along the corridor were taken off to allow an uninterrupted flow for the public. However, the salon's most remarkable feature was the skylights in the two largest rooms (a former orangery), which provided an excellent level of illumination for items on display. Few exhibition spaces in Moscow at that time could offer such luxury.

The lease document which set up terms and conditions of the salon's rent sheds interesting light on Mikhailova's business strategy. It clearly defined the purpose of the new venture, stating that the tenant took on a lease of the premises with the view to 'organising exhibitions of paintings and applied art, as well as selling art collections'. Mikhailova, the tenant, was also granted the right to 'sub-rent the leased space to societies and individuals of her choice so that they would be able to use it for art exhibitions and art sales'. This confirms that the enterprise was not after all a charity, as it might seem from Tugendkhold's advocacy, given that Mikhailova hoped to receive at least some profit from her endeavours. It also reveals that she planned to supervise personally only some of the salon's exhibitions, sub-renting the place for other curators' projects from time to time. It corroborates the notion that from the very start she considered an inclusive broad approach as the most convenient line of dealing with her gallery business.

Mikhailova and her landlord also put on paper the specific terms for advertising the salon's events. These entailed the permission of 'hanging out advertisement signboards and flags on the façade of the building'. This clause highlights how seriously Mikhailova took into account her future promotional campaign, including street advertising. However, the landlord reserved the right 'to approve of their [signboard and flags] size and design as well as of the exact spot of their placement'. All advertising would also have to be endorsed by the appropriate authorities. Strict as they might appear, the imposed conditions must have been based on practical trade considerations rather than on issues of censorship. Indeed, one should keep in mind that Mikhailova's salon occupied the part of the building adjacent to the luxury fur shop owned by the family of her landlord. The agreement over the size and design of the gallery's visual advertisements was thus indispensable to avoid interference and the possible clash between the visual publicity of the two businesses sharing the same façade.

The rental agreement had to be renewed annually, with due amendments of costs and expenses. The price for the first year of the rent was a conspicuous sum

of 6,800 roubles per annum, to be paid quarterly. As it happened, Mikhailova continued to hire the same space for the next six years. The last receipt confirming payment of the rent dates from 1 March 1918. By then the monarchy had been abolished, the Bolshevik government was in power, Tsar Nicholas II and his family were imprisoned in Siberia and the Treaty of Brest-Litovsk was signed on 3 March 1918, ending Russia's participation in the First World War. In spring 1918, Mikhailova's salon as a private enterprise was nationalised and allocated to the newly established People's Commissariat for Education (*Narkompros*). Neither she nor anyone else could have predicted so radical a turn in life.

The first contract between the property's owner and Mikhailova dates from April 1912, while the first exhibition of the salon opened only in November of the same year. It means that Mikhailova spent more than half a year making alterations and adapting the rooms to the needs of her gallery. Finally, by autumn 1912 the Art Salon was ready to launch its first season. It proved to be lively and eventful.

CHAPTER 3

From Convention to Hooliganism

Despite Nikolai Kulbin's early exhibitions of modern art, the St Petersburg artistic milieu in the first decade of the twentieth century was rather hostile to any form of innovation. While in Moscow the Golden Fleece salons and Jack of Diamonds exhibitions were shaping the Russian Avant-garde, in the capital the retrospective artists of the World of Art circle were still seen as the pioneers of modern art. This discrepancy was largely influenced by the Imperial Academy of Arts in St Petersburg, which, despite the reforms of 1893–4, was quite far removed from the most recent developments in contemporary art. Graduates of the academy would receive the title of the artist, which guaranteed commissions and good income. However, the growing dissatisfaction with this backward-looking institution made even one of its most distinguished graduates, Grigory Miasoedov, admit in 1908 that it was 'naturally suffering under the influence of social discord and decline, which, forcing their way into its inner life, paralysed all energy, faith in the value of art, its need, purpose, and joy of creation'.

At the same time, the Moscow-based alternative to the Imperial Academy – the School of Painting, Sculpture and Architecture – was much more tolerant to the new tendencies in art. Compared to the Imperial Academy of Arts, it had a more democratic approach in both its curriculum and social make-up. No wonder that from the early 1900s, Moscow in general and the School in particular, provided a fertile breeding ground for many Russian Avant-garde artists.

3.1. The opening season of 1912–13 in Mikhailova's Art Salon

The Art Salon's opening season of winter 1912–spring 1913 proved to be rather intense. Mikhailova's gallery quickly became known among the art-loving public and press, because its events stood out from the majority of other concurrent art events by their originality and innovative quality. The undisputed stars of the Moscow winter art calendar of 1912–13 – deemed to be popular as always – were three exhibitions organised by the most prominent art groups: *Peredvizhniki*, the Union of Russian Artists and the World of Art. However, despite considerable differences in their artistic outlook and thematic approach, this trio of heavyweights

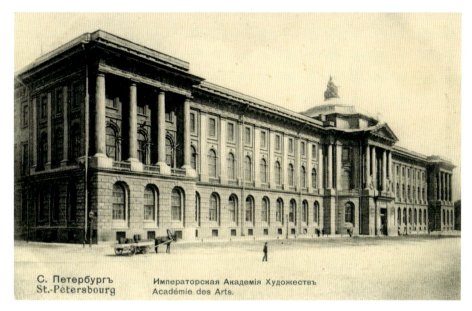

Imperial Academy of Arts, St Petersburg. Postcard, 1912.

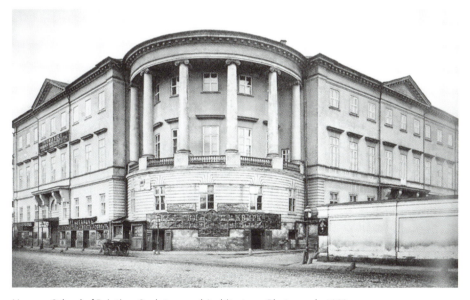

Moscow School of Painting, Sculpture and Architecture. Photograph, 1900s.

by and large conformed to the pictorial style rooted in the conventions of naturalism. Their displays therefore were not supposed to surprise the public in any way.

Meanwhile, new Modernist tendencies – both moderate and radical – were asserting their place within the Russian art scene ever more vigorously. In fact, in the winter season of 1912–13, the early Russian Avant-garde was in full blossom.

Acolytes of artistic innovations were looking for an opportunity to raise their visibility and improve their standing. Apparently, Mikhailova promptly realised the great artistic and public potential of these innovative trends, if we consider the nature of the events which took place in her salon in its opening season. With hindsight, it almost seems that she set out the salon's exhibition timetable to illustrate the progression stages of modern art. Indeed, the first two exhibitions were dedicated to Symbolism. These were followed by a display of the latest currents in contemporary French art. Finally, the first season at the salon culminated with a deafening crescendo of the hell-raising Avant-garde event carrying the bold name *Target* (*Mishen'*).

The salon was inaugurated quietly in November 1912 with the *Exhibition of Painting by Vasily Denisov and Rosa Riuss*. Apparently, this first display was a rather modest affair and the actual level of Mikhailova's personal involvement with the project remains unknown. It seems plausible, though, that Denisov and Riuss had full responsibility for its organisation, while Mikhailova was busy putting together two large, forthcoming exhibitions scheduled for December 1912.

The name of the artist Rosa Riuss was little known at that time and it remains obscure today, whereas Vasily Denisov had already earned a good reputation. Mikhailova must have known him personally, as they shared the same circle of

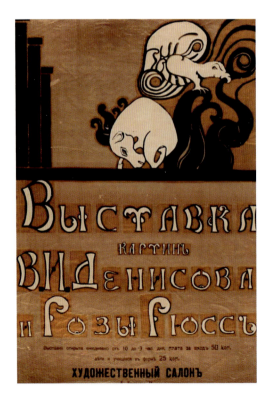

Unknown artist, *Poster for the Exhibition of paintings by Vasily Denisov and Rosa Riuss*, 1912, chromolithography. The State Tretyakov Gallery, Moscow.

acquaintances: both studied in the Moscow School of Painting, Sculpture and Architecture, albeit some years apart; both participated in the exhibitions of the Independent Ones, the same exhibition group Mikhailova collaborated with; and both showed an inclination to fantasy subjects in their paintings. All considered, this event at the Art Salon, despite being announced as a joint exhibition, must have been in fact a display shaped primarily around well-crafted works by Denisov.

By 1912 Denisov (1862–1922), a Symbolist artist, was considered to be a moderate innovator. In the early 1900s, he became involved in theatre productions, creating stage designs for the pioneering director Vsevolod Meyerhold. In autumn 1910, Denisov participated in the second Izdebsky salon, side by side with the ringleaders of the Russian Avant-garde, including Mikhail Larionov, Natalia Goncharova, David and Vladimir Burliuk, Georgy Yakulov, Wassily Kandinsky and Alexey Jawlensky. While works of his fellow artists were mercilessly dismissed as insults to public taste, Denisov's paintings received mostly positive reviews. Commentators praised him as an artist 'in command of his painterly technique, possessing a strong identity and an indisputable talent'.

The poster for Denisov–Riuss show had a distinct Art Nouveau flavour, with its strong contrasts of black and white sinuous shapes placed against the subdued brown background. It remains a rare and perhaps only known sample of the salon's poster containing a picture. Evidently, the design of this first trial poster failed to impress Mikhailova. Or, maybe, she considered illustrated posters unworthy of the efforts and finances. Whatever the case, in future the Art Salon's advertising placards would consistently follow a uniform standard based on a clear intelligible layout with no images, ornamentation or any other sort of embellishment. Instead, a combination of two or more fonts of different size and pattern were used in such a way as to draw the public attention initially to the most important piece of information concerning the forthcoming event. Thus, the title of the exhibition, the name of the painter or the topic of the lecture were emphasised by big letters in bold, while the other details were printed in a less prominent type.

The Denisov–Riuss exhibition poster announced that the display was open to the public seven days a week from 10.00 am to 3.00 pm, which was a shorter time slot than all consequent shows at the salon. The entrance was priced at 50 kopeks for adults and 25 kopeks for children and students – an average price paid for comparable attractions in Moscow at the time. The exhibition did not receive any press reviews, which is probably unsurprising given that Mikhailova's salon was a newcomer to the busy Moscow art scene and had not as yet established useful contacts with the media and art critics. The next show would change this situation dramatically, propelling the salon into public view.

On 26 November 1912, the Art Salon presented the Moscow public with an unprecedented display of Mikhail Vrubel's imposing study for his gigantic panel

called the *Dream Princess* (*Printsessa Greza*). Without doubt, the exhibition was conceived as a homage to the tragic master who had passed away two years earlier. Vrubel occupied a special place in Russian public consciousness. His art, highly experimental and idiosyncratic, was met with little recognition for most of his relatively short professional career. His fame and prestige gradually grew in the last few years of his life, when he disappeared from public view, having been admitted into a psychiatric clinic because of a deteriorating mental illness. Finally, by the time of his death at the age of fifty-four, Vrubel was almost unanimously recognised as the most exceptional talent and a national treasure of Russian art. He was particularly exalted by young Russian artists who were inspired not only by his experimental technique, but also by his concept of painting as an intellectual activity which had to follow its own purposes and rules, disentangled from any sort of social or ideological propaganda. Naum Gabo, a prominent sculptor and theorist, believed that Vrubel's art was responsible for moulding the visual consciousness of the entire generation of Russian Avant-garde artists of the early twentieth century.

The paradox about Vrubel was that his artistic legacy largely remained out of reach of both general and specialised audiences, given that only a few of his works were purchased for national museums. Exhibition-goers had a rare chance to see his art during his lifetime, as he participated in some important art shows both in Russia and abroad. However, after his death in 1910, the overwhelming majority of Vrubel's oeuvre became inaccessible for public viewing, as his creations were exclusively confined to private collections. Although the idea of organising a large Vrubel retrospective was talked about in cultural circles and in the press time and again, his only posthumous solo exhibition took place in Kiev in the spring of 1910, soon after his demise.

This situation changed in the winter season of 1912–13, when two exhibitions of Vrubel's work were arranged simultaneously in St Petersburg and Moscow. To be strictly precise, Vrubel's display in St Petersburg was not a self-contained affair, but an integral part of the bigger annual exhibition organised by the New Society of Artists (*Novoye Obshchestvo Khudozhnikov*). This association was founded in 1903 to provide 'moral and financial support' to artists who graduated from the Imperial Academy of Arts in St Petersburg. Its eighth exhibition in December 1912–January 1913, in addition to members' submissions, also featured 162 Vrubel works which belonged to the artist's widow, the opera singer Nadezhda Zabella-Vrubel. These were displayed in two specially appointed rooms and were offered for sale. In fact, several Vrubel's paintings were acquired by the Russian Museum and by Princess Maria Tenisheva for her private collection. The chance to see Vrubel's art greatly improved the attendance of the New Society of Artists exhibition, which was visited by 10,000 people – four times more than in any previous year.

Vrubel's works in Moscow, in Mikhailova's Art Salon, was on display throughout the same time slot as his exhibition in St Petersburg: from 28 November to the end of January. It might have been a pure coincidence; however, it seems more plausible that Mikhailova decided to keep in step with the capital city and its key art players. After all, the exhibition of Vrubel's work was bound to be popular, so she seized her chance to assert her gallery's standing by presenting the Moscow public with an alternative show of the artist who was particularly in vogue at that moment. Moreover, it appears to have been conceived as a distinct and subversive event, given that at the heart of it was the study for his monumental panel, the *Dream Princess*. The dramatic story of this work is worth telling in more detail, so as to appreciate fully how Mikhailova's exhibition might have been perceived by its audience.

The actual panel, oil on canvas, was truly gigantic, measuring 750 × 1400 cm. It had an unusual semi-circular shape because it was created to fit a specific space. Together with its pairing piece – the panel called *Mikula Selianinovich and Volga* – the *Dream Princess* was Vrubel's largest work. Both panels had been commissioned nearly twenty years earlier in 1896 to decorate the Art Pavilion in the All-Russian Industry and Art Summer Fair in Nizhny-Novgorod. The fact that such a prestigious project backed by the government was assigned to Vrubel, a little-known artist, was due to powerful lobbying by energetic Savva Mamontov, Vrubel's committed supporter. In other words, the *Dream Princess* signified both Vrubel's first encounter with a large audience and Mamontov's endorsement of his artistic innovations.

Mamontov gave Vrubel a free hand in selecting the subject and style of the panels. The painter, excited by such a unique opportunity to prove his artistic skill, chose two motifs based on fairy tales. *Mikula Selianinovich* was a story taken from

Mikhail Vrubel, *The Dream Princess*, 1896, oil on canvas, 750 × 1400 cm. The State Tretyakov Gallery, Moscow.

the Russian heroic epic, which featured the mighty warrior (*bogatyr*) Mikula Selianinovich and his companion Volga. The *Dream Princess* was based on the romantic play in the neo-Gothic style, *La Princesse Lointaine*, by the French poet and dramatist Edmond Rostand. The plot tells the story of the medieval prince-troubadour Jaufre who falls in love with the beautiful princess Mélissinde without having ever seen her. He dedicates poems and songs to his 'Dream Princess'. Feeling his death approaching, he sets out on a dangerous journey to join his beloved but passes away in her arms, exhausted by his old wounds and long pilgrimage. Staged in Paris in 1895, the play was quickly translated into Russian and performed in St Petersburg in 1896, garnering huge success and popularity. Vrubel saw the production and remained fascinated by its melancholic symbolism.

No matter how idiosyncratic such a choice of subjects may seem, each panel had an underlying symbolism, which was both transparent and complementary. The *Mikula* panel embodied the strength of the Russian soil and was based on bulky, simplified shapes harking back to Russian folk art. In contrast, the *Dream Princess* stood for the illusive ideal of refined beauty extolled by artists. Its mystical and ethereal quality evoked fantasies about European medieval culture. According to Mamontov and Vrubel's plan, the two panels were to be hung on opposite walls of the art pavilion for the purpose of facing each other. This deliberate juxtaposition of two mythological stories was intended to establish a dynamic dialogue between the native and western European traditions so vital for the history of Russian art.

The scandal erupted as soon as both paintings were installed at the fair. Mamontov failed to discuss Vrubel's panels with the academic artists who supervised the Art Pavilion's display. In addition to considering this disregard as an offence to their authority, they were shocked by both Vrubel's choice of subject matter and his artistic style. In the Russian *fin de siècle* shaken by social and political conflicts, Symbolism was perceived by many enlightened thinkers as a decadent escapism from the problems of real life. The composition and manner of the execution of the *Dream Princess* also appeared strange and distorted to the contemporary audience, accustomed as it was to the realism of *Peredvizhniki*. The volume in the panel was created out of a complex net of flattened planes – this peculiar technique developed by Vrubel would soon be particularly appreciated by the next generation of Russian Avant-garde artists as a foretaste to Cubism. The muted colour palette of the canvas evoked faded medieval tapestry, while also conveying the image's dream-like quality.

The academic jury declared the works to be too pretentious and suggested their removal from the pavilion. Vrubel, in utter distress, left Nizhny Novgorod where he was working on his canvas, while Mamontov, a man of strong will and decisive action, refused to bow to the pressure of the exhibition's officials. He paid

the artist a conspicuous sum of 5,000 roubles for his endeavours. Moreover, in an act of defiance, he built a special pavilion in close proximity to the fair's grounds, where he accommodated Vrubel's rejected works. At the entrance of this improvised display, he placed a sign, announcing the 'Exhibition of the decorative panels of the artist M.A. Vrubel, rebuffed by the jury of the Imperial Academy of Arts'. Predictably, the sign had to be taken down a few days later, following the authorities' order. However, the episode sparked such public interest in the 'scandalous' works of the obscure artist that Mamontov's pavilion was visited by a conspicuous number of viewers. The public verdict was split between those who considered Vrubel's panels naïve, incoherent and savage, and those who instead recognised his unique artistic gift and innovative input. In whatever way, that episode marked the introduction of Vrubel's name to the wide audience. Since then, his art would always attract interest and in time would gradually win over an increasing number of admirers.

The huge size of both panels suggests that initially Vrubel and Mamontov might have hoped to attract a museum or an important art collector as a potential buyer. Nothing of the kind happened at the fair or in the following years. While the *Mikula Selianinovich* panel eventually disappeared and its subsequent existence remains obscure to this day, the *Dream Princess*'s adventures continued. As history relates, Mamontov first took the canvas to the premises of his private Opera Theatre – known to the public as Mamontov's Opera. It was located at the same Bolshaia Dmitrovka Street where Mikhailova's salon would be established a decade later. However, the panel was soon moved to Mamontov's ceramic factory to be used as a design for the decorative majolica panel intended to go at the top of the façade of the luxurious Hotel Metropol in the centre of Moscow, a stone throw away from the Kremlin. Mamontov supervised the restructuring of this massive building, which was meant to become a focus of Moscow cultural life. According to his ambitious plans, the Metropol – in addition to its hospitality functions – was to incorporate an exhibition hall, a theatre, a winter garden and several salons for public events. This grandiose project was never fully accomplished, not least because Mamontov was accused of financial offences and had to stand trial. Although eventually acquitted, he was a broken man who never quite recovered from the scandal. The scandal cut short his various art projects and many of Mamontov's former protégés and acquittances turned their backs on him. Meanwhile, the arched pediment of the Metropol was embellished with the majolica ornamentation featuring Vrubel's motive. Thus, the *Dream Princess* came to be an integral part of Moscow city environment and remains so today.

As for the original panel, it was returned to Mamontov's Opera, which after Mamontov's downfall changed hands, becoming the Zimin Opera House. Apparently, Vrubel's gigantic creation was kept there in storage, hidden from the public

view. The proximity of the Zimin Opera to the Art Salon – both being located on Bolshaia Dmitrovka Street – might have added special overtones to the gallery's second exhibition.

Without doubt, the enlightened part of contemporary audience was well aware of all the dramatic and scandalous circumstances attached to the *Dream Princess*. By December 1912, when Mikhailova put up Vrubel's exhibition in her Art Salon, the artist, ridiculed for the most part of his career, was already dead and eulogised as a great talent, while his patron Mamontov was living in self-imposed isolation from the society that was painfully quick in depriving him of respect and dignity. Was the message about fickleness of public opinion and taste embedded in the concept of this second show of the Art Salon? No one will ever know that for sure. However, the fact that a majolica mantelpiece based on the pairing motive of *Mikula Selianinovich* was included into the display seems to consolidate the speculation.

These two focal points of the exhibition were complemented by a fair number of Vrubel's mature graphic works – watercolours and pencil sketches – which reflected his exceptional artistic mastery. All in all, the event attracted such an avid

Mikhail Vrubel (artist), Petr Vaulin (ceramist), *Fireplace Volga Sviatoslavich and Mikula Selianinovich*, between 1898–1900, majolica, coloured glaze, 246 × 295 cm. Kolomenskoye Museum-Reserve, Moscow.

public interest that the salon was able to charge more for entrance than for Denisov's show. Thus, on Thursdays, visitors had to pay 1 rouble for a ticket, while on all other days of the week the price remained as usual: 50 kopeks for adults and 25 kopeks for children and students.

The Russian press finally acknowledged the emergence of a new art gallery by publishing short reports on Vrubel's exhibition. However, not all the reviewers were indiscriminately favourable. For instance, a certain commentator writing under the pen-name 'Philographer' (*Filograf*) complained that 'the room where the panel has been displayed is not particularly suited for its size. The viewer is unable to move back to take in all the painterly surface at once.' In addition, *Filograf* remained unimpressed by the quality of some of the pieces of graphic art shown at the exhibition, asserting that their significance rested exclusively on the fact that they were created by Vrubel. This rather cold reaction was counterbalanced by a positive response from the prominent art critic Aleksandr Koiransky published in the *Morning of Russia* (*Utro Rossii*) newspaper. Comparing the two first events at Mikhailova's newly opened salon with displays at the Lemercier Gallery, Koirancky observed: 'The Art Salon, as it seems, pursues more artistic goals. It started its activities with a very interesting exhibition of works by V. Denisov. Now thanks to its initiative Moscow has been able to discover one of the most important works of Vrubel's genius – his decorative panel the *Dream Princess*.'

Vrubel's exhibition, with its centrepiece based on the popular play by Edmond Rostand, also served as a sort of a virtual link with the next event to take place at the Art Salon – the exhibition of the French painters under the title *Contemporary Art*. It opened on the first day of 1913 and included 220 works which represented all the newest directions of French painting. On the occasion of the exhibition, the salon published its first catalogue, thus introducing the practice of accompanying each show with an appropriate catalogue.

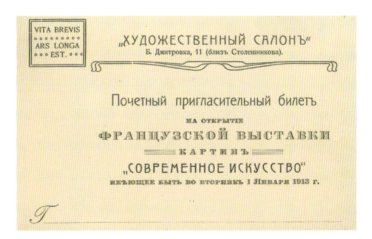

Formal invitation to the opening of the French exhibition of painting 'Contemporary Art' in Mikhailova's Art Salon, 1912. Russian State Archive of Literature and Art RGALI, Moscow.

FROM CONVENTION TO HOOLIGANISM

Among the participants were the major masters of French Modernism, including the Nabis, Fauves and Cubists painters. The number of contributors was such that the advertising poster announcing the show enumerated only twenty-one names – all spelled in French with no Russian translation – ending the incomplete list with the intriguing 'et exc etc', which presumably meant 'and many others'. The artists mentioned individually were arranged in alphabetical order by their surnames, followed by their first name initial. They included (as printed on the poster): H. Bolz, H. Bruce, M. Denis, K. van Dongen, R. Dufy, H. Doucet, E. Friesz, P. Gerieud, C. Guérin, A. Herbin, P. Laprade, A. Le Beau, A. Marquet, J. Marchand, H. Matisse, H. Ottmann, P. Picasso, C. Percy, C.A. Picart le Doux, F. Vallotton and Van Ries. It would seem that the names of these painters were already familiar to Moscow lovers of art; therefore their participation was supposed to attract potential visitors.

The list as it appeared on the advertisement contained some inconsistencies, which were probably due to lack of proper editing before being submitted to print. In fact, five surnames from this roll (van Dongen, Picasso, Picart le Doux, Vallotton and Van Ries – the latter being now a completely obscure figure) were published without the initials. In addition, the surname of Charles Alexandre Picart le Doux was misspelled as 'Picard le Doux'. It is unlikely, however, that the overwhelming majority of Russian public picked out any of these trivial inaccuracies and omissions.

The *Contemporary Art* exhibition was indisputably Mikhailova's own brainchild. Unfortunately, surviving archival documents do not shed any light on how exactly she managed to select the artists and invite them to take part in her show. Nor do we know how works were sent to Russia and then returned, nor how many were sold. Some might have already belonged to Russian collectors who simply lent them to the display. Influential Parisian dealers such as Paul Durand-Ruel and Ambroise Vollard might also have been valuable points of business contact. After all, their long-term liaisons with some major Russian art patrons, such as Sergey Shchukin or Ivan Morozov, have been well documented in the art historical literature. However, there are no documents confirming any direct connection of Mikhailova with either of these important figures. The fact that she never travelled to Paris only deepens the mystery. There is some evidence confirming that her husband, the artist and exhibition organiser Ivan Mikhailov, used to visit the French capital, but he apparently did not participate in his wife's endeavours with the gallery. In all likelihood, Mikhailova turned for assistance to some Russian artist or art critic who happened to live in Paris during that period and was familiar with the Parisian art milieu. At least, that is how she would organise her international exhibitions in the future.

The exhibition proved to be an immediate hit with the public. In addition to the artists mentioned in the advertisement poster, the display also featured works

by such prominent masters of French Modernism as Jean Metzinger, Fernand Léger, Raoul Dufy and Juan Gris – the last two being exhibited in Russia for the first time. In the first two days after its opening, the number of visitors reached one thousand, despite the opening evening not proving to be particularly promising. According to one of the reviews published in the press, 'The opening attracted few visitors. They were mostly artists who were examining the creations of authentic Cubists and Futurists with great interest.' Art critics, however, were mostly disappointed. For instance, one of the commentators reported that the French modern art displayed in the exhibition 'appeared brutish and absurd. Visitors did not shy away from loudly expressing their outrage.'

Judging by reports published by authoritative critics, the French exhibition mostly offered examples of lamentable deviation from what they considered to be the authentic great art. Therefore, in their view, the works displayed in the Art Salon were only able to provoke curiosity but not admiration. The influential columnist Sergey Glagol (the pen-name of the artist Sergey Goloushev) in his review for the newspaper the *Capital's Rumours* (*Stolichnaia Molva*) mockingly appealed to his readers:

> Hurry up, dear admirers of Modernism, and enjoy. All the latest *crie* of Futurism and Cubism are stockpiled here. It is unnecessary to try to figure them out. Everything speaks for itself. In any case those who are interested in the latest Herculean Pillars of painterly inventions can here satisfy their curiosity in full.

Another prominent art critic Sergey Mamontov echoed the verdict that Glagol had made. In his rather cold review, he advised the young generation of Russian artists to take a tour of the French exhibition only in order to understand how '*not* to paint pictures'. The works shown in this exhibition, insisted Mamontov, represented a distortion of nature and life. Therefore, they should only be valued as negative examples not to be followed.

Mamontov was particularly disgusted by Fernand Léger's now celebrated Cubist work *Woman in Blue*. In his view, only Juan Gris was worse than Léger. With hindsight, such a severe critique comes as a surprise, given that the Shchukin and Morozov collections should have already enabled Moscow art connoisseurs to better appreciate Avant-garde experimentations. Yet, this adverse reaction was symptomatic of a strong resistance to the radical remaking of fine art which still lingered in the Russian progressive cultural milieu. At the same time, Mamontov's review, rather paradoxically, also attested to the ongoing process of gradual acceptance of Avant-garde tendencies. In fact, after taking issue with Léger and Gris, Mamontov criticised Picasso's works for not being radical enough. He remarked wryly: 'Perhaps, celebrated Picasso had no opportunity to send his really talented

Fernand Léger, *Woman in Blue*, 1912, oil on canvas, 193 × 130 cm. Kunstmuseum, Basel.

creations. Those displayed at the exhibition are tentative and flabby.' Mamontov concluded his report by stating: 'The nightmarish and charlatan attempts of our young artists from the Jack of Diamonds and Donkey's Tail groups look quite forgivable in comparison with the contrived absurdities which their French colleagues put upon our viewing.'

Despite the press backlash, none of the critics accused Mikhailova of bad taste in selecting the works, nor did anyone hold her responsible for organising a show of such controversial painting. Little did they know that the next event to take place in her gallery would be even more problematic. As it happened, Mamontov's closing remark about Russia's own Avant-garde groups, the Jack of Diamonds and the Donkey's Tail, proved to be an involuntary teaser which anticipated the next exhibition to be held in the Art Salon under the provocative title *Target* (*Mishen'*) organised by zealots of the Donkey's Tale set. As Mikhailova agreed to sub-rent her gallery space to this group of radical artists under the leadership of the indomitable Mikhail Larionov, she must have been well aware that a scandal could occur.

Still, she took the risk. Thus, the salon's first season was rounded out in the most clamorous and controversial way.

The spirit of revolt and the eagerness to overthrow traditional rules of representation were gaining their momentum, galvanising the artistic life in Moscow. Various Avant-garde groupings were competing for the banner of the leader of Russian radical art, and their rivalry grew more intense in the 1912–13 season. Yet, only two years earlier, the Moscow Avant-garde represented a unified coalition, which in December 1910 organised the international exhibition under the controversial title, the *Jack of Diamonds*. A stated objective of the event was 'to offer young Russian artists who find it extremely difficult to get accepted for exhibitions under the existing indolence and cliquishness of our artistic spheres, the chance to get onto the main road'.

The exhibition opened in the headquarters of the Moscow Society of Friends of Fine Arts in Levisson House on Bolshaia Dmitrovka, that is on the same street where Mikhailova would soon establish her own salon. The display, which included works by Russian, French and German painters of Modernist orientation, attracted a considerable number of visitors and a unanimous indignation from the press. The event also inaugurated the birth of the new Russian art association at the core of which was a group of ex-students of the Moscow School of Painting, Sculpture and Architecture, headed by the enterprising and talented painter Mikhail Larionov. According to Aleksandr Kuprin, one of the founding members of the group, the Jack of Diamonds' artists rejected traditional canons in favour of other avenues offered by the painterly experiments of Cézanne, Matisse, Van Gogh and Gauguin: 'It was a revolt. We discarded all things old and dull. … We were attracted to and enchanted by the new art … so strong by its colour and form … so freehand and broad.'

From the very start, the Jack of Diamonds aligned itself with the international Avant-garde movement. Following in the steps of the Golden Fleece salons, the group kept inviting foreign artists – mostly French and German – to participate in their annual displays. However, the struggle for leadership and innovation intensified centrifugal tendencies within the Russian Avant-garde milieu. So, before long Larionov, his faithful partner and supporter Natalia Goncharova and a group of their allies grew dissatisfied with the Jack of Diamonds' policies, especially with what they perceived as a slavish following of the French Modernist trends. In protest, they publicly announced their split from the Jack of Diamonds and established a new society under the provocative name of the Donkey's Tail. From that moment on, shocking titles, bold declarations and outrageous gestures came to play a major role in the promotional strategy of the radical wing of Russian Modernism. The Donkey's Tail put on only one exhibition, which took place in March–April 1912. It featured 307 works by nineteen artists who were adamant

in declaring their independence from new western European art in founding a completely autonomous and authentically Russian art movement. Larionov and Goncharova were joined by other militants of the Russian Avant-garde, including such distinguished figures of radical art as Kazimir Malevich, Marc Chagall and Vladimir Tatlin. The display featured Neo-Primitivist, Cubist and Futurist works, which were inspired, according to their creators, by Russian indigenous art: icons, popular prints (*lubki*), embroidery and shop signs. In the press release announcing the exhibition, the organisers especially insisted on the fact that the Donkey's Tail followed exclusively native traditions, which is why no foreign artist was invited to take part in their show. Despite all this patriotic rhetoric, the Donkey's Tail exhibition failed to achieve financial and public success, unlike the Jack of Diamonds group, which consolidated its reputation with the success of its second exhibition in January 1912. Inevitably, the head-on confrontation between these two associations escalated in the next 1912–13 season and Mikhailova's salon was directedly involved in this collision.

The third annual exhibition of the Jack of Diamonds group opened on 7 February 1913. Once again, the venue was provided by the Moscow Society of Friends of Fine Arts in their quarters in the Levisson House on Bolshaia Dmitrovka Street. The show ran for a whole month until 7 March and, in addition to Russian Modernist art, the display featured works by French Cubists including Georges Braque, Pablo Picasso, André Derain, Paul Signac, Henri Le Fauconnier and others. Thus, the Jack of Diamonds reconfirmed its allegiance to western Modernism, especially to its French version. The organisers also advertised the participation of Italian Futurist painters, but in the end their work did not arrive. The exhibition was relatively popular. In total it was visited by approximately 5,000 people. All considered, Larionov and his group had to provide their own show with some really good enticement in order to lure the public and surpass rivals. Inventive and ambitious Larionov came up with some brilliant ideas.

Larionov, as the undisputed leader, advertised the event in the press several months before its actual opening. The forthcoming show received a catchy name – *Target*. Larionov explained this unconventional choice of title to a specially invited reporter from the *Voice of Moscow* (*Golos Moskvy*) newspaper. In an act of pretended victimhood mixed with defiance, he declared: 'We and our creativity serve as a target for ridicule and indignation of those who do not appreciate our art, of those for whom we are far too novel.' Larionov also anticipated that the event in store 'would not have too many canvases. One of our new principles is not to overwhelm the public with lots of paintings.' Thus, he distanced his brainchild from the Jack of Diamonds' extensive displays. He also announced that the *Target* would bring together known painters, which included Larionov himself, his inseparable partner Natalia Goncharova, as well as Mikhail Le-Dantiu, Evgeniy

Sagaidachnyi, Viktor Bart and Aleksandr Shevchenko, and some 'three or four' young talents whose names he strategically kept secret. As it happened, the actual display included the twenty-eight artists and 152 works. Who exactly Larionov planned to cast in the roles of rising stars remains unknown, as the display included several young newcomers, among whom were two important Avant-garde ground breakers: Kazimir Malevich, the future inventor of Suprematism, and Marc Chagall, who was then living in Paris as a resident of the vibrant art colony La Ruche.

Another intriguing attraction divulged by Larionov through the Moscow press included, in his words, the participation of 'the outstanding masters of primitivism. These are the self-taught artists who have not been spoiled by any external influence and who achieve the great power of expression exclusively by virtue of their talent.' One of them was Niko Pirosmani, a Georgian naïve artist whose speciality was painting on oilcloth. In general, Pirosmani's life and intuitive art resembles the biography and pictorial style of *Le Douanier*, Henri Rousseau. Pirosmani's main patrons were Tbilisi shopkeepers, for whom he executed shop signs, portraits and genre scenes in his spare time, while earning his living by performing various manual jobs. Given that works by Rousseau participated in the recent exhibition of

Niko Pirosmani, *Portrait of Ilya Zdanevich*, 1913, oil on cardboard, 150 × 120 cm. Private collection.

FROM CONVENTION TO HOOLIGANISM

the rival Donkey's Tail group, it is reasonable to conclude that Larionov decided to display works by Pirosmani and other amateur artists as to give special emphasis to his group's anti-western rhetoric by evincing the richness, variety and originality of the Russian Empire's indigenous culture.

Furthermore, in his interview Larionov revealed that *Target*'s display would be divided into three sections, each exemplifying a particular type of creativity. 'The contemporary primitivists', as he called them, would comprise of both amateurs (such as Pirosmani) and professional painters, among which Larionov particularly singled out his partner Natalia Goncharova and her canvases depicting 'fieldwork and episodes from village life'. The second part was classified as 'Painting in the manner of the Donkey's Tail', which was a rather vague description, given that artists associated with that direction followed various styles ranging from Cubism to Futurism and Neo-Primitivism. Finally, and most importantly, Larionov announced the launch of the new Avant-garde style called Rayism (*Luchism*), which he proudly explained as 'my own novel theory of painting'.

It turned out that Rayism was, indeed, a pioneering and original art style which radically challenged illusionistic representation. Larionov's theoretical approach underpinning its creation was loosely based on the recently discovered optical phenomena of X-rays and radiation. He claimed that the human eye was not a reliable organ for observing reality correctly, because it perceived not the object as such, but a sum of rays reflected from the object. Therefore, according to Larionov's reasoning, conventional pictures distorted reality. He aspired to correct this discrepancy by rendering the sum of rays reflected from the object as well as reflex rays 'belonging to other nearby objects'. One of the exhibition's reviews offered the résumé of this rather tangled theory in Larionov's own words:

> The sum of rays emanated by the object A intersects with the sum of rays from the object B. A certain form distilled by the artist's will emerges in the space between those [two] objects. In effect the ray is depicted on the painterly surface as a coloured line. But one must see it in reality. It cannot be described adequately.

In effect, this singular approach essentially signalled a move towards non-figurative painting and thus was running in parallel with other contemporary abstract tendencies in European Modernist art. The Rayist paintings shown at *Target* were nearly abstract, although their titles still preserved links to conventional reality. For instance, one of Larionov's works was called *Rayist Sausages and Mackerel*, while Goncharova's experimental pictures included *Lilies*, *Rayist Evening: Red and Blue* and *Cats: Rayist Perception in Rose, Black and Yellow*. In other words, even before the exhibition was opened it was clear that the show would represent

Mikhail Larionov, *Rayist Mackerel and Sausages*, 1912, oil on canvas, 46 × 61 cm. Ludvig Museum, Cologne.

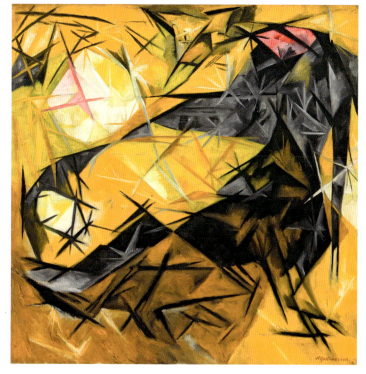

Natalia Goncharova, *Cats: Rayist Perception in Rose, Black and Yellow*, 1913, oil on canvas, 85 × 85 cm. Solomon R. Guggenheim Foundation, New York.

a challenge to public taste. These expectations proved correct, as *Target* arguably became the most staggering and explosive event of the season.

Needless to say, Larionov's ambitious plans for this exhibition required an adequate venue capable of accommodating a display containing 152 Avant-garde

paintings complemented by a substantial number of works by children. Last, but not least, he also needed a space to install his *Exhibition of Icon Patterns and Lubki*, which he planned to run simultaneously with *Target*. This second display included broadsheet prints (*lubki*) as well as special pattern books used by icon painters to create their works according to the approved Orthodox canon. The exhibits came from several private collections, including Larionov's own. The pairing of these events was vitally important for Larionov and his supporters. In this way they aspired to evince visual connection between Russian folk art and Avant-garde experimentations. The ultimate aim here was to reconfirm their claim to the originality of Russian Avant-garde and its independence from western influences.

Mikhailova's gallery, with its newly refurbished bright rooms and well-organised layout, was a real find. During the high season, from December to March, art groups and individual artists famously struggled to secure adequate space for their displays in Moscow where exhibition venues were limited in number and always in high demand. No wonder Larionov was absolutely delighted to obtain 'the brand-new premises with the skylights which is the best setting available in Moscow', as he enthusiastically wrote in a letter to his associate Ilia Zdanevich.

In relation to the *Target* exhibition, Mikhailova obviously played a marginal role, merely subletting her gallery to this explosive Avant-garde event. However, the level of her courage in doing so must not be underestimated. As if various transgressive inventions publicised by Larionov in the months leading up to the exhibition were not enough, on the very eve of the *Target* opening an unheard-of episode of hooliganism took place. The debate organised by Larionov and his associates in the conference hall of the Polytechnical Institute under the title 'The East, Nationality, and the West', which was supposed to further excite public interest for the imminent inauguration of Larionov's exhibition, degenerated into a fight between the speakers and the audience. Police were called in to restore order. Larionov and some of his peers were arrested. While they put on brave faces, claiming to be proud of their brawl, the authorities initiated a criminal investigation against Larionov. Judicial proceedings took six months, only concluding in October 1913. Larionov was charged with inciting public unrest. He was sentenced to a fine of 25 roubles, which could be converted into fifteen days' arrest in case of insolvency. Unsurprisingly, he settled for the fine.

In view of these developments, it becomes clear that Mikhailova was putting her salon's growing reputation at risk by granting permission to hold the *Target* exhibition. Even the cursory description of Larionov's track record evinces the unconventional, unpredictable and defiant nature of this perpetual troublemaker. Considering his problematic public image, as well as his nonconformist idiosyncratic ideas expressed during the extensive propaganda campaign he ran in the

press prior to the exhibition, Mikhailova must have been well aware of Larionov's views in general and his *Target* agenda in particular. Therefore, her decision to cooperate was conscious and well-informed. It is doubtful that she ever shared Larionov's radical views on the rules of painterly representation or his uncompromising rejection of European cultural heritage for the developments of Russian visual arts. In her own painting, which she never gave up, even during her gallery directorship, she generally followed conventional rules of figurative representation, so in theory she must have sided more with Larionov's opponents than with his supporters. Yet, nothing of these put her off the case. Moreover, the *Target* exhibition marked the beginning of a close collaboration between Mikhailova and Larionov, as the latter soon became one of her trusted curators and art agents until his final emigration to France in August 1915. The story of this unexpected partnership attests to Mikhailova's strong will and her remarkable ability to appreciate talent and energy, even when her own attitudes were at odds with the person in question.

On the *Target* opening day, a photograph of some participating artists, including Larionov and Goncharova, was taken inside the Art Salon premises. Relaxed, confident and cheery, they sit in a row facing the camera. The background wall behind them displays some of Larionov's paintings in the Neo-Primitive style,

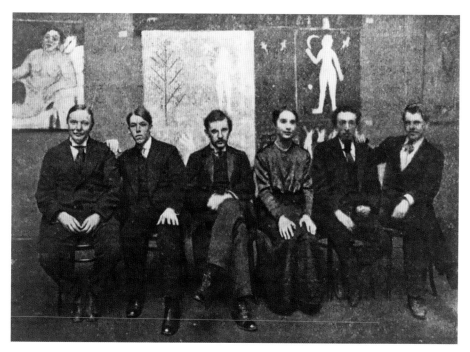

Group of artists at the Target exhibition. From left to right: M. Larionov, S. Romanovich, M. Le Dantue, N. Goncharova, M. Fabbri, V. Obolensky. Photograph, 1913.

Mikhail Larionov, *Jewish Venus*, 1912, oil on canvas, 104.8 × 147 cm. The Yekaterinburg Museum of Fine Arts, Yekaterinburg.

including *Jewish Venus* and *The Seasons*. This image, published by the contemporary press, captured the spirit of the most sensational and controversial show to take place in the Art Salon during its first season of existence, even if in a financial sense it turned out to be a fiasco. The exhibition ran for two weeks from 24 March to 7 April 1913, and the number of its visitors did not exceed 1,500. No paintings were sold. However, the failure to hit the target and surpass the rival Jack of Diamonds group could not stop the indefatigable Larionov. He was full of exciting ideas. Moreover, now he had an excellent space in which to enact his projects and a sympathetic ally who would lend him her support. The Moscow public was in for more surprises.

3.2. Nadezhda Dobychina: the Russian 'Durand-Ruel in a skirt'

In 1913, Nadezhda's husband, Petr, unexpectedly came into an inheritance of 3,000 roubles from his late uncle. At the time the average monthly salary in Russia was 35 roubles, so this inheritance was large enough for the family to move to the much more prestigious Moika Embankment just around the corner from the main avenue in the city, Nevsky Prospect, where a larger art gallery had now opened.

Petr Dobychin, 1913.

Petr Dobychin at his desk in the family's apartment on Moika Embankment, 1913.

From late September 1913 until April 1914, Dobychina's Art Bureau was based at Moika Embankment, 63.[5] The new premises comprised of eight tastefully decorated and well-lit rooms and, according to contemporary reviews, the lighting superseded even the grand rooms of the Hermitage Museum. Together with the bureau, the *Permanent Exhibition of Paintings* also moved here. Apart from Dobychina, it was now organised by the leading artists Evgeny Lansere, Vladimir Mate, Anna Ostroumova-Lebedeva and Nikolay Remizov (known as Re-Mi). Nadezhda also had two secretaries – both wives of the artists whose works were included in the exhibition – Elena Shukhaeva and Eliza Radlova. This exhibition ran from 27 September until 22 October 1913 and included artists of all trends. In the catalogue published in 1913 (the cover of which was designed by the graphic artist Ostroumova-Lebedeva, who also made the signboard for the bureau) seventy-eight artists were listed, from well-established artists from the World of Art to Kandinsky and Kulbin.

On 1 October 1913, the newspaper *Vechernee Vremia* (*Evening Times*) published a review of this remarkable exhibition:

> Our artists became extremely quarrelsome and impatient with one another – they usually divide into groups. *The Permanent Exhibition of Paintings* is

5 In 1915, the building where Dobychina had her second bureau was demolished and replaced by the Russian Bank for Foreign Trade.

beyond different fractions of artists. Here St Petersburg and Moscow-based artists peacefully settled next to each other – raging youngsters next to more sedate members of the Union of Artists and the World of Art, as well as young academics: painters, graphic artists and architects. The Art Bureau is organised in a respectable manner and quite diligently. In one year, it attracted many talented and serious artists.

Already in 1913 Dobychina was being compared to the leading French art dealer, Paul Durand-Ruel, and her bureau with salons in Paris. While Alexandre Benois called Nadezhda 'Durand-Ruel in a skirt', the famous art critic Aleksandr Rostislavov wrote in the newspaper *Rech*: 'Of course, such ventures do not develop here into the same kind of mediation and specialisation as the famous enterprises organised by Durand-Ruel. … But the time has come for our public to have an opportunity to see and to be able to find what it needs without having to look through all the rubbish on sale at the art shop.' In the article 'It's about Time', art critic and artist (whose works would be exhibited at the bureau in 1916–17), Vladimir Denisov called the opening of the Art Bureau the main highlight of autumn 1913 and compared the *Permanent Exhibition*, which united artists from various artistic strands under one roof, with the Parisian salons.

Nadezhda Dobychina in a long dress, *c.*1913.

The tradition of a woman as a hostess of a literary salon dates back to the first half of the nineteenth century. Like her predecessors, Dobychina shared her apartment with the art gallery. As Lina Bernstein observed in her essay on the Russian salon hostesses in the first half of the nineteenth century:

> Whereas a salon is almost always situated in a private home, it projects in various ways a liminal space between private and public. … Just as the salon is at once private and public in orientation, it very often performs the double function of 'social and intellectual event', serving as a venue for debating ideas and showcasing new works as well as for conversation, entertainment.[6]

In his memoirs, Benedikt Livshits described Dobychina as 'the organiser of fashionable exhibitions and salons', and occasionally in her correspondence Nadezhda also referred to her bureau as a salon where all forms of cultural activities took place, rather than just a commercial art gallery. Along with the exhibitions, she organised poetry recitals and concerts where music by the leading Russian composers was performed. Thus, on 28 November 1912, an evening of chamber music dedicated to a Romantic composer Aleksandr Borodin took place at the bureau with great acclaim. It was followed by immensely popular music recitals of Sergey Prokofiev and Igor Stravinsky in February 1914, as well as theatrical plays and lectures.

Soon Dobychina's bureau became a major centre for the promotion of Russian Modernism and on 1 January 1917 the newspaper *Odessky Listok* (*Odessa Paper*) remarked: 'One must admit that Dobychina's Bureau is the epicentre of artistic life of Petrograd. The most interesting and fresh events took place in the modest rooms of Madam Dobychina.' In his famous chronicle of the development of the Avant-garde in Russia, *The One and a Half-Eyed Archer*, Benedikt Livshitz wrote that the gallery on the Moika River is 'a real museum of leftist painting'.

The *Permanent Exhibition* at the bureau included around 300 works, many of which were executed by less-known young Avant-garde artists, such as the Burliuk brothers, Wassily Kandinsky, Aristarkh Lentulov, Martiros Sarian, Natan Altman and Boris Grigoriev. Some art critics credited Dobychina with discovering Grigoriev – at the time a young and still unknown artist, who from 1909 was a member of the 'Impressionist studio' founded by Nikolay Kulbin, and in 1913 spent four months studying at the Académie de la Grande Chaumière in Paris.

Although Nadezhda always strove to support young talent, her exhibition was highly eclectic, which probably could be explained by Paul Durand-Ruel himself, who wrote that his gallery dealt in works by academic artists, 'which we found

6 Lina Bernstein, 'Women on the Verge of a New Language: Russian Salon Hostesses in the First Half of the Nineteenth Century', in Helena Goscilo and Beth Holmgren (eds), *Russia. Women. Culture* (Bloomington: Indiana University Press, 1996), p. 226.

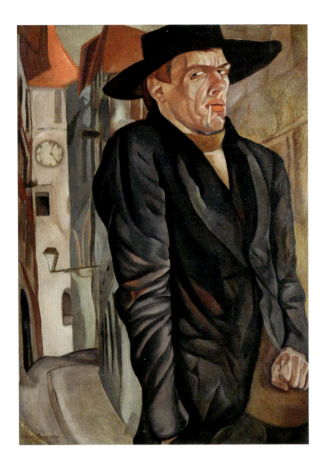

Boris Grigoriev, *Self-portrait*, 1916, oil on canvas, 95 × 69 cm. Private Collection.

easier to sell than the works we favoured. It was beneficial to the firm because we could increase our business by satisfying different kinds of art lovers and the profits we made allowed us to broadly support our friends … [whose] works were still difficult to sell.' Dobychina followed the same business model and like the French art dealer, often visited the artists' studios to reserve the best works.

Not all the reviews of the new bureau were favourable, and in October 1913 the most prestigious art magazine, *Apollon*, published an article about the *Permanent Exhibition*, criticising it for charging an entrance fee and for selling the exhibition catalogue. It stated that if it was selling some random works of art, most of which had been exhibited before, it should have behaved like any other art shop rather than pretending to be a gallery. Taking this criticism on board, shortly after her move to larger premises Dobychina wrote to her friend and advisor, Alexandre Benois, that the relocation was prompted 'by a need to expand the operation. … I have in mind not only expansion of the operation of the permanent exhibition – the sale of paintings, but also organisation of a group of temporary exhibitions of one or another type of art or an individual artists.'

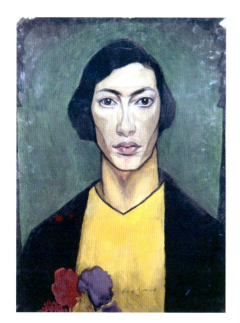

Natan Altman, *Self-portrait*, 1911, tempera on paper, 63 × 46.5 cm. The State Russian Museum, St Petersburg.

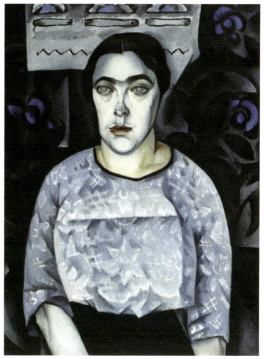

Natan Altman, *Portrait of Nadezhda Dobychina*, 1913, oil on canvas, 83.5 × 65 cm. Private Collection, Moscow.

The first exhibition, which opened at the end of October 1913 at the new bureau on Moika Embankment, was the *Exhibition of Graphic Arts*. Dobychina invited a group of artists – Evgeny Lansere, Anna Ostroumova-Lebedeva, Ilya Repin and Re-Mi – to form the governing committee of the exhibition, which included lithographs, woodcuts and book illustrations mainly by members of the World of Art group. An entire room of the Art Bureau was dedicated to engravings by Ostroumova-Lebedeva. Sixty-seven of her woodcuts were included in the exhibition, and even in her autobiography the artist referred to the *Exhibition of Graphic Arts* as the first retrospective of her works.

Although Ostroumova-Lebedeva worked in watercolour and occasionally in oil, she is best known for her woodcuts. In Russia, the woodcut was traditionally linked with *lubki*, popular prints dating to the late eighteenth and early nineteenth centuries which were produced in large numbers in the cities and hand-coloured in the villages, and were characterised by a naïve pictorial style, bright pure colours and inclusion of text. Ostroumova-Lebedeva elevated this traditional art form by producing small editions of prints, which were characterised by sophisticated and laconic lines.

Anna Ostroumova-Lebedeva, *View of St Petersburg, Summer Gardens*, 1902, coloured xylography, 35.5 × 22.8 cm. Private Collection.

Despite the popularity of *lubki*, in the beginning of the twentieth century there was still little understanding and appreciation of the graphic arts in Russia. In her autobiography, Ostroumova-Lebedeva recalled how at the Art Bureau exhibition some visitors assumed that her woodcuts were produced by wood-burning, while others expected to receive an image on wood rather than on paper when they purchased a woodcut.

Some art critics referred to the exhibition as a 'showcase of minor art' and believed that the artists' prints could not be considered original works of art. At the same time, Vladimir Denisov wrote in the newspaper, *Den'*, that before the *Exhibition of Graphic Arts* engravings were often overlooked in the larger exhibitions, where they were inconspicuous next to paintings and theatre designs. He concluded that an independent exhibition would be very useful for public

Labels for paintings exhibited at the Art Bureau, 1913.

understanding and appreciation of engravings. Critic Rostislavov wrote in the newspaper, *Rech*, that at the exhibition 'the usually scattered around several larger shows prints were successfully concentrated, which would help to see the true face of these artists'.

Although the exhibition was not very successful commercially, by selecting a niche subject for her first temporary display, Dobychina strove to form a public image as a serious connoisseur rather than a profit-chasing business person. Her efforts were appreciated by the critics, who remarked that she was obviously a patron of the arts rather than an art dealer.

In November 1913, the next exhibition of graphic arts was opened at the bureau. This time it was dedicated to caricatures and drawings from the journal *Novyi Satirikon* (*New Satire*), the foremost satirical journal published in Russia from 1913 until 1918. This display was probably inspired by the small exhibition of the prints from *Satirikon*[7] which was held at the editorial office of the magazine *Apollon* in 1909. These sharp and beautiful illustrations by such artists as A.A. Radakov, N.V. Remizov (Re-Mi), A.E. Yakovlev and A.A. Yunger appealed to a broad spectrum of the Russian society and became the barometer of educated public opinion.

7 Due to disagreements in the editorial board, some of the staff at *Satirikon* (1908–14) took on publishing the *Novyi Satirikon* journal (1913–18), with Averchenko as editor, from July 1917 – Bukhov was the editor-in-chief.

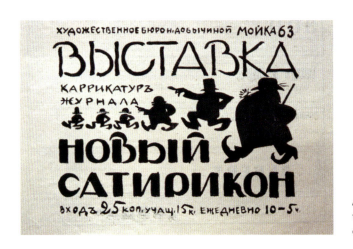

Advertisement for the *Novyi Satirikon* exhibition, 1913.

The exhibition at the bureau was well attended and received several glowing reviews. Unlike the earlier display organised by the *Apollon*, Dobychina's exhibition did not include explanatory texts which would usually accompany these cartoons. Denisov explained that the texts had been omitted in order to emphasise the artistic qualities of each print. He wrote:

> We still like to 'read' works of art. From every drawing, painting, sculpture and even a building we try to decipher the context, the 'main idea' – thus, to find the contextual meaning of every artist's creation, often forgetting about its artistic qualities.

At the same time, some critics felt that without the comments to each caricature, the public struggled to understand the meaning of these prints.

At the same time as the *Novyi Satirikon* display, Dobychina's Art Bureau opened a small exhibition, *Artistic Svetopis' of Miron Sherling*. Forty-two photographic prints were displayed in a small room at the gallery. At the time, Sherling was a leading photographer who had an atelier in St Petersburg where photographs were taken with only natural rather than artificial light. At the bureau, his photographic portraits of the artist Nikolay Roerich, singer Feodor Chaliapin, theatre director Vsevolod Meyerkhold and Dobychina herself were included.

By the end of 1913, the Art Bureau became an important part of the artistic life of St Petersburg. Summarising the most important events in the cultural life of the capital, art critic Levinson wrote about the decline of the increasingly stagnant and overly decorative World of Art movement: 'the influential group of artists which is gradually turning into a purely superficial and pervasive dictator of taste in art'. In his article, Levinson stressed that during this time the *Peredvizhniki* were merely 'imitating yesterday's Modernism' and the best members of the Union of Russian Artists were repeating themselves, while the worst were copying other artists. He

Miron Sherling, *Portrait of Nadezhda Dobychina*. Photograph, 1913.

Miron Sherling, *Feodor Chaliapin as Boris Godunov*. Photograph, 1909.

concluded that the Imperial Academy of Arts 'completes the general picture of decline' and found the only vitalising force in Dobychina's bureau 'a venture, very useful for revival of artistic life and communication between the artists and the society as well as the right organisation of the art market'.

The spring season at the Art Bureau was opened by a posthumous exhibition of Ian Tsioglinsky – the largest show at the bureau since its foundation – which opened on 2 February 1914. Private sponsorship made possible inclusion of 980 works by Tsioglinsky – the Polish artist, who lived and worked in St Petersburg and whose paintings are considered to be the first examples of Russian Impressionism. A catalogue of the exhibition included an artist's biography, articles about him and sixteen reproductions of his works. Although Tsioglinsky's paintings were probably too academic for Dobychina's taste, his exhibition brought high acclaim to the bureau and attracted the attention of most newspapers and art journals. On 1 March 1914, Her Imperial Highness, The Most August President of the Imperial Academy of Arts, Grand Princess Maria Pavlovna, visited the exhibition at the Art Bureau and was given a private tour by Dobychina and the artist's brother, Mikhail (who had appealed to all private collectors to lend their Tsioglinsky paintings for

the exhibition). The exhibition was open for six weeks and was visited by more than 4,000 people. Dobychina also sold forty paintings for the sum of 12,000 roubles. Among the buyers were the Russian Museum, the Tretyakov Gallery and the Imperial Academy of Arts.

The success of this exhibition brought great fame and recognition to Dobychina's Art Bureau as a prime venue in the capital. It was only to be expected that the highly acclaimed exhibition of the leader of the Russian Avant-garde, Natalia Goncharova, which had taken place at Mikhailova's salon in 1913, would next open at the Art Bureau, which it did on 15 March 1914.

This exhibition marked the turning point in the history of Dobychina's gallery. From now, a large part of her business activity would be dedicated to the Avant-garde artists, and the most important exhibitions, which would define the character and make an impact on the development of the Russian Avant-garde, would take place at her bureau. Nadezhda's interest in these young experimental artists was influenced by her friendship with Nikolay Kulbin and her involvement with his exhibitions.

3.3. The Art Salon's second season: on the verge of an international cataclysm

Recalling the year 1913, artist Sergey Romanovich, one of Larionov's closest allies and a participant in the *Target* exhibition, remarked: 'Actually, in that last year preceding the war feelings were running particularly high. Life was extraordinary intense, full of gaiety and unrestrained jamborees. Each and every one seemed to go crazy.'

Moscow cultural life was bustling with frenetic energy and the last pre-war exhibition season proved to be particularly rich. The upsurge in avant-garde tendencies continued to grow in autumn 1913–winter 1914 which was only to be expected after the previous 1912–13 season. Evsei Shor, an art historian and philosopher wrote in his letter to Wassily Kandinsky:

> The ending of 1913 spring season culminated in the resurgence of a certain interest in Futurism. Torn between abuse and admiration, the Moscow public, who has no idea about the essence and ramifications of this movement nor is able to distinguish between western European 'Futurism' and Russian homegrown 'Futurism', expected a revelation from it.

The words 'Futurism' and 'Futurists', which initially described the newly invented Italian movement, now acquired a broader meaning, entering the everyday usage to label various modes of social behaviour deviating from traditional well-established rules. As for the fine arts, the neologism 'Futurism' came to be employed as a kind

of an umbrella term for describing art, performances and public actions of a loose assemblage of disparate, often competing, avant-garde individuals, groups and associations.

Strictly speaking, Russian artists hardly produced a single work based entirely on pure Futurist stylistic principles. Instead, they would ingeniously mix together inspirations taken from Futurism, Primitivism, Expressionism and Cubism. Instigators of avant-garde styles were fully aware of this inaccurate application of the term but did nothing to clarify the issue, as the remarkable flexibility of the term suited them well. Slowly but steadily a new concept of art as an act of merging lifestyle and creativity was taking shape. Futurist performances acquired no less importance than avant-garde artistic production. It is no accident that Kazimir Malevich, in his autobiographical recollections written in 1933, retrospectively described Russian Futurism of 1910s as being a 'mix of all the forms that stirred up the irrational in society'. In his opinion, 'Futurism never existed in [Russian] painting. … Futurism was mostly expressed in the way of behaving, in the attitude towards the present state of society. Therefore, our Futurism was much more clearly articulated in public performances than in works of art.'

The major trigger for this new trend was Larionov. Not at all discouraged by the fiasco of his *Target* exhibition, he spared no effort in fulfilling growing public expectations for anything ultra-modern, provocative and sensational. Thanks to his remarkable resourcefulness, he promptly realised the huge potential of extending his field of activity beyond the strict boundaries of painting.

In planning his upcoming ventures, Larionov was determined to make the most of his newly established collaboration with Mikhailova's Art Salon. As it follows from correspondence that has survived between Larionov and his closest allies, Mikhail Le-Dantiu and Ilia Zdanevich, Mikhailova and he devised a preventive timetable for the next 1913–14 season, immediately after the termination of *Target*. In a letter to Zdanevich written in April 1913, Larionov outlined the imminent plan. Three exhibitions were proposed for the new season: a joint display by the artists of Larionov's circle, followed by Goncharova's entire career retrospective and, finally, the exhibition of exclusively Rayist works to draw the season to a close. However, the undated letter from Larionov to Le-Dantiu, written in the summer, contained the amendment to the programme. Now it would be Goncharova's monographic show that was supposed to begin the season. The event to follow would be a joint exhibition of Larionov, Goncharova and their associates. The letter also contained an interesting passage which highlights the role of Mikhailova in Larionov's strategic moves. Discussing the schedule for the forthcoming months he writes: '… it has been suggested that we hold a series of mono-exhibitions: yours [referring to Le-Dantiu] if you say yes to it and Shevchenko's [yet another close associate of Larionov]. Mine I think I will postpone until the next season.'

Although Larionov did not mention Mikhailova in his letter directly, it seems more than plausible that she was the person who suggested alterations to his future exhibition plans taking place in her gallery. Indeed, Larionov's interest in further collaboration with the Art Salon clearly coincided with Mikhailova's own ambition to establish her enterprise's reputation as the venue for progressive forward-looking events. Apparently, she saw the potential for monographic exhibitions as a befitting format, hence her advice to organise two more displays entirely based on the oeuvre of the young artists Mikhail Le-Dantiu and Aleksandr Shevchenko. At the same time, she advanced astutely and firmly in defining her gallery's strategy. The focus of her agenda was to keep the right balance between explosive Avant-garde shows bound to ruffle the public's feathers and more decorous events to suit mainstream aesthetic taste. At the end of the day, only one Avant-garde exhibition curated by Larionov was included in the Art Salon's eventful schedule for winter 1913–spring 1914. Nevertheless, this significant correction of plans did not damage the Larionov-Mikhailova relationship. They remained in close contact, busily devising plans for the following year while the sole radical show inaugurating the salon's second season turned out to be one of its highlights.

After the summer break the salon resumed its activities in early September 1913, in clamorous style. The indomitable Larionov, who did nothing by halves, masterminded a gigantic solo exhibition of Natalia Goncharova's works called *Exhibition of Paintings by Natalia Sergeevna Goncharova 1900–1913*, which was conceived as a retrospective, embracing the whole of Goncharova's artistic career over thirteen years. As a painter Goncharova was exceptionally prolific, so the display was huge, consisting of 761 pieces. Mikhailova's Art Salon, with its spacious, airy rooms and long stretches of walls was the ideal space to accommodate such an imposing arrangement.

In 1913, Goncharova turned thirty-two. The daughter of a relatively successful architect, she started her art training in 1901 at the Moscow School of Painting, Sculpture and Architecture, where she met Larionov. They fell in love and became inseparable – in life and in art. Strongminded and non-conformist as they both were, they refused to get married in defiance of bourgeois morality. The couple went on to live together in Goncharova's family home in the centre of Moscow. Remarkably, this openly civil partnership never created any public scandal. Nor was it ever used to harass the couple for the breach of decency, no matter how controversial or scandalous their avant-garde actions might have been.

Together Larionov and Goncharova formed the most influential pair of the early Russian Avant-garde. This duo's uniqueness lay in Larionov famously taking more care of the popularisation of Goncharova's art than his own. Hence, it was Goncharova's solo exhibition which occupied the first position in Larionov's agenda for the forthcoming season, as he hoped to take revenge on his rivals. However, he

knew perfectly well that to realise his ambition he needed to entice Moscow public with some fresh extravaganza.

He masterminded a trend, which became known as 'Rayist face painting'. It represented an ingenious mix of art and everyday life, while also offering a rich array of references from exotic tribal traditions to the latest Modernist art styles. The imminent demonstration of this extreme fashion was announced in Larionov's interview with the *Moscow Newspaper* (*Moskovskaia Gazeta*) on 9 September 1913, three weeks before the opening of Goncharova's exhibition at the Art Salon. He promised to stroll along Kuznetsky Most – one of the central streets of Moscow situated a stone's throw from Mikhailova's gallery – on 14 September, accompanied by some of his closest allies, with their faces painted in the Rayist style. In this way, claimed the inventor of the new avant-garde vogue, the general public would be able to fully appreciate the advantages of the painted face over a normal one. Taking up his usual defiant stance, Larionov expressed confidence that his invention would soon attract many followers.

Predictably, Larionov's announcement did not go unnoticed: the local and national press were very much looking forward to publishing sensational material about the 'Futurists' latest lunacy'. In the meantime, Larionov further elaborated his ideas that were immediately disseminated by the newspapers. In addition to the face painting, he now declared that the whole image of men and women should be changed. For instance, men were to shave off one side of their moustache, braid their beard and weave silk and golden threads into it. Their trousers – long in winter and knee-length in summer – should be wide-legged at the top and rigorously straight at the hem. For the cold season Larionov recommended wearing soft leather shoes with square noses and metal buckles. In summer, men were advised to wear sandals on bare feet. For female fashion Larionov had less elaborate, but certainly no less radical proposals. Women were simply encouraged to leave their bosom fully exposed and decorated by Rayist painting.

Kuznetsky Most Street was chosen to become a podium for the Futurist fashion show. It was the city's most expensive shopping street, akin to Bond Street in London. Known as 'a sanctuary of luxury and style', it was mainly frequented by the affluent public and flaneurs idling along its opulent shop windows. The appearance of a batch of young troublemakers with their faces made-up in the oddest manner could not have gone unnoticed there. Besides, Mikhailova's salon was situated close by and all the preparations for the announced stroll were made there. One of Moscow newspapers reported from the scene:

> A curious event is taking place in one of the rooms of the Arts Salon, which is completely littered with the painter Goncharova's canvases in preparation for the exhibition. The faces of the gentlemen Futurists are being painted.

The Fabergé Store on Kuznetsky Most. Photograph, 1910s.

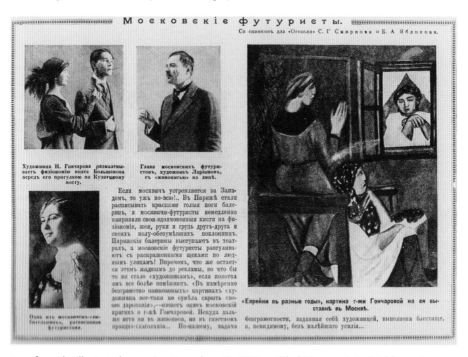

Page from the illustrated magazine *Ogonek*, n. 40, 1913, entitled 'Moscow Futurists'. (From top left to right): 1. 'The woman painter Natalia Goncharova paints the physiognomy of the poet Bolshakov before he goes for a stroll along Kuznetsky Most Street.' 2. 'The leader of Moscow Futurists artist Mikhail Larionov with his face painted.' 3. 'Natalia Goncharova's painting *Jewish Women of Different Ages* displayed at her Moscow exhibition.' (Bottom left): 4. 'One of the Muscovite ladies painted by Futurists.'

Near the door M-me Goncharova herself is 'decorating' a certain Futurist poet Bolshakov. Some blue and red stripes and dots appear on his neck, cheek and collar (the principle is asymmetry). The poet has been done. Mikhail Larionov paints himself before the mirror. Some vague reminiscence of a blue sea star takes shape on his right cheek. The third participant of the 'Futurist walk' … is being painted by Larionov. The preparations are now over and done with. The gentlemen Futurists get into a car and ride to the crossing between Neglinnaia and Kuznetsky Most streets. Here they leave the car and start strolling down the street. The oncoming public glimpses at their smeared faces with surprise. … 'What mavericks!' – says somebody. 'Imbeciles', – adds the other.

All in all, this first Futurist performance elicited a rather mild public reaction. Passers-by appeared to be more bewildered than interested, and the parade was generally viewed as a foolish prank. The contemporary press, however, gave the event a good coverage, illustrating the articles with photographs featuring the face painting process inside the Art Salon. Therefore, in the end, Larionov obtained the desired result with his stratagem. The Futurist walk whipped up interest for radical avant-garde inventions in Moscow's society. Moreover, against all odds the Futurist 'fashion' started to enlist followers soon after it had been launched. *Moscow Newspaper* (*Moscovskaya Gazeta*) gave an account of what was happening in the Art Salon the day after the notorious walk:

> The new fashion has already found its admirers. In most of the cases they are female admirers. … In relation to women, Larionov somewhat modified the method of colouring: it is not their faces that are covered with paint, but their bosoms, which are decorated with a varicoloured ornament. Yesterday the experiments of painting the female breast were already carried out in the Art Salon. One of the devotees painted by Larionov came out 'elegantly' done – her deep neckline and one of her shoulders were completely covered with a Rayist pattern.

Explosive news on the Futurist performances threw Larionov, Goncharova and their associates into the national spotlight. Slowly but surely, they were forging the image of eccentric *enfants terribles* of contemporary art – deliberately provocative to the point of being absurd, but at the same time inventive and funny. Public interest for the imminent Goncharova's exhibition had been drummed up effectively.

The Exhibition of Paintings by Natalia Sergeevna Goncharova 1900–1913 opened on 29 September and ran for more than a month until 5 November 1913. The staggering number of her works on display included oil paintings, pastels, drawings,

Catalogue of the 'Exhibition of Paintings by Natalia Sergeevna Goncharova 1900–1913', 1913. Private collection.

fashion designs and preparatory sketches, which the prolific artist had produced over thirteen years of her professional career. After the militant subversiveness of *Target* and face painting shenanigans, the Moscow public was expecting something no less radical. Instead, according to one of the early reviews:

> This time, after having seen the display of the whole artistic life, a sort of 'confession', the public as well as most critics left the exhibition's opening day not only placated, but also impressed by the undoubted talent. The exhibition is very interesting, has been organised on time and deserves due attention.

The exhibitions proved an undisputed success among the public. The catalogue with Goncharova's introduction was published in three editions. The overall number of visitors exceeded 12,000 and thirty-one works were sold, including a particularly prestigious acquisition from the 'national art sanctuary', the Tretyakov Gallery, which purchased the *Bunch of Flowers and a Bottle of Paints*. The majority of local and national press responded to the show with positive reviews.

Goncharova's works were analysed in detail. Her inventiveness and her excellent sense of colour and form were rightly appreciated. Although her astonishing diversity of styles was criticised as shallow eclecticism or, at best, as a sign of not-as-yet-fully-developed personal outlook, most of the commentators recognised

Natalia Goncharova, *Bunch of Flowers and a Bottle of Paint*, 1910, oil on canvas, 101 × 75 cm. The State Tretyakov Gallery, Moscow.

her great talent and potential. One of the observers concisely summarised the prevailing verdict:

> The artist's colossal energy, her rare capacity for work, and, most importantly, her heartfelt honest stance makes even the most ardent opponents of the newest trends in painting sympathetic and ready to treat the displayed exhibits more attentively and thoughtfully.

In addition to Goncharova's genuine artistic talent and Larionov's great curatorial skills, such an encouraging outcome was without doubt also the result of the right venue choice. Mikhailova's salon, appointed to the highest standard, offered Larionov the curator the best possible exhibition space in Moscow and he used it to the fullest extent. Yet, his task was not an easy one. He had no experience in organising monographic shows, with all his previous curatorial projects being collective exhibitions. In addition, the sheer number of Goncharova's works, which included pieces of different sizes, media and styles, represented a real challenge.

There are no surviving photographs of the display. The only contemporary documental evidence is the exhibition catalogue, illustrated with some reproductions of Goncharova's paintings. The numbering of the works allows us to reconstruct the layout of the display to a certain extent. Apparently, the salon's six interconnecting rooms were used to organise a vast amount of Goncharova's oeuvre thematically, moving from one genre to another. The cityscapes and country scenes were followed by still lifes and genre paintings. The biggest room with the skylights hosted the religious paintings, among which were several polyptychs of imposing sizes. The largest and tallest was a four-part composition called *The Evangelists*, where each canvas measured 208 × 58 cm. In contrast with Vrubel's *Dream Princess* exhibition, commentators were satisfied with the space provided for the display, noting that it allowed enough distance to view each polyptych in its entirety. Finally, the last two rooms accommodated the Futurist works as well as the Rayist paintings to mark the highest point in Goncharova's creative career. Larionov's idea to complement some of the oil paintings with preparatory drawings proved an effective stratagem. It put the process of creating Avant-garde works in perspective, thus

Natalia Gonchrova, *The Evangelists*. Polyptych, 1911, oil on canvas, 204 × 58 cm. The State Russian Museum, St Petersburg.

challenging a widespread opinion that Modernist painting was no more than an amateurish daub.

However, the exhibition's arrangement was not without its faults, which attracted the attention of several commentators. The main point of reproach was the overall impression of visual confusion, as in each thematical section Larionov amassed works produced in a variety of artistic modes. Goncharova was indeed prone to move quickly from one Modernist style to another. Being an incredibly prolific artist who (in her own words) especially enjoyed the process of making, she successively went through Impressionist, Post-Impressionist, Cubist, Futurist and Neo-Primitivist styles in relatively quick succession. Yet, the display's organisation did not follow this progression. Instead, landscapes and still lifes of different styles and time periods were put together indiscriminately, creating a sense of disorientation. According to contemporary critics, this genre-based arrangement prevented the viewers from appreciating the main stylistic milestones of Goncharova's artistic route, as well as her purported emancipation from western influences in favour of national and Eastern traditions.

Goncharova's monographic show was indeed supposed to reconfirm the anti-western, pro-national orientation artistic credo already announced during the *Target* exhibition. Larionov, Goncharova and their close ally Zdanevich, realising that the display might not be driving this point home, articulated their position in the catalogue's introduction. It was signed by Goncharova, but almost certainly drafted with the help of Larionov and Zdanevich. In the text Goncharova traced her evolutionary trajectory through Impressionism, Cubism and Neo-Primitivism to the present stage, where she finally realised that: 'Present-day Western ideas … cannot benefit us anymore.' Therefore, now she was 'brushing the dust of the past and moving away from the West, considering its offsetting significance rather petty and unimportant'. From that point on her path was leading 'to the primary source of all arts, that is to the East'. She expressed confidence that Russian art would soon play the primary role in international life, while Moscow, in her opinion, was 'the major centre of painting'.

The same set of ideas was repeated by Ilia Zdanevich in his lecture 'Natalia Goncharova and the Everythingness (*Vsechestvo*)', which took place in Mikhailova's salon on the exhibition's closing day. 'Everythingness' was an invented word which designated a new pioneering trend in art. Zdanevich described it as a purely Russian invention and a real breakthrough more radical than Futurism. This new style essentially promoted an indiscriminating aesthetic pluralism of the artist who was declared to be free to select and use art styles taken from various cultural traditions of past and present without the accusation of plagiarism.

In actual fact, Zdanevich and Larionov toyed with the idea for quite some time. Goncharova's exhibition provided a good opportunity to make their latest

Poster of Ilia Zdanevich's lecture, 'Natalia Goncharova and Everythingness (Vsechestvo)' at the Art Salon. Lithographic print, 1914. Russian State Archive of Literature and Art RGALI, Moscow.

invention public. In his talk, Zdanevich praised Goncharova for the most comprehensive application of this method in her painting, inspired as it was by a wide range of various aesthetically distant influences, including African tribal sculpture, Japanese prints, Eastern religious art and western Modernist trends. The chameleon's endless variability was proclaimed to be the highest ideal of Goncharova, Larionov and their allies – the true advocates of the perpetual renovation, change and rebellion. It goes without saying that the promulgation of Everythingness was well-timed, as it both rebuffed the accusation of Goncharova in eclecticism and asserted the ultimate independence of Larionov's group from any western influence.

In all probability, this ideological conundrum had little to do with Mikhailova's own aesthetic views. That said, the Futurists' face painting and the remarkable success of Goncharova's show further improved the status and popularity of Mikhailova's gallery. In just one year her Art Salon had become the most well-known private gallery space in Moscow. The unprecedented attention of the press and critics to Goncharova's exhibition gave Mikhailova a perfect chance to widen her networking within the Russian art milieu, adding to her list of useful contacts a fair number of new connections among art reporters, critics and columnists, including such 'heavyweights' as Yakov Tugendkhold and Alexandre Benois.

Zdanevich's lecture, controversial and polemical as it was, introduced a new practice in the salon's activities. From that point on, during the high season the gallery started to offer extensive public lecture programmes. Some of them were conceived as complementary events to the co-running exhibitions, while others presented a wide variety of topics on national and international history of art. For instance, in 1913–14 the salon put on a series of lectures, talks and discussions on a broad range of subjects which included talks about Cubism and its developments, old Russian painting, Italian frescoes, Spanish artists, Gauguin, French art of the nineteenth and early twentieth centuries, and several others. Lecture programmes for a season were published in the press and advertised with posters. To attract bigger audience, tickets were sold not only in the salon but also in a number of bookshops in central Moscow. In the pre-war period the ticket price varied from 40 kopeks for the cheapest seats and student concessions to 2 roubles 50 kopeks (by comparison, the price of a cinema ticket ranged from 30 kopeks to 1 rouble). As far as one can tell, Mikhailova did not spare time or effort in organising her educational events to the highest of standards. The lectures took place in the salon's biggest room and were accompanied by slide shows, which at the time were poetically called 'nebulous pictures'. The speakers included renowned academics, artists, art historians, poets and writers. This new initiative turned the Art Salon into a vibrant art centre.

Goncharova's retrospective proved to be such a hit with the public that two months later it was shown in Dobychina's Art Bureau in St Petersburg, albeit at a reduced scale. Unsurprisingly, the event exposed once again the differences between the conservatism of St Petersburg and the liberalism of Moscow in appreciation of modern art. The polyptych *The Evangelists*, which constituted the visual focus of the Moscow display and was praised by some critics for its fresh expressiveness, caused a big scandal in St Petersburg. The four paintings, deemed blasphemous, were temporarily confiscated by the police and removed from public view. It took the intervention by some influential figures to resolve this unexpected crisis in Goncharova's favour.

Goncharova's exhibition was the only known case when the parallel activities of Mikhailova and Dobychina intersected. However, there is no evidence that the two women entrepreneurs met or entered into direct contact on that occasion. The organisation of the St Petersburg exhibition was managed by Larionov and Zdanevich. There was no reason to involve Mikhailova. Besides, she was busy arranging other imminent displays to take place in her gallery.

In November–December 1913, the Art Salon hosted the second exhibition of modern French art. The fact that it was mounted in the immediate aftermath of Goncharova's retrospective with its anti-western rhetoric confirms – however indirectly – that Mikhailova was determined to keep her gallery's agenda well-balanced

and diverse. Conceived as a sequel to the previous year's show bearing the same name, the French exhibition was Mikhailova's own curatorial project. This time she opted for a more conventional type of modern French art, presumably in an attempt to avoid the criticism of her first French exhibition, which had been accused of having been too radical. Unfortunately, she failed to meet high expectations of her demanding audience once again. Quite curiously, this time the show was criticised for being far too dull and passé. Apart from two paintings by Monet and a pair of Sisleys shown in a separate room, most commentators remained unimpressed by the quality of the displayed art, observing that 'the exhibition consists of the works which had been shown at the Parisian Salon in the course of the last few years. They are clearly not the best works which participated in those Salons.' The commonly shared verdict was summarised by the prominent art columnist Rosstsy (pen name of Abram Efros) in the *Russian Gazette* (*Russkie Vedomosti*):

> The exhibition of French art inaugurated yesterday in the Art Salon marked a truly unfortunate stage in the activities of this promising enterprise. It entered as a dissonance (albeit an accidental dissonance) into the interesting series of exhibitions which had been so far organised by the Art Salon.

After this odd lapse, the gallery's good reputation was further busted by a huge success of Valentin Serov's posthumous exhibition, which opened in the salon on 8 February 1914. Serov (1865–1911), a remarkably talented painter, graphic and theatre designer, was rightly regarded as one of the most outstanding Russian masters and a national treasure. His works belonged to the major Russian museums and best private collections, including the Imperial court. The committee in charge of organising the retrospective of his works consisted of an impressive number of influential personalities, including acclaimed artists, among whom

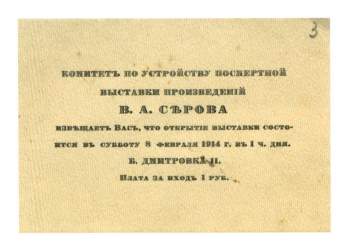

Invitation to the Valentin Serov exhibition: 'The Organizing Committee of V.A. Serov's posthumous exhibition of paintings informs you that the exhibition will open on the 8th of February 1914 at 1 p.m. at B. Dmitrovka, 11. Entrance fee 1 rouble.' 1914. Russian State Archive of Literature and Art RGALI, Moscow.

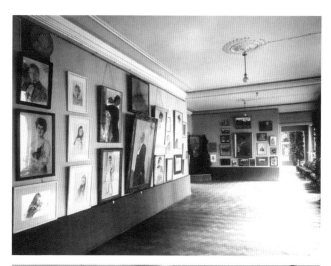
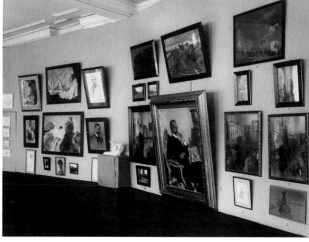
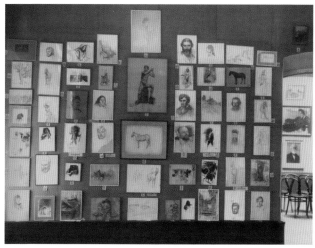

Display of Serov's posthumous exhibition in the Art Salon. Photograph, 1914. Russian State Archive of Literature and Art RGALI, Moscow.

FROM CONVENTION TO HOOLIGANISM

were Alexandre Benois, Sergey Makovsky, Petr Neradovsky, and Igor Grabar. It also comprised the major art patrons and collectors from St Petersburg and Moscow: Ivan Morozov, Mikhail Riabushinsky, Vladimir and Henrietta Girshman, and Maria Yakunchikova.

To appreciate the prestige associated with hosting such an event, it is worth mentioning that Serov's monographic exhibition was firstly shown in January 1914 in St Petersburg in the Imperial Academy of Arts, where it was visited by 27,000 people in the month that it was on show. The decision to choose the Art Salon in Moscow as the venue for Serov's retrospective was the ultimate confirmation of the gallery's high standing. In addition, the salon, with its spacious layout, was the only well-appointed private exhibition space in Moscow able to accommodate the display of 500 works and large crowds. The salon's status as a private gallery also represented an important advantage, since the exhibition was conceived as a commercial venture. In fact, the display included both works already belonging to important collections and the ones for sale to assist financially the late artist's family.

Serov's posthumous exhibition turned out to be yet another impressive milestone in the salon's history. The reviewers praised the immaculate decoration of the gallery's interior, with its freshly painted walls and tasteful flower arrangements, which created a pleasant background and complemented the display visually. On some days the number of visitors reached 2,000. The total attendance for the exhibition amounted to an impressive 30,000, which was almost three times more than attendance at Goncharova's show. The gallery certainly profited from this success not only in prestige but also commercially: the public enthusiasm for the event allowed ticket prices to double from 50 kopeks to 1 rouble.

The extensive plans for collaboration in winter 1913–spring 1914 devised by Larionov and Mikhailova were eventually put on hold. Ultimately, no more Avantgarde displays were mounted in the salon in that last pre-war season. Apparently, the reasons for this change of heart were primarily technical. After the startling popularity of her Moscow exhibition, Natalia Goncharova was commissioned by Sergey Diaghilev, a renowned art entrepreneur and international theatre impresario, to create sets and costumes for the production of the Rimsky-Korsakov opera-ballet *The Golden Cockerel*, to be staged in Paris in spring 1914 by Diaghilev's Ballet Russes company. Goncharova started to work on the assignment in December 1913. As was often the case for the artistic couple, Larionov also got closely involved. At around the same time both artists were also actively engaged in the creation of handmade Futurist books illustrating Velimir Khlebnikov's and Aleksei Kruchenykh's experimental poetry.

The projects were time-consuming, therefore they might have interfered with Larionov's ambitious exhibition plans for the 1913–14 season. Whatever the case,

the intended solo exhibitions of Mikhail Le-Dantiu and Aleksandr Shevchenko, as well as a show of Rayist works, never took place. Instead, Larionov, Goncharova and some other Avant-garde artists, including Georgy Yakulov, Vladimir Tatlin and Natan Altman, were invited to take part in the annual Moscow exhibition of the prestigious World of Art group. Based in St Petersburg, the World of Art built-up a reputation of an aesthetically refined and well-established society. Its annual St Petersburg and Moscow exhibitions were at the top of the list of events in the Russian art calendar. In the winter season of 1913–14, the Art Salon was selected to host the society's Moscow Exhibition, which was a clear indicator of the gallery's upmarket rank. Moreover, the recent success of Goncharova's retrospective and the effective partnership of Mikhailova with Larionov and his associates might have influenced the unorthodox decision of the World of Art to include a few works of radical Avant-garde artists in their display in Moscow. Thus, a small number of paintings by Larionov, Goncharova, Tatlin, Shevchenko, Yakulov and Altman were mounted in Mikhailova's salon as part of the World of Art annual exhibition. The aspiring artists received a brilliant occasion to further raise their stakes in public opinion.

Yet, the high status of the event did not soften their artistic extremism. Larionov exhibited his provocative Neo-Primitivist painting *Boulevard Venus*, which depicted a vulgarly clad prostitute in motion, Goncharova showed two Rayist works and Yakulov put on display a Simultanist picture, *Urbanistic painting. A Construction on Speed of Glass*. Less controversial were Tatlin's theatrical designs for Mikhail Glinka's opera, *The Life for the Tsar*, and Altman's portraits and drawings. The Avant-garde art failed to receive much response from the critics, although commentators took notice of its presence in the exhibition display, which they assessed as a sign of radicalisation of the World of Art aesthetic orientation.

Interestingly, some reviewers traced a direct connection between radical art and the Art Salon as the platform for its promotion. The *Voice of Moscow* (*Golos Moskvy*) newspaper observed that paying a call to the Art Salon was becoming an increasingly fashionable practice among the cultured Moscow public. 'For Moscow *moderne* [sic],' wrote its commentator, 'a visit to the opening evening of this exhibition is not only a sign of "bon ton", but it is also a demonstration of their penchant for the "progressive art".'

As for the well-established members of the World of Art, they remained positively impressed by their collaboration with Mikhailova's Art Salon and were bent on consolidating their newly established partnership. Soon after the exhibition's closing, the Chair of the society's governing committee, Evgeny Lansere, sent a thank you letter to Mikhailova, asking her to book the slot for their group's exhibition in the next season of 1914–15. He also expressed the group's gratitude for Mikhailova's 'sympathy for our society, which was expressed in a discount of four

Mikhail Larionov, *Boulevard Venus*, 1913, oil on canvas, 117 × 87 cm. Centre National d'Art et de Culture Georges Pompidou, Paris.

Vladimir Tatlin, *'Spassky Gate'*. Stage design for M. Glinka's opera *The Life for the Tsar*, 1913, cardboard, glue paint. The State Tretyakov Gallery, Moscow.

hundred roubles in the rent cost for your exhibition space'. As it follows from the letter, the discount was conceded during the final settling of the bill between the salon and the World of Art after the closure of the exhibition. This episode sheds some light upon the way Mikhailova ran her business. It seems to confirm that she was rather flexible in her financial dealings with her partners and, indeed, willing – at least on some occasions – to minimise her own profit in favour of her fellow colleagues in art.

The reputation of Mikhailova's gallery was consolidated by the final event of the 1913–14 season – the posthumous exhibition of the celebrated Symbolist painter, Nikolai Sapunov, who died tragically in a boating accident in 1912, aged only thirty-two. Sapunov's retrospective opened at the salon in April 1912. It was curated by Mikhailova, who might have felt personal admiration for the late painter's art if we are to speculate on her own artistic tastes. Sapunov was close to the World of Art cultural circle and was a founding member of the Russian Symbolist group, the Blue Rose. He was particularly prized for his sumptuously colourful still lifes executed in a free virtuoso manner. Sapunov also enjoyed success as a theatre designer, collaborating with the pioneering director and producer Vsevolod Meyerhold on a number of his experimental Symbolist productions. The artist's involvement with theatrical projects found reflection in Sapunov's genre paintings, which

Nikolai Sapunov, *A Ballet*, 1906, cardboard, tempera, silver and bronze paint, lead pencil, 69 × 102 cm. The State Tretyakov Gallery, Moscow.

Nikolai Sapunov, *Tea Party in a Tavern*, 1911–1912, oil on canvas, 93.5 × 128 cm. The State Tretyakov Gallery, Moscow.

often represented stage scenes infused with Symbolist allusions and a melancholic mood. Talented and inventive, Sapunov gravitated towards ever-more radical painterly modes, arriving by the end of his short life to the Neo-Primitivist compositions based on the subject of folk festivals, street performances and carousels.

In organising his exhibition, Mikhailova aimed to represent the entirety of Sapunov's artistic career from his first painting in the style of Whistler, his flamboyant Impressionist still lifes, Symbolist paintings and theatrical designs to his last Primitivist compositions. Her curatorial skills were highly appreciated by reviewers, including Yakov Tugendkhold, who published an extensive article in *Apollon*. It commenced with compliments to the salon for the exhibition which

> … illustrates perfectly all stages of Sapunov's art. Moreover, due to the spaciousness of the gallery the artist's oeuvre has been displayed in the most fitting manner. Sapunov's paintings – on their own and collectively – infuse you with happiness to a rare feast of art. They are mounted in big intervals, thus giving the viewer the opportunity to have psychological pauses. Unfortunately, this scheme of hanging pictures remains hardly accessible

for the living contemporary artist. However, this is the only rational scheme which is valid aesthetically!

The last pre-war season of the Art Salon turned out to be a busy and successful one. The gallery cemented its place within the Moscow cultural scene, acquiring the reputation of a well-run and vibrant art centre. Its diversified activities now included group and solo exhibitions, Futurist performances and public lectures. Klavdia Mikhailova established working contacts with a wide range of artists and critics of various aesthetic directions. She was determined to maintain this momentum and engage in new, exciting projects, but the wheel of history was about to turn and crush her aspirations.

3.4. Breaking the ice: Natalia Goncharova's exhibition at Dobychina's Art Bureau

In St Petersburg, interest in the new modern art was mainly encouraged by the Union of Youth group of artists and the raucous showcases of their artistic experiments. Between 1910 and 1914 they organised seven exhibitions, in which works by such figureheads of the Russian Avant-garde as Kazimir Malevich, Natalia Goncharova, Mikhail Larionov and Vladimir Tatlin were represented. The leader of the union was Levky Zheverzheev – a famous patron of modern art, whose collection of theatre designs would be exhibited at Dobychina's bureau in December 1915. Apart from the exhibitions, the Union of Youth organised Futurist theatre performances, some of which were sponsored by the artist Aleksandr Gaush, whose one-man show opened at the bureau in September 1916. So although Nadezhda did not participate in the Union of Youth activities, she obviously had a close collaboration with its main patrons.

The last Union of Youth exhibition closed in January 1914 – shortly before the visit of the father of the Futurism, Filippo Tommaso Marinetti, who first arrived with great aplomb to Moscow, and on 26 January disembarked the train in St Petersburg. His visit to the capital was largely organised by Kulbin, who arranged his public lectures, a party at the famous gathering place of the Russian Futurists, the Stray Dog Café, and a dinner with pancakes in his house. A close friend and collaborator of Kulbin, Dobychina took an active part in these important events. She can be seen next to Marinetti in most photographs which were published in St Petersburg newspapers at the time of the visit and can be seen next to the host in the first row on the depiction of the crowded gathering in Kulbin's apartment.

Marinetti's visit caused a split in the ranks of the Russian Avant-garde artists. Mikhail Larionov and Natalia Goncharova, who had announced in 1913 that they

had learned everything necessary from the western European artistic strands and now strove to look to the East for inspiration, decided to distance themselves from the leader of Italian Futurists. Shortly before his visit to St Petersburg on 24 January 1914, they announced in the newspaper *Vechernie Izvestiia*: 'Neither Marinetti nor his Futurism in painting is a mixture of Impressionism and Cubism. Complete junk. The attempts of the Futurists to record movement on the canvas were achieved much earlier and much better in cinema.' When asked by a journalist if she would meet Marinetti, Goncharova replied: 'That individual is of little interest to me.'

Dobychina obviously did not subscribe to such reservations about the visit of a famous Italian artist and ideologue but following the great success of Goncharova's debut at Mikhailova's Art Salon, the *Exhibition of Works by Natalia Goncharova*, opened at the Art Bureau on 15 March 1914.

Natalia Goncharova was a true provocateur for the Moscow avant-garde. She instigated controversial fashion and invited critical media and general public outrage through face painting. Such scandalous behaviour raised her profile, thereby increasing income at paid events. Even before these so-called outrages, Goncharova was already a notorious figure. In 1910, she had been arrested on charges of pornography for publicly exhibiting nude paintings, the first woman artist to have done so in Russia. She was found innocent in the trial. These, and other activities by the Russian Futurists, raised the level of controversy to scandal.

After refusing to participate in the Union of Youth exhibitions (even before they were stopped in early 1914), the artist found more favourable conditions for

Natalia Goncharova, 1912.

presenting her works at Dobychina's bureau. Instead of showing her works together with other artists at one of the Union of Youth exhibitions, Goncharova now had a chance to organise her retrospective on much more flexible terms. Nadezhda was easy-going and open to negotiations on the choice of works and dates of the exhibition. As in Moscow, the exhibition at the Art Bureau was curated by Goncharova's partner, the artist Mikhail Larionov, who collaborated with Dobychina to determine which paintings should be displayed and how they should be presented.

Goncharova's exhibition at the bureau was much smaller than the one at Mikhailova's salon and included 249 out of the 800 works shown in Moscow. It was attended by only 2,000 people and just two watercolours were sold. After St Petersburg, the exhibition was meant to travel on to Kiev, Kharkiv and beyond, but the lack of commercial success at Dobychina's bureau impeded the onward plans.

Nevertheless, the exhibition occupies an important place in the history of the Russian Avant-garde, largely due to a scandal which occurred at this retrospective. Immediately after the opening, the police impound sixteen works on religious themes. It all started well and originally the censor did not object to any paintings at the exhibition; however, everything changed after the publication of the article 'Futurism and Sacrilege', which appeared in the *Petersburgsky Listok* on 16 March and was signed by an anonymous 'W'. The article stated:

> A sparse motley public gathered yesterday, 15 March at the third floor of the house no. 63 on the Moika Embankment at the 'vernissage' (?!) of the exhibition of one of the most rebellious of the Moscow Futurists.
>
> A courteous hostess of the premises of the Arts Bureau, Madam N.E. Dobychina amiably greeted all the invitees, doing everything she could to persuade them that the exhibition is of great artistic (?) interest.
>
> However, the guests, after having the first look at the paintings on the walls, felt rather awkward and rushed to the next room, vacantly thanking the hostess on the way and trying hard to find at least one work on which they could rest their confused eyes.
>
> From everywhere disgusting, oblique, crooked, green and red faces of peasants mowing or collecting apples, with boats and horses, were staring; from everywhere ugly beasts were protruding – helplessly smeared flowers, trees, still lifes and landscapes.

In this negative review of the exhibition, the anonymous critic lamented that the most insulting about it was the inclusion of paintings on religious subjects. He found the distorted face of the Virgin Mary and ugly Evangelists offensive, and concluded that even though this Futurist artist should be free to depict still lives and portraits in any way she chose, she should not have touched, with her 'dirty hands', religious subjects sacred to the Russian people.

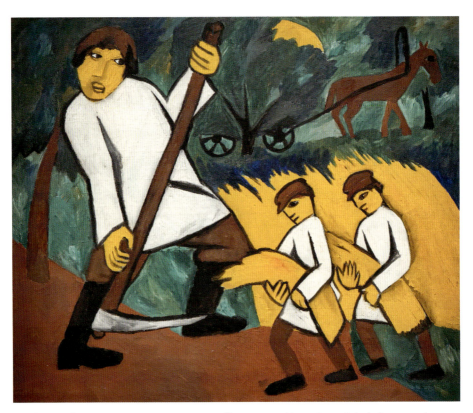

Natalia Goncharova, *Hay Cutting*, 1907–1908, oil on canvas, 98 × 118 cm. Galerie Gmurzynska, Cologne, Germany.

At 9.00 am on the day this article was published, police arrived at the bureau and demanded that Dobychina should immediately remove twenty-two paintings on religious subjects from the exhibition. Numerous articles, which appeared in all the Russian newspapers, described this incident in great detail, pointing out that at first the hostess, in her defence, refused to fulfil the demands of the police, using the previously obtained permission from the censor to include all the works in the exhibition. However, at 6.00 pm the chief inspector, accompanied by the head of the city council, arrived at the bureau and presented Dobychina with the new order to remove the paintings in question immediately. She had no choice but to comply, even though priced at 2,000–3,000 roubles these paintings were the most expensive at the exhibition and all of them had been shown previously at Mikhailova's salon without any objections and with quite positive reviews.

This incident received great publicity, with such important players in the St Petersburg art scene as the Vice-President of the Imperial Academy of Arts, Count Ivan Tolstoy, and the Keeper of the Hermitage collection, Baron Nikolay Wrangel, writing in defence of Goncharova and her exhibition at the bureau. Thus, Tolstoy

declared that removal of religious paintings from the retrospective wrong, since such actions made the authorities look incompetent and helpless. Wrangel decided that the censor based his judgement of his own artistic taste – an approach he found completely unacceptable. One of the founders of the World of Art group of artists, Mstislav Dobuzhinsky, exclaimed in the interview for the newspaper *Peterburgsky Kurier*:

> Natalia Goncharova is one of the most outstanding modern artists. Currently under arrest, her pictures are painted in the style of old Russian icon-painting. They contain only bright artistic talent and certainly nothing profane.

Following these objections, the religious censor himself, Archimandrite Aleksandr, attended the exhibition and announced that he 'permits the paintings to be returned, failing to find anything sacrilegious and even decrying every indication of the appropriate style'. On 23 March – a week after the incident – all the paintings were returned to the exhibition.

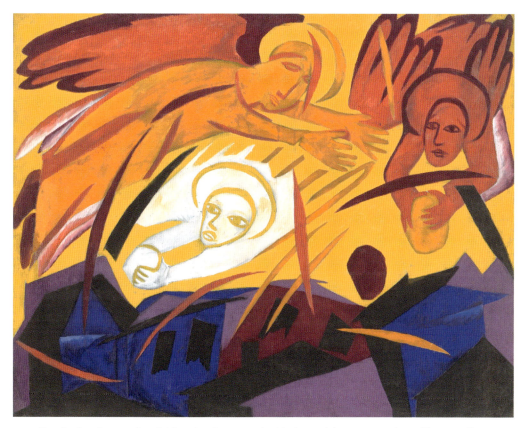

Natalia Goncharova, *Angels Throwing Stones on the City (part of the Harvest polyptych)*, 1911, oil on canvas, 100 × 129 cm. The State Tretyakov Gallery, Moscow.

It was not the first time Goncharova's icon-based works were removed by the censors from the public display. At the 1912 Donkey's Tail exhibition, her cycle of four works, *The Evangelists* (later exhibited at Dobychina's bureau) – portraits of the Four Apostles holding scrolls of their respective Gospel – was removed from the exhibition on religious grounds. The allegation was that her religious works could not be associated with an exhibition with such a title.

The scandal following the removal and subsequent return of the religious works from the exhibition worked well for the publicity of Dobychina's bureau and the art critics were generally more in favour of Goncharova's retrospective in St Petersburg than in Moscow. As Rostislavov wrote in his article published in the newspaper *Rech*:

> Goncharova's exhibition is an extremely important phenomenon. The unquestionable talent of this 'Cubist and Futurist', fractured at various individual exhibitions, is far more convincing than all the manifestoes, lectures and brochures. Her exhibition also shows, for the first time, the path of continuity and returns, confirming the new principles and ideas of painterly beauty.

The critic also commented on Goncharova's religious paintings:

> Before the scandalous incident with the censor, I managed to see what is, perhaps, the most interesting aspect of the whole show – Goncharova's cycle of religious paintings. She approaches the rebirth of the Primitives and ancient folk art with such outstanding judgement of compositional tasks.

During the exhibition, the Nonpartisan Society of the Artists (*Vnepartiinoe Obshchestvo Khudozhnikov*) organised a lecture by the young artist Ilya Zdanevich, 'On Natalia Goncharova', in which he upheld the ideas of so-called 'Everythingism' (*Vsyochestvo*), which were used to describe the diverse range of Goncharova's work and her openness to multiple styles and sources. He proclaimed that the artist had created Everythingism and destroyed Futurism – 'pulverised it and shaken off its dust'. Zdanevich declared Goncharova's oeuvre as the rebirth of art. In his lecture he explained:

> Art should be primitive. There should be no perspective, chiaroscuro, etc. This is the great mistake of the western artists. Their art is erroneous. Art should only contain painting technique and composition. The content is not important. Art should be outside time and space. Hence the term Everythingism.

Most critics found this lecture rather absurd and it did not have the desirable effect on the success of the exhibition. By March 1914, the St Petersburg public was rather saturated by Futurism, thanks to the Avant-garde exhibitions of the Union

Front cover of the catalogue of the *Exhibition of the Three*, April 1914.

of Youths, lectures of Marinetti and confrontational Futurist performances. Disappointed with the outcome of her first retrospective of the 'left artist', Dobychina went back to the safe haven of realistic landscapes and in April 1914 opened the *Exhibition of the Three*, where paintings by the leader of the Nonpartisan Society of the Artists, Yakov Belzen, were shown next to the fellow members of the society, Stepan Pisakhov and Alexei Yasensky.

All three artists were very pleased by the visit of the most prominent master of realism, Ilya Repin, at the exhibition. However, the reaction of the press was lukewarm. Belzen's experiments in systematisation of colour were considered to be an 'interesting attempt', Yasensky was dismissed as a 'sincere dilettante' and Pisakhov was referred to as 'a singer of the gloomy distant North'.

This exhibition was the last one to take place at Dobychina's second gallery on Moika Embankment, 63. In 1914, Nadezhda's mother died. Her distraught father lost his sight and became completely dependent on Dobychina and her two sisters. On the edge of the nervous breakdown, she spent several months travelling, visiting Malmö, Berlin and Paris and hoping to organise international exhibitions at her bureau. Her plans and aspirations were halted by the outbreak of the First World War.

Stepan Pisakhov, *Sailors at the Fishing Pier in Arkhangelsk*, 1912, oil on canvas, 36.5 × 48 cm. Regional Art Museum, Arkhangelsk.

However, Dobychina's despair did not last long. In October 1914 the Art Bureau moved to its new premises and a new chapter in the history of this unique establishment began. Despite the First World War and the two revolutions of 1917, the Art Bureau held the most important and remarkable exhibitions in its new and last premises – Adamini House. Until it was forced to close down in 1919, it held more than thirty exhibitions in which works by around 300 artists were shown.

CHAPTER 4

'Who has time for art now, when human life is in danger?'

On 1 August 1914, Germany declared war on Russia. The vast Russian Empire became the first Triple Entente power to enter the Great War. The country would also be the first to exit, when on 3 March 1918 the recently established Bolshevik government signed a separate peace treaty with the Central Powers confirming the end of Russia's participation in the first global military conflict of the twentieth century. The three-and-a-half years of war was a period of heavy military and civil

Natalia Goncharova, *The Christ-loving Army*. Folio 9 from the series *War: Mystical Images of War*, 1914, lithograph on paper, 32 × 24.5 cm. The State Tretyakov Gallery, Moscow.

loses. Around two million Russian citizens were killed. Substantial territories were occupied by German troops, leading to a large-scale dislocation of the population and a refugee crisis.

The advent of the Great War was drastic and unexpected, and despite the patriotic enthusiasm of the first months, it was perceived by many as a cataclysmic event. 'Life came off the beaten track; all trivial worldly concerns faded away; everything was mixed up, broke loose and was overwhelmed by one aim, one idea – the idea of war.' That was how Ivan Kliun, the Avant-garde artist and Kazimir Malevich's close associate, recalled the beginning of the war in his memoirs.

Wartime economics deeply affected many aspects of social life. The fine arts seemed to be in a particularly vulnerable position. David Burliuk, one of the Futurist ringleaders pondered the grim question: 'Who has time for art now, when human life is in danger?' His pessimism was shared by Yulia Arapova, an aspiring painter and wife of the graphic artist and theatre designer Anatoliy Arapov. In her diary, Yulia looked nostalgically back to the time of peace as a foregone golden age:

> 1914 seemed to predict 'crazy happiness' …. Everything promised us success. A wide path was opening up … promising the artist an unconfined space for free creativity without any prejudice of violence against his individual intentions and personality …. All our hopes for happiness and a free quiet life collapsed one terrible day and perhaps forever. The future hung over us as a kind of mist, which the sun was unable to disperse.

The new realities of wartime recast lifestyles and professional prospects for many artists, affecting their standards of living and especially their income. Some were called to arms. Although this group was relatively small, it included a number of energetic young painters, among whom were Mikhail Larionov and his close allies Mikhail Le Dantiu, Aleksandr Shevchenko and Vasily Kamensky, as well as the leaders of the rival Jack of Diamonds group Petr Konchalovsky and Vasily Rozhdestvensky. The others had to leave St Petersburg or Moscow for various economic and family reasons. As commuting between cities and towns proved at times problematic, many artists experienced difficulties in sending their works for exhibitions or in maintaining important professional contacts. However, probably the hardest blow that the Great War dealt to artistic life in Russia was the severe disruption of international travel and artistic exchange. From August 1914, the movement of people and goods between Russia and western Europe was practically brought to a halt, resulting in serious shortages of high-quality imported art supplies. More importantly still, this sudden and unexpected isolation from Paris, Rome, Berlin and Munich had major repercussions on artists' ability to travel, keep studios and participate in exhibitions abroad. A considerable number of Russian works that were displayed in various international events remained abroad, with no hope of

being returned to their lawful owners before the end of the conflict. Their whereabouts often remain unascertained. The artists who lived outside Russia had to repatriate hastily, leaving behind a significant part of their body of work, which placed an additional strain on their professional potential.

For all that, it would be short-sighted to consider the period of the Great War as a bleak time made up exclusively of oppression and everyday anxieties. For despite the changed circumstances, life in the art world continued to take its course and, in some ways, became even more intense. For instance, the authoritative art magazine, *Apollon*, took issue with David Burliuk's opinion about the uselessness of art in the times of war. In its new regular column, 'Arts and War', the editorial team maintained:

> No matter how much all interests are now being absorbed by the unfolding events, our cultural and artistic endeavours should not be put on hold. In fact, they should not be even diminished. Artists and other culture workers have to ensure its vigour regardless of the 'attitude of the society' and the belief that 'there is no time for art when blood is shed'.

It turned out that artistic life in Russia was not put on hold after all. While the war disrupted many plans and destroyed many hopes, some of its negative effects were double-sided. For instance, the repatriation of many Russian artists – traumatic and disadvantageous on a personal level – exerted a beneficial effect on the evolution of Russian visual arts, as many of those who returned were young professionals in search of novel ways to express their creative power. The high concentration of energetic, talented and ambitious personalities invigorated Russian artistic life and reinforced its Modernist tendencies. This fertile environment bore abundant fruit and led to some major Avant-garde exhibitions in Petrograd[8] and in Moscow. Participation in fundraising events in support of the war effort improved the Avant-garde's chances to reach a wider audience and be reviewed (even if not necessarily positively) by leading art critics.

Wartime circumstances had a mixed effect on Dobychina and Mikhailova's respective art businesses. The outbreak of hostilities forced both women dealers to cancel a few ambitious international projects. They had to re-orientate their artistic policies promptly by reshuffling previous programmes and offering their galleries to charitable exhibitions in tune with the patriotic mood of the moment. As the war dragged on, many places previously used as exhibition halls were transformed into military hospitals or refugee accommodation. Fortunately for Mikhailova, her Art Salon was never requisitioned for war needs. By contrast, the Petrograd city

8 Immediately after the start of the war with Germany, the capital's original name of St Petersburg was officially changed from its Germanic sounding version to the Russified one – Petrograd.

authorities made several attempts to take over the premises housing Dobychina's Art Bureau in order to transform it into a hospital. In the end, her enterprise was spared on the grounds of an acute shortage of exhibition premises in the capital. In a situation in which ever-more public spaces were commandeered by the Ministry of Defence and the availability of exhibition sites decreased, the enterprises of Nadezhda Dobychina and Klavdia Mikhailova gained greater prominence in Russian artistic life, attracting the close attention of artistic circles and a mass audience. All in all, their tactical shrewdness allowed to adjust their businesses to the new harsh realities. Moreover, the Avant-garde exhibitions that took place in their galleries in wartime became major milestones in the history of modern Russian art.

4.1. Mikhailova's shattered plans

After the success of the 1913–14 season, Mikhailova was looking forward to maintaining the momentum. For the forthcoming season she was drawing up a varied programme of events, hoping to enrich it with some exciting international displays. The humiliating fiasco of the second French exhibition in the Art Salon did not discourage her determination to promote the gallery as a cosmopolitan hub for art exchange. She resolved to widen the geography of her international exhibitions, despite the task she faced being a hazardous one.

As far back as in 1913, Mikhailova came into contact with two Germans – a certain Irvin Pini, who remains an obscure figure, and Oskar Freiwirth-Lüßow, a historic painter of some repute with well-established connections within Munich artistic circles. The reason for her correspondence with the two men was to investigate prospects for an eventual exhibition of the contemporary German artists in the Art Salon. Judging by her letters, Mikhailova was well informed about the contemporary artistic landscape in Germany. She drafted an impressive list of potential participants, which contained prominent painters of Modernist orientation belonging to the Munich and Berlin Secession, as well as to Die Scholle and Luitpold groups. Mikhailova and her German counterparts arrived at the point of discussing the practicalities of the event, such as the number of pictures she needed to fill her gallery, insurance, transport and logistics. However, for unknown reasons this ambitious project was not realised in 1913–14. Perhaps, Mikhailova was still harbouring the hope to make it happen in the next season but the war with Germany completely dashed her hopes.

More effective proved to be Mikhailova's dealings with the Parisian artistic milieu, as her French-orientated plans were progressing better. From the beginning of 1914 she had at least three emissaries acting in Paris on her behalf. One was the ubiquitous Mikhail Larionov. In spring 1914, he duly accompanied Goncharova to the French capital, where they both supervised set installations and costume

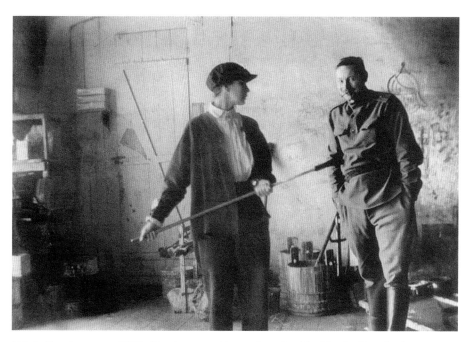

Natalia Goncharova and Mikhail Larionov working on the sets of the Rimsky-Korsakov's opera-ballet *Le Coq d'Or* in the workshops of the Bolshoi Theatre, Moscow. Photograph, 1914. The State Tretyakov Gallery, Moscow.

fitting for Diaghilev's Ballet Russes production of *Le Coq d'Or*. Goncharova's flamboyant creations caused a sensation among the Parisian public. Some of her drawings for this theatrical project were bought by the French government for national collections. Following this tremendous success, Larionov, always an efficient entrepreneur, organised a joint exhibition of his and Goncharova's paintings and graphics at the Galérie Paul Guillaume in June 1914. The event attracted the attention of international patrons and members of the Parisian Avant-garde, including Picasso and Léger. Guillaume Apollinaire, a well-known champion of Cubism, wrote the introduction to the exhibition catalogue, praising Goncharova's ability to combine successfully a love of Russian folk art with 'the modern harshness contributed by Marinetti's metallic Futurism' and 'the refined light of Rayism'. Thus, the concept of non-figurative style pioneered by Larionov and Goncharova spread among the French audience. In Apollinaire's review published in *Paris-Journal*, Goncharova was even proclaimed the 'leader of the Russian Futurist school'.

During the couple's sojourn in Paris, Larionov maintained a regular correspondence with Mikhailova, keeping her posted about their life in the French capital. Among other things, he gave her insights into the local art business practices. Writing about the joint display at the Galérie Paul Guillaume, he reported that 'exhibitions here are free of charge as are the catalogues and all the rest. We did

not even have to provide stretchers for our canvases. They [the gallery] propose to do all the entrepreneurship and for this they only take one painting from each of us.' Judging by this passage, the Art Salon's policy differed from the Parisian custom – namely, Mikhailova apparently charged the artists who organised their events in her gallery for all the aforementioned services. It almost seems that Larionov covertly attempted to make Mikhailova reconsider her business rules by representing his dealings with the Galérie Paul Guillaume as an example to follow. Be that as it may, their letters unveil a dynamic collaboration between the two ambitious and energetic personalities, each pursuing their own goals but still able to find the middle ground for the realisation of their joint plans.

Inspired by the popularity acquired among Parisian artistic circles, Larionov was determined to put his much-widened network of international contacts to good use. He was undoubtedly well informed of Mikhailova's commitment to organising regular displays of modern French art in the Art Salon. Now he was in a position to participate in projects of this kind and was not going to let such a great opportunity pass by. However, the situation was a delicate one, given that until then Goncharova and he had based their rhetoric on the rejection of the 'detrimental' influence of the west (France included) on Russian Modernist art. However, Larionov was a resourceful problem-solver who had never shied away from a challenge. Apparently, at some point before his departure for Paris, Mikhailova assigned him the mission to investigate the feasibility of mounting the display of Picasso's latest works at the salon in the forthcoming season. Although the planned Moscow exhibition of his major foreign rival was hardly to his liking, Larionov diligently reported the preliminary results of his endeavours regarding this task. He confirmed that the event could be organised, but with a one-year delay, i.e. not earlier then in 1915. He wrote: 'Picasso consigns all of his new production to Kahnweiler.[9] The latter cannot or does not want for whatever reason to lend Picasso's works any sooner.' However, Larionov did not see any problem with this unforeseen setback and took a proactive approach. He proposed to Mikhailova to make adjustments to the initial idea by complementing the display of Picasso's paintings with works by Fernand Léger:

> Here in Paris in addition to Picasso (there are not many of his works here, just about to fill your main hall with the skylight) there is also a very interesting and talented Léger. You had already exhibited his *Lady in the Blue*. Léger also must consign all of his works to Kahnweiler. I consider him to be extremely

9 Daniel-Henry Kahnweiler was a Parisian art dealer and gallery owner who was one of the first to champion Cubism and to lend his support to the most radical French art. In 1912–13, he entered into an exclusive agreement with Pablo Picasso, Georges Braque, André Derain, Maurice de Vlaminck and Fernand Léger, according to which these painters had to hand him all their new works for a regular fee. With the start of the First World War, Kahnweiler, who had German citizenship, left Paris for Switzerland. His gallery was confiscated by the French government. He was only able to return to Paris in 1920.

interesting. Now no one makes anything more interesting here. It would be wonderful to show him together with Picasso. I have already told him about you and gave him your address. He does not mind participating in such an exhibition. If he were to be shown in Russia, his work would attract a keen interest and his display would have a great success. After all, Picasso is well known to our public thanks to the Shchukin's gallery. And Picasso here is less impressive than in the Shchukin's collection.

In the same letter Larionov informed Mikhailova that Nadezhda Dobychina also went to Paris with the hope of reaching an agreement with Kahnweiler about a Picasso exhibition in her Art Bureau, 'but to no avail'. This short piece of news invites speculation about the secret competition between the two women entrepreneurs for leadership in the Russian gallery business. In the absence of Dobychina's or Mikhailova's own accounts on the matter, it remains difficult to confirm this conjecture. However, pieces of circumstantial evidence make it clear that Mikhailova was well aware of Dobychina's enterprise and was also interested to know what her rival was up to.

Other than making enquiries into Picasso's show, the enterprising Larionov also came up with another exciting project on his own initiative. In his other letter, he reminded Mikhailova of her wish to mount an exhibition of African sculpture at the salon. The idea was well attuned to the general European tendency towards apprising aesthetic qualities of African art, instead of considering it exclusively in anthropological terms.

Fascination with African sculpture became an essential attribute of the European Avant-garde, with Picasso and Braque setting the trend in their early Cubist creations. By the 1910s, African art already acquired commercial value in the European art market. It appeared in exhibitions, antiquarian shops and art galleries. Products of traditional culture became thereby sought-after collectables strongly associated with radical modernity. This paradoxical link was not lost on the Moscow enlightened public, as Sergey Shchukin's famous collection contained a number of tribal artefacts. In 1912, Shchukin acquired some African sculptures and masks to complement his display of Picasso's works. He made his purchase from Joseph Brummer, a Parisian art dealer renowned for his promotion of indigenous art forms that did not belong to the European aesthetic canon. Brummer, for his part, was allied to the same cultural circle with which Larionov became involved, following his and Goncharova's sojourn in the French capital.

In addition to his impressive connoisseur's skills, Brummer was also a talented entrepreneur always looking for possibilities to expand his trade network. He established solid links with other international art dealers of African and Asian indigenous art. One of his closest contacts was Charles Vignier, a Symbolist poet

turned antiquarian. Larionov was almost certainly referring to Brummer and Vignier when, in his letter to Mikhailova from Paris, he wrote:

> Here I struck up an acquaintance and do some business with the salesman and collector from whom Shchukin had bought [his African sculpture]. There is also another one here who also has many African artefacts. They are thinking of organising an exhibition in Moscow. If your intentions on this matter have not changed and you have no objection to mount such a display in your gallery, I could arrange this business, especially since they are willing to make the event happen all by themselves anyway. In view of this, the transportation and insurance will be at their expense. There will be no need to charge them the interest for the sale.

The rest of the letter reveals Larionov's organisational and curatorial prowess, as he presented Mikhailova with an exhibition proposal that conveniently amalgamated her intentions with his personal goals. He devised a plan of a joint show which would include African tribal sculpture, paintings by the French Avant-garde artist, Francis Picabia, and his own works. Larionov had only recently come to know Picabia and considered him 'a very interesting painter'. Indeed, Larionov must have felt an affinity with Picabia's proto-Dada stance and non-figurative idiosyncratic compositions of dynamic volumes. Recommending the French artist as a perfect candidate for the eventual joint exhibition, Larionov strived to win over Mikhailova:

> If you were to agree to the exhibition, the transportation of his works [i.e. by Picabia] would cost you nothing. This artist and African art would take two or three of your rooms. … If you gave your consent and slotted the event in for October, November or any other winter or early spring month, I would be able to mount my works in the other vacant rooms of the gallery.

The idea to display African sculpture side by side with works by Avant-garde artists was not a breakthrough for the gallery business in 1914, especially for the Moscow public which had access to Shchukin's private collection. However, Larionov seemed to be particularly eager to promote this show, as it was in accord with the position promoted by him, Goncharova and their group who claimed that the roots of true modern art had to be traced back to indigenous primordial cultures outside western European artistic heritage. Such an exhibition, had it been held, would reconfirm visual lineage between non-European tribal art and Larionov's and Picabia's latest painterly experiments.

Mikhailova was quick in answering Larionov's proposals. In her letter of 11 June 1914, she wholeheartedly supported the project of African exhibition in her salon in the forthcoming season. Her major requirement, however, was that the transport and insurance must be paid by the artefacts' owners. Her other concern was

to fit this event into an already busy timetable that she was in the process of finalising. She promised to confirm within the following two months whether there would be a time slot for the proposed show. However, Mikhailova's vision of the display did not exactly coincide with Larionov's masterplan:

> I would be extremely sorry to lose a chance to have such an interesting and original exhibition, especially if it can be truly representative and incorporate all types of African art, i.e. to include fabrics, weapons decorated with ornaments, weaving, wooden artefacts and so on. Please, Mikhail Fedorovich, confirm whether it would be feasible, as well as how many sculptures are available for the display and how many rooms can they fill.

From her message it is clear that Mikhailova did not go along with Larionov's idea of combining the African exhibition with the display of his and Picabia's works. Without entering into an argument, she simply ignored his proposal for a joint show. At the same time, she did not dismiss the event altogether, but suggested a one-year delay: 'Regarding the other exhibition you mentioned in your letter, we can consider it for the 1915–16 season. Especially since by then, to my admiration, Picasso's show will also be possible.' It would seem that Mikhailova was dropping him a subtle hint: she would agree to Larionov's exhibition as soon as he managed to organise the Picasso's event.

Larionov's reaction to such a perspective is unknown. Goncharova and he remained in Paris until the end of July 1914, when they went on holiday to St Trojan on the Île d'Oléron. Only a few days after their arrival, Germany declared war on Russia. The couple had to hurry back home, travelling via Switzerland, Italy, Greece and the Ottoman Empire. In Russia, Larionov was called up and sent to the front, where he was soon severely wounded, and in early 1915 demobilised from the army on grounds of incapacity. None of the French events he was hoping to arrange and curate in the Art Salon were brought to fruition.

In the last pre-war months of 1914, Mikhailova was busy coordinating another ambitious international project that was going to be called the *Exposition Franco-Russe*. Its concept followed the blueprint already developed in Izdebsky's salon and the exhibitions of the Jack of Diamonds group when works by Russian and western European artists were displayed together. Mikhailova's project, however, had one distinguishing characteristic – the Russian section was to be made up exclusively of paintings produced by Russians living and working in Paris. Admittedly, this was a fresh approach aimed to illustrate the close dialogue between the Russian and French artistic milieu. According to the plans, the exhibition was to be opened first in Paris for a short period of time and then transported to Moscow.

To make this happen Mikhailova teamed up with Yakov Tugendkhold, who in addition to be an esteemed art critic was also an expert in modern European art.

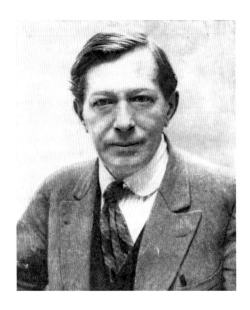
Yakov Tugendkhold. Photograph, 1920s.

Since the success of Goncharova's solo exhibition in autumn 1913, Tugendkhold had forged a close connection with Mikhailova's gallery. He regularly published reviews of the salon's events as well as taking part in its public programme, giving lectures and talks on various art historical subjects. In the spring of 1914, Tugendkhold travelled to Paris with the view of selecting paintings for Sergey Shchukin's collection. Mikhailova took advantage of such a convenient opportunity and asked Tugendkhold to enquire about the eventual participation of French artists in the joint exhibition at her salon. The fact that Mikhailova was able to launch her project through the agency of this influential figure vouches for the considerable prestige her business had gained in just two years of its existence.

Tugendkhold approached the task responsibly and used his extensive network of French connections to the full. He managed to secure the participation of Frantz Jourdain, the acting president of the Salon d'Automne, who agreed to act as the patron of the exhibition and honorary chair of its management committee. From the French side, the committee also counted Paul Boyer, a professor of Oriental languages from the Sorbonne, Rodolphe Kepl, an art critic, and Louis Réan, Director of The French Institute in St Petersburg. From the Russian side, it included a number of expatriate artists living in Paris, among whom were salon portrait painter Princess Marie Eristoff-Kazak, Adolphe Féder, a Post-Impressionist artist and sculptor, Vladimir Perelman, and painter, Iosif Teper.

Tugendkhold assured Mikhailova that he received the preliminary confirmation from a number of prominent French artists, including Bourdelle, Bonnard, Derain, van Dongen, Dufy, Lhote, Laurencin, Metzinger, Matisse, Picasso, Rivera, Vuillard, Vallotton, Vlaminck, Rodin and Redon. At that initial stage, Tugendkhold

Official form of the Russo-French joint exhibition 'Exposition Franco-Russe'. 1914. Russian State Archive of Literature and Art RGALI, Moscow.

Verso of the official form of the Russo-French joint exhibition 'Exposition Franco-Russe'. 1914. Russian State Archive of Literature and Art RGALI, Moscow.

List of participants in the Russo-French joint exhibition 'Exposition Franco-Russe'. 1914. Russian State Archive of Literature and Art RGALI, Moscow.

confirmed about eighty-five French paintings ready to be displayed at the salon. The list of Russian contributors was predictably less impressive, given that the circle of expatriate artists was rather restricted. Yet, it still featured some distinguished names: Elizaveta Kruglikova, a founding member of the World of Art group and a brilliant printmaker; Jean Lébédeff (known in Russia as Ivan Lebedev), an accomplished illustrator and graphic artist, closely involved with the Montparnasse Avant-garde circle; and Wladimir Baranov-Rossiné, a Cubist artist and a resident of La Ruche artists' colony. Tugendkhold also hoped to involve Marc Chagall, but for some unknown reason this did not happen.

At some point in July 1914 Tugendkhold delegated his duties regarding the exhibition management to Iosif Teper, who was already a member of the management committee. From that moment on, Teper became Mikhailova's main point of reference and the chief coordinator of the show. He was the one who secured a close liaison between the participants in Paris and the Art Salon in Moscow. His letters to Mikhailova confirm that the exhibition of this format was envisaged as an annual event. Teper supervised everything in France: invitations to the artists, selection of works, the opening day in Paris and transport logistics. With no surviving written replies from Mikhailova, it is impossible to ascertain the degree of her

participation in these activities. It seems very likely, however, that she played an important role in the final approval of selected artists and their works.

Teper was clearly eager to prove his organisational skills, with the view to becoming a permanent representative of the annual Russo-French exhibition and ultimately ensuring a long-term relationship between Mikhailova's gallery and the Parisian artistic circles. The success of the first such event was vital for him, and he spared no effort in attempting to meet this goal. In addition to sending official letters of invitation to each eventual participant, he also made personal visits to the artists, persuading them to give their best works for the display. Pleased with the results of his endeavours, he proudly informed Mikhailova that 'the activities of the young organisation that succeeded in getting its ambitious plans going, immediately received the attention and appreciation of the wide circles of the Parisian art world so that the most outstanding forces from both opposing camps reciprocated our efforts'.

In one of his letters, Teper confirmed that the potential contributors were selected exclusively on the basis of their artistic talent and prominence, regardless of eventual stylistic inclinations. Therefore, he believed, the display was covering 'everything that has now been done in Paris from Cottet, Aman-Jean and Ménard, to Lhote, van Dongen and Metzinger'. Thus, the *Exposition Franco-Russe* was designed to provide an overall view of the current Parisian artistic landscape, presenting neoclassical, Symbolist, Post-Impressionist and Cubist schools as co-existing, parallel and equal art movements without putting them into evolutionary perspective. Teper expected to secure about 120 paintings by French artists and about one hundred works by their Russian colleagues in total. The latter were to be selected by a special jury composed of members of the management committee, joined by three art critics.

Teper's missives, long and detailed, allow us to reconstruct some aspects of business he hoped to establish with Mikhailova's gallery. For instance, the French partners headed by Teper were supposed to cover in full the costs of the transportation of art works to Moscow and back to Paris, as well as their insurance *en route* and throughout the time of display. For her part, Mikhailova had to provide premises with 'all appropriate equipment' and publish the catalogue which, as Teper specified, 'must look very elegant. For the illustration on the cover, we will give you a prototype featuring a mask by Rodin executed by Bourdelle.' The salon was also to produce advertising posters, as well as organise all the logistics in Moscow, including packaging and transportation of works from the railway station to the gallery and back. To compensate Mikhailova's expenses, the French side offered to go halves with the sums received from the sale of entrance tickets and catalogues. The advertising campaign in the press in Teper's vision 'must be done on a massive scale'. He offered Mikhailova a choice on this point: it could be arranged either by

himself or by Mikhailova, in which case she was entitled to receive 10 per cent of works sold. Teper was going to arrive in Moscow prior to the exhibition opening, promising Mikhailova 'to spare no effort in order to ensure the greatest success'.

On 19 July 1914, Teper proudly notified Mikhailova about the opening of the exhibition for the Parisian public. Unfortunately, his letter does not contain any information on the venue or on the final list of participants. He only mentioned that Bonnard and Vuillard would not be taking part in the exhibition, after all, because the works they offered were 'far too insignificant and out of their style'. Therefore, the committee had turned them down. Whatever the case, the opening day was a success according to Teper's account: 'Russian and French art critics visited the exhibition. Apart from two or three of them who were displeased by the prevalence of the avant-garde works, all the others find our exhibition extremely interesting and marvel on such a fortunate choice of works.' The display remained on show in Paris for a week. On 23 July it was dismounted and Teper went ahead in making provisions for its transportation to Moscow. The arrangements were in full swing when Germany declared war on Russia.

Teper was desperate. Apparently, until 4 September 1914 he was not even capable of answering Mikhailova's letters:

> I have not replied to your kind letter, because all this time Paris was swept by a sort of an epidemic of the most peculiar type: a complete atrophy of will and a heavy depressing passivity. People were just wandering aimlessly in the streets unable to engage with anything. I could not live in this suffocating atmosphere of the enforced idleness.

For health reasons Teper was recognised unfit for military service in the French army and at the end of August he was repatriated to Russia, settling in Odessa. From his new address he informed Mikhailova that after a week-long display in Paris, the Russo-French exhibition was ready to travel to Russia. However, 'the thunderstorm broke and we were left high and dry'.

Given that at the beginning of the hostilities no one in Europe expected the war to last long, at first the works were provisionally left in storage and the participants did not claim them back. Teper also believed that the conflict would soon be over, enabling him to organise the transportation to Russia. He put in so much effort and held such high expectations for this project that he still hoped against all odds that the exhibition might after all take place in the nearest future. In his last letter sent to Mikhailova from Odessa he tried to persuade her not to take it off her programme just yet: '… it would be a real pity, after all those endeavours and money spent on its organisation, to give the works back and abandon this event, especially since after this first failure it will be impossible to assemble the same display again'. He begged Mikhailova to share her thoughts on the matter in view

of the fact that she 'must be in close touch with the current situation and public opinion'. Mikhailova's answer to Teper's desperate plea remains unknown. It is, however, certain that after a while the works were indeed returned to the artists and the Russo-French exhibition remained sadly only partially realised, as the war raged for the next four tragic years.

4.2. The Art Salon in wartime

The changed circumstances of the wartime led Mikhailova to adopt new tactics. Following the cancellation of the ambitious Russo-French project which was supposed to inaugurate the opening of the 1914–15 season at the salon, she had to promptly put together a new display, starting from scratch. The patriotic mood of the moment required a special sort of an event in tune with ongoing public mobilisation. Challenging times also drastically increased the popularity of charitable and fundraising exhibitions, which now focused on providing for injured soldiers and refugees. This format became a common feature of the artistic life during the Great War and the Art Salon was quick to respond to the new trend.

During October–December 1914, Mikhailova's Art Salon opened a charity exhibition featuring Vasily Polenov's cycle of sixty-eight canvases entitled *From the Life of Christ* (*Iz zhizni Khrista*). Mikhailova coordinated all the arrangements and

Cover of the catalogue of the charity exhibition of Vasily Polenov's cycle *From the Life of Christ* in the Art Salon. 1914. State History, Art and Natural Museum Reserve Polenovo, Tula.

First page of the catalogue of the charity exhibition of Vasily Polenov's cycle *From the Life of Christ* in the Art Salon. 1914. State History, Art and Natural Museum Reserve Polenovo, Tula.

offered her gallery space free of charge. Her correspondence with Polenov reveals that the idea to showcase the cycle also belonged to her. Polenov answered her proposal as early as September, which means that Mikhailova started planning the show shortly after the outbreak of the war, even though the outcome of the Russo-French project must have still been uncertain at that point. Apparently, she did not share the widespread optimism that the war would come to an end in just a few months. Thus, instead of indulging in false hopes, she promptly reacted to harsh reality with her characteristic dynamism and perceptiveness.

Polenov gladly accepted Mikhailova's invitation, confirming that it would be very gratifying for him 'if at this moment of brotherly unity and striving for the eradication of war, my Christ would come to our aid with his words of love and mercy'. Polenov's emphasis on 'the eradication of war' and 'words of love and mercy' illuminates one important fact – that Mikhailova's first charitable exhibition was an event infused with the spirit of Christian compassion and condemnation of any form of violence. That being so, the display mounted at the Art Salon contrasted sharply with the omnipresent visual propaganda of the first months of the conflict that aggressively promoted belligerent patriotism and hatred for the enemy. In addition, the scrupulous historicism of Polenov's paintings had little in common with the mystical transcendental idealisation of canonical iconography, offering instead a rather unorthodox take on the Gospels' imagery. All considered, *From the Life of Christ* exhibition provided a clear alternative to the officially promoted set of values.

Polenov worked on his massive cycle for almost all of his long artistic career, adding more to it over the years. Producing the first paintings in 1860s, in 1894 he even decided to give up his teaching position at the Moscow School of Painting, Sculpture and Architecture to devote more time and energy to this work, which he perceived as a mission. A talented Realist and one of the most prominent members of the *Peredvizhniki*, Polenov strove to reconstruct the earthly life of Christ, placing a special emphasis on the universal significance of Jesus's message of tolerance, compassion and love. In his interpretation of the main character, the artist avoided any reference to the mystery of the incarnation of God the Son representing Jesus Christ as a historical personality of exceptional spiritual purity and strength.

Some of the paintings from the series were already known to the Russian audience, as Polenov had exhibited selected canvases in the *Peredvizhniki*'s exhibitions over previous years. Black-and-white reproductions of the cycle's finished works were published in 1909 in a separate edition, receiving the wholehearted approval of the celebrated writer Leo Tolstoy and criticism of many others who found Polenov's unorthodox approach to the canonical imagery problematic. No wonder that the proposed display of the cycle at Mikhailova's gallery met with resistance from ecclesiastical authorities who argued that 'at present time the exhibition of this kind is out of place'. The controversy lasted until the very opening of the event – so much so that the final hanging of the works took place only on the eve of the exhibition's inauguration. Despite all these difficulties and tribulations, the show turned out to be such a huge success with the public that it was extended until the end of December, having initially been scheduled to last a month.

From the Life of Christ exhibition at the Art Salon differed from most other charitable events of the time, since works on display were not up for sale. Having spent so much time and effort on their creation, Polenov was not prepared to disperse his cherished series among different buyers. Instead, the show's format was more akin to a museum display. Mikhailova and Polenov consciously distanced themselves from the commercial aspect, advocating the idea of art as a major vehicle of society's moral and aesthetic improvement. All the proceeds collected from tickets and exhibition catalogue sales were donated to wartime charities of Polenov and Mikhailova's choice. They agreed to have an equal share of the raised sum, although her expenses in organising and running the event, as well as printing the catalogues, must have been considerably higher than his.

Mikhailova also assured the affordability of her show, and her generosity was duly appreciated by the press. For instance, the short article announcing the opening of the exhibition, published in the newspaper *Early Morning* (*Rannee utro*) specifically highlighted the fact that she did not charge fees for the use of her gallery, while the minimum recommended entrance price of 10 kopeks was low enough 'to allow access to a wide number of general public'. In addition, the salon

also allocated a special daily quota which granted free admission to the exhibition for wounded soldiers treated in Moscow hospitals and for students from secondary schools.

Soon after the exhibition Mikhailova received many letters expressing gratitude for organising the event. In addition to members of public, senders also included a number of institutions that greatly benefited from her charity. In particular, The Russian Towns' Union for the Assistance of Ill and Wounded Soldiers (*Vserossiisky gorodskoi soiuz v pomoshch' ranenym i bol'nym voinam*) expressed its deep gratitude for Mikhailova's substantial contribution, 'which allowed the Union to provide assistance to many sick and wounded soldiers'. In addition to the union, she also sent money to a military hospital organised by the Moscow Society of People's Universities (*Moskovskoe Obshchestvo Narodnykh Universitetov*) and, significantly, to the Wartime Donation Committee of Belebey. The latter donation was an affectionate homage to a small town in Ufa province, the birthplace of Klavdia's husband, Ivan.

As the war went on, Mikhailova continued taking part in charity initiatives, although the real extent of her involvement remains unknown. There is surviving evidence of only some instances of her wartime non-profit undertakings. These mainly include offers of the salon's space free of charge for various fundraising events. In the 1914–15 season, for example, the gallery hosted the group exhibition of the Union of Russian Artists (*Soiuz Russkikh Khudozhnikov*), which donated all its proceeds to the same Russian Towns' Union for the Assistance of Ill and Wounded Soldiers – a major beneficiary of Polenov's show. In the following season, 1915–16, Mikhailova conceded her salon for a three-day fête, called the Allegri Bazaar, for financial support of soldiers fighting at the front. Her wartime charitable activities did not stop there, as in the same 1915–16 season she sent her painting, *Lilac*, to the charity exhibition of the Free Creativity (*Svobodnoe Tvorchestvo*) art society, which collected money in favour of the Committee of Her Imperial Highness, Grand Duchess Tatyana Nikolayevna, to assist victims of military action. Also substantial was Mikhailova's donation to the Society for the Provision of Welfare to the Children of Fighting Soldiers, to which she sent her profits from running the Jack of Diamonds exhibition in November–December 1916. To boost popularity of that show, the gallery hosted a number of concerts featuring performances of prominent poets and theatre actors.

All these useful contributions to the cause of public mobilisation could not, however, completely substitute market-orientated activities for the salon. It seems that during wartime Mikhailova started to reduce her direct involvement in curatorship, turning instead for assistance in mounting the exhibitions and opting ever more to subletting her gallery for art events organised by others. In fact, by this time she had already built up a substantial list of reliable contacts who were

eager to rent the salon for their projects, so the venue was booked solid, leaving Mikhailova more time to devote to her art and to deal with her dysfunctional family. Her close connection with the avant-garde, however, did not cease, and for the whole war period the Art Salon continued to represent a major platform for radical Russian art.

Without doubt, the most remarkable exhibition of this kind was a show with a rather straightforward name, the *Exhibition of Painting of the 1915*, which took place in the first wartime season from 23 March to 26 April 1915. Mikhail Larionov, the key organiser of Avant-garde events in Mikhailova's gallery, was still convalescing from the wounds received at the front. Given his relative disability, the display was supervised by Konstantin Kandaurov, a theatre designer and lighting technician at the renowned Maliy Theatre in Moscow, as well as an avid art collector. From the 1910s, Kandaurov also acquired a reputation of a competent art events' organiser. His curatorial activities intensified after the outbreak of the war, given a massive upsurge in the number of charitable exhibitions. In fact, Mikhailova also enlisted Kandaurov to help her in arranging Polenov's display for *From the Life of Christ* show. Apparently, that first experience of working together was quite agreeable, as it marked the start of their solid collaboration for the next four years until the nationalisation of Mikhailova's gallery in 1918.

Kandaurov did not possess Larionov's vivid imagination and cutting-edge inventiveness, but he definitely had enough character and managerial skills to arrange an exhibition that could bring together works of different, sometimes competing, avant-garde groups from Moscow and Petrograd. From Kandaurov's correspondence with his friends, it appears that he forged the plan of *Painting of the 1915* project as early as in October 1914 while he was closely involved with mounting Polenov's exhibition in Mikhailova's gallery. Perhaps his first episode of collaboration with Mikhailova helped him to fully appreciate the great potential of the salon's space.

Despite his apparent respectability and moderate orientation, Kandaurov valued the experimental thrust of the Russian Avant-garde. Hence, he envisaged his project as an up-to-date overview of the newest tendencies, movements and directions of the radical art. He was fully conscious of the potentially explosive nature of this show, yet this did not daunt him in the least; quite the opposite, it was high on his agenda. In one of his letters written when preparing for the event, he disclosed revealed his ultimate ambition:

> It will be a powerful exhibition; and if everything goes as I want, it will blow the artistic societies to pieces. There will be no middle ground in this show's perception: it will be either scolded or praised. Women artists will be the best.

The last sentence also reveals Kandaurov's good grasp of the latest trends emerging in Russian society and the arts. In fact, his special focus on the art of women was in tune with the new visibility and importance women were steadily acquiring at the time of the first total war of the twentieth century, which commanded broad public mobilisation of citizens of both sexes. This significant social shift had tangible consequences for female artists whose standing within the visual arts grew significantly. The percentage of women participating in the important exhibition was on a rise; and in the case of avant-garde events, it sometimes was equal in number to men. Inspired by the egalitarian spirit of the moment, Kandaurov invited a substantial number of young female painters to take part in his exhibition. Although his hopes for a special role for women artists did not quite materialise, some female works were indeed signalled out in the press and appreciated by art critics. On that account, the *Exhibition of Painting of the 1915*, without doubt, was an important step towards the further enhancement of women within the art profession.

Kandaurov certainly deserves full credit for an impressive set of contributors which included a host of important names destined for glory in the history of the early Russian Avant-garde. Among them were David and Vladimir Burliuk, Natalia Goncharova, Vasily Kandinsky Marc Chagall, Kazimir Malevich, Vladimir Tatlin, Robert Falk, Natan Altman, Petr Konchalovsky, Aristarkh Lentulov, Ilya Mashkov, Martiros Sarian, Vladimir Mayakovsky and many others. Given that many of these highly ambitious and competitive personalities were not on friendly terms with each other, the task Kandaurov faced was a tough one. The irreverent attitude of some of them often annoyed the good-natured man, yet he somehow succeeded in making this explosive group of people coexist under the same roof at the Art Salon. Mikhailova – who was not directly involved in the arrangement of this event, but supervised its developments – also deserves recognition for the great loyalty she always displayed to these rebels, considered by many as upstart imposters at best or mentally deranged at worst. However, this time even her remarkable patience would be put to a real test.

Ultimately, Kandaurov's hope that his show would shatter the art establishment to pieces came true, albeit not in a way he envisaged. His biggest mistake was that he underestimated the tremendous charisma and unlimited inventiveness of just one person: Mikhail Larionov. Badly wounded in the first months of the war, Larionov spent a considerable time recovering in one of Moscow's military hospitals, but by March 1915, when preparations for the exhibition was in full swing, he felt strong enough to face a new challenge. Andrei Shemshurin, a rich merchant turned literary critic and a sturdy supporter of the early Avant-garde was an eyewitness to an unexpected turn of events which mixed everything up. Fate delt zealous Kandaurov a cruel hand as he suddenly fell ill a few days before the exhibition's opening and the initiative was hijacked by resourceful Larionov.

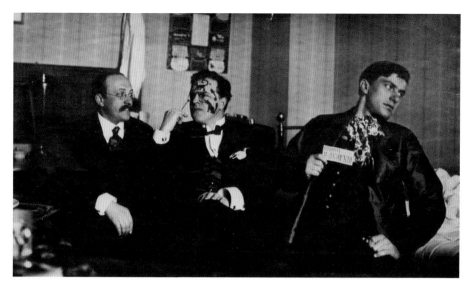

Russian Futurists. From left to right: Andrei Shemshurin, David Burliuk and Vladimir Mayakovsky. Photograph, 1913. The State Mayakovsky Museum, Moscow.

In the absence of Kandaurov, recalls Shemshurin, the most ambitious and enterprising participants took matters into their own hands, racking their brains as to how they could organise the display to attract the demanding public.

> Someone said: 'Well, what about the show? What about the paintings? The assembled works are, unquestionably, great. But who can truly appreciate the art? You and I? And what about the public, do they understand anything? All they need is clamour! Gossip! For how can we do the exhibition without public? What kind of trick should we invent?'

The gathering was taking place in one of the salon's rooms, for the party of artists had free access to the gallery space in advance of the exhibition's opening. Knowing Larionov's legendary ingeniousness, recollected Shemshurin, all eyes were on him, but he kept silent, immersed in studying the running electrical fan on a wall in front of him. Finally, he asked the others if he could use that particular wall for hanging one of his works. The request was unanimously granted, given that the space in question – limited and poorly lit – was ill-suited for displaying canvases. Thus, over the next few days Larionov was busy arranging something on the wall, his manipulations causing ever greater concern among his fellows. As stated by Shemshurin:

> Someone began to guess what was going on. People began to whisper. … Larionov's comrades considered themselves left out. His invention was really ingenious; and it was deemed to cause a huge noise in society. … Larionov

nailed his wife's [i.e. Goncharova's] cut-off braid, a hatbox, newspaper clippings, a geographic map, etc. to the wall. When everything was ready, Larionov would take one of his colleagues by the arm, show him the wall and set the fan in motion. That discouraged everyone. All were desperate. All understood that Larionov's wall would attract the crowd, and no one would look at paintings in other rooms.

However, the general confusion did not last long. Larionov's invention inspired a real avalanche of creativity. On the exhibition's opening day, several other installations appeared on the salon walls. Poet Vladimir Mayakovsky, who in addition to his exceptional literary talent was also a professionally trained artist, nailed half of his top hat, a waistcoat, a book of poetry and some playing cards to the wall, calling this impromptu composition *My Own Portrait*. Aristarkh Lentulov, one of the Jack of Diamonds group's main pillars, hung a shirt, a bucket hat, a sponge and a bar of soap, giving his assemblage the title *Chaliapin is Going to a Bathhouse*.[10] Kazimir Malevich and Aleksey Morgunov exhibited their freshly fabricated coats of arms, embellished with a wooden spoon and a tantalising inscription: 'We are *Februarists*. We set free from reason in February.' However, the most extravagant take on Larionov's conceptual challenge belonged to Vasily Kamensky, a Futurist poet and one of the first Russian aviators, who came up with the idea of attaching a small cage with a live mouse to the wall. This last stunt overtaxed Mikhailova's remarkable tolerance. She declared that if the mouse was not immediately removed, she would cancel the event. The frustrated author had no choice but to obey. However, he had his full revenge on the opening day when he appeared among the elegant crowd representing 'a kind of a synthetic object', as Valentina Khodasevich, one of young women participants in the show, called him in her recollections of the event. According to her account:

> He was singing ditties and telling jokes to the accompaniment of strokes of a ladle against a frying pan. He had two cages with live mice hanging over his shoulder – one in front and another one behind. Vasya, as he was known, golden-haired, fair skinned, with his delicate pink face and blue eyes could have easily appear agreeable if not for those mice. The public shied away from him with horror while he was triumphantly walking through the gallery halls.

In an act of mocking the *Peredvizhniki*, Kamensky styled his performance as 'my personal travelling exhibition'.

The inaugural evening for the exhibition put management skills of both Mikhailova and Kandaurov to a tough test, as they were forced to manoeuvre

10 Feodor Chaliapin (1869–1942) was an internationally renowned Russian opera singer with a deep and expressive bass voice.

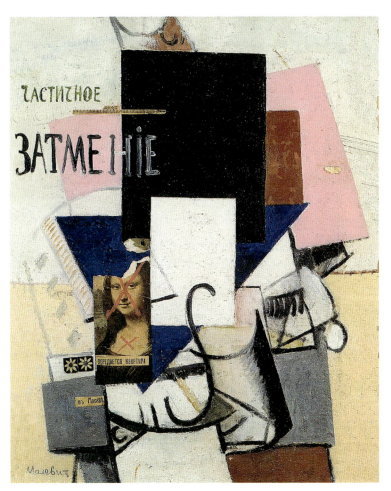

Kazimir Malevich, *Composition with Mona Lisa* also known as *Partial Eclipse*, 1914, oil, paper and lead pencil on canvas, 62.5 × 49.3 cm. The State Russian Museum, St Petersburg.

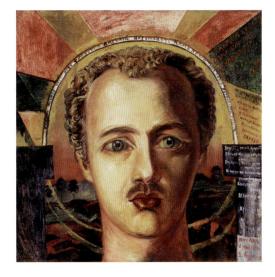

David Burliuk, *Portrait of the Poet Vasily Kamensky*, 1917, oil on canvas, 104 × 104 cm. The State Russian Museum, St Petersburg.

between the enterprising artists and the shocked visitors, among whom were a great number of influential Moscow *beau monde* and art patrons. Little did this select public know about major surprises that awaited them inside the Art Salon. Khodasevich vividly described the moment the salon's doors opened to welcome the first guests:

> And so it began … Well-known patronesses of art: Nosova, Loseva, Girshman, Vysotskaya and others, ascended to the gallery moving up the stairs solemnly and slowly with long trains of their opulent dresses well in view (everyone knew that for the opening days ladies commissioned especially luxurious outfits trying to outdo each other). Men followed the ladies like a herd. Greetings, conversations …

As the imagination of some participants ran wild in the last days preceding the event, Vladimir Tatlin came up with an ingenious device meant to draw the crowd's attention to his own creation called *Madonna*. Right in this period Tatlin was immersed in experiments with three-dimensional constrictions from metal, wood and cardboard, which he called *Painting Reliefs*. His endeavours would soon result in the invention of a new style called Constructivism. Although the official birth of this non-figurative Avant-garde trend would be inaugurated by the seminal *0,10* Futurist exhibition at Dobychina's Art Bureau at the end of the same year, 1915, Tatlin included some preliminary trials in Kandaurov's show at the Art Salon. *Madonna*, which was made of triangular three-dimensional shapes, was one such pilot study displayed in the exhibition's first room. In order to make the visitors take a special note of his pioneering piece, Tatlin nailed an iron square from a sundial to the floor in an upright position. Around he drew a white line about 3 cm thick, which ran diagonally from the iron square to the place where his *Madonna* hung. As he was making these final preparations, just a few hours before the exhibition's opening, Kandaurov, busy with the last preparations, did not realise the potential trouble and left the artist to finish his ploy. Khodasevich remembered: 'Tatlin was pleased. He said: "Great! Now they could absolutely not get away from my *Madonna*. Willy-nilly they will be forced to look. The white line will guide them.'

A scandal broke out immediately after the exhibition opening. The first to enter the room was Evfimia Nosova, a renowned art patroness and collector whose sumptuous mansion in the centre of Moscow was one of the focal points of the old capital's cultural life. Wearing a floor-length show-stopping gown designed by the famous dressmaker Nadezhda Lamanova,

> Nosova stopped, looked around and asked: 'And what is over there on the wall sticking out so weirdly?' She took a few steps and suddenly stopped, her face flashing with anger: she could not move for her train was caught on

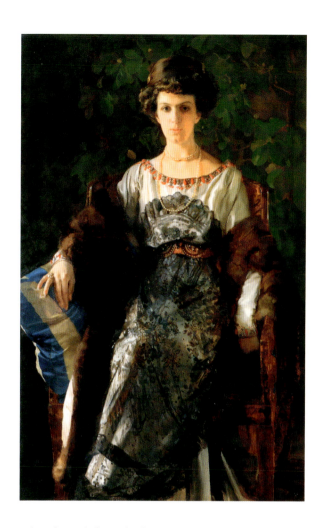

Konstantin Somov, *Portrait of Evfimia Nosova*, 1911, oil on canvas, 138.5 × 88 cm. The State Tretyakov Gallery, Moscow.

the sundial. 'Who is a supervisor here?' she asked menacingly. Kandaurov appeared from somewhere and froze in front of her – after all, he was a 'bridge' between the patrons and the artists. Nosova was considering leaving the event immediately. Kandaurov persuaded her to stay and she sauntered into the next, much safer, room. A service woman with a scraper, a screwdriver and a wet rag removed the sundial from the floor. The white line was scrubbed away and washed off as well. Kandaurov helped the disgruntled Tatlin rehang his *Madonna* in a new place.

While Kandaurov was preoccupied with resolving the Nosova–Tatlin incident, Mikhailova was trying to talk some sense into Morgunov and Malevich regarding their installation's inscription, 'We are *Februarists*. We set free from reason in February.' One of the art reviewers, pouring scorn to all Avant-garde artists by calling them collectively 'Burliuks', described in his report the following scene:

The lady owner of the exhibition space pointed to Morgunov's declaration in front of the Burliuks' crowd saying calmly, authoritatively and loudly that this was an indecency that could not be tolerated. The Burliuks turned out to be not such an intractable people after all and surrendered immediately. 'Maybe it is possible,' ventured David Burliuk, 'to write instead "We trampled reason"?'

No wonder the general reaction to the *Painting of the 1915* exhibition was predominantly negative. The pioneering inventions of radical artists who for the first time in the history of Russian art broke completely free from classical canons of painting were too radical and extreme to be fully appreciated by the contemporary audience. Professional critics, however, perceived this important shift very well. Thus, the reviews distinguished between the two parts of the display: the one that included works made on canvas or paper, and the other one that contained the Larionov and co installations, Tatlin's *Painting Relif* constructions and Kamensky's art performance.

Needless to say, the first painting-orientated group was met with far greater tolerance and understanding than the second one. Indeed, the exhibition put on display an impressive array of first-rate works on canvas. Art commentators praised the artistic mastery of Ilya Mashkov, Petr Konchalovsky, Natalia Goncharova, Natan Altman, Robert Falk and Marc Chagall. Non-figurative 'musical' compositions by Wassily Kandinsky were also signalled out as controversial but still treated as an engaging artistic development. Paintings by the young female artists Valentina Khodasevich, Yulia Obolenskaia, Magda Nakhman and Nadezhda Lermontova were also commended by the press, helping to establish their professional standing within the competitive artistic milieu. However, the lion's share of comments fell on the discussion of 'tomfool caper' put on show by the radical wing of the exhibition's participants. Thus, the rebellious non-conformists ultimately succeeded in making the public and professionals take notice of their latest experiments, for despite all the harsh criticism of their creations as helplessly passé, the leaders of Russian Avant-garde proved once more their enormous creative potential. Their spontaneous spur-of-the-moment inventions made public in Mikhailova's Art Salon for the first time inaugurated the birth of art installation and art performance as integral part of modern visual culture. That being so, Kandaurov's desire to blow the artistic establishment to pieces came to fruition, even if neither he nor Mikhailova were able to realise at the time the true historic consequences of the troublesome event they organised and managed at the Art Salon.

Close collaboration between Mikhailova and Kandaurov continued for two more years, as the latter soon became an official representative of the influential World of Art group in Moscow, which traditionally held its annual exhibition at the Art Salon. In June 1915, just a few months after the clamorous *Painting of the 1915*

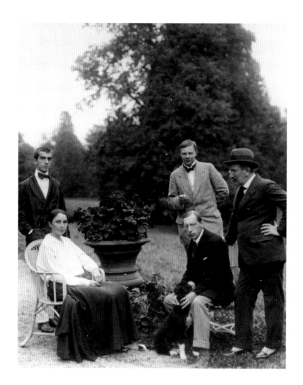

Igor Stravinsky and Diaghilev's Ballet Russes Team in Lausanne. From left to right: Léonide Massine, Natalia Goncharova, Mikhail Larionov, Igor Stravinsky and Léon Bakst. Photograph, 1915.

event in Mikhailova's gallery, Sergey Diaghilev invited Natalia Goncharova and Mikhail Larionov to join his Ballets Russes company in Switzerland. As it turned out, the couple had left their homeland forever, the war and subsequent revolutions preventing them from ever returning. The Art Salon lost its most unconventional and enterprising curator.

It seems that at some point after 1916 the Art Salon began to experience financial difficulties. A number of important shows, including solo shows by Ilia Repin and Nikolai Roerich, had to be cancelled. By 1917 the quality of paper and design for the advertising posters declined considerably, owning probably to war-inflicted shortages and a lack of funds. At about the same time Mikhailova's health started deteriorating. She was diagnosed with progressing bone tuberculosis and had to use a walking stick to move around. The best days of her gallery business were over, but she was not aware of it just yet.

4.3. Dobychina's Art Bureau and exhibitions in Petrograd during the First World War

Even before Germany declared war on Russia, St Petersburg had been transformed in just a few days. On 20 July 1914, the leading Russian art critic, Nikolay Punin, wrote to his future wife:

Since the mobilisation was announced, St Petersburg stopped being what it always was. Just a few coachmen about and almost no trams. Pavements are not swept since there is nobody to do it, everywhere are workers – walking around, waving their hands and reading papers; there aren't many representatives of the 'intelligentsia' around or perhaps they are just too conspicuous among the common people. Every once in a while soldiers from the reserves are going to war with their small bundles and their wives; when they go through the crowds, they are welcomed with the screams: 'Win!'; everyone is waving their hats and scarves at them; lots of windows are open, since most people came back from their dachas as there are no short-haul trains any more …

Despite the war and mobilisation, in October 1914 Dobychina's Art Bureau moved to the beautiful new premises on the Field of Mars, one of the most prestigious locations in St Petersburg, within a stone's throw of the Winter Palace, the Hermitage Museum and the Museum of Emperor Aleksandr III (now the State Russian Museum). It occupied six rooms in the ten-room corner apartment of Petr and Nadezhda Dobychin, on the first floor of the famous building, Adamini House, which had a prominent place in the cultural history of the capital. Built by the

Adamini House where in the first-floor corner apartment Dobychina's Art Bureau opened in October 1914, St Petersburg.

Italian architect, Domenico Adamini, in the mid-1820s, it was originally commissioned by the merchant Antonov, who intended to use the ground floor for trading while the large arched windows were designed as an open gallery. From 1916–19, Adamini House was home to the Comedians' Halt (*Priut Komedianta*), a cabaret founded by the actor and theatrical director, Boris Pronin, as the successor to his famous Stray Dog Café, organised with the help of Kulbin. Like the former venue, the Comedians' Halt became a centre for Petrograd's avant-garde, with Vsevolod Meyerkhold staging performances here, and such famous literary figures as the poets Aleksandr Blok, Nikolay Gumiliev and Anna Akhmatova, Vladimir Mayakovsky and the first Soviet People's Commissar of Enlightenment, Anatoly Lunacharsky, frequenting this vibrant place.

The Art Bureau had wonderful natural light pouring in from large windows overlooking the Field of Mars, the courtyard and the Moika Embankment. Dobychina's acting tutor, friend and collaborator of Kulbin, the famous theatre director Nikolay Evreinov, who also lived at Adamini House, described its cultural atmosphere:

Nikolay Kulbin, *Portrait of Nikolay Evreinov*, first published in Evreinov, Nikolay, *Teatr kak takovoi* [Theater as such], St Petersburg: Sovremennoye Iskusstvo (Butkovskaya), 1912.

… Here was the Art Bureau of the student of my 'Drama studio', N.E. Dobychina; also here was the Comedians' Halt – the child of the Stray Dog Café, where I served as all-mighty dictator for half a year. … In this house lived my friends A.L. Volynsky and Leonid Andreev and a Futurist Vasily Kamensky – my admirer, who wrote the whole book about me. … Here lived S. Yu. Sudeikin, who once painted my portrait … and O. A. Glebova-Sudeikina – a charming performer of one of my short polka dances – a great joy! And finally in this house for many years has lived my mother! – Field of Mard, 7 – the historic house, truly historic!

With somewhat less enthusiasm Evreinov also mentioned that Dobychina's Art Bureau was the venue for the early rehearsals of his rival Vsevolod Meyerkhold's performances, which were staged at the Comedians' Halt.

The famous Soviet artist, Arkady Rykov, described this famous cultural centre in his memoires: 'According to the plans of its shareholders, the Dom Adamini was supposed to become the centre of artistic life of the city: downstairs: The Comedians' Halt:, upstairs Dobychina's exhibition salon, and in addition assorted plans which even included an art school.'

The First World War diminished public interest in art, but it also inspired a great patriotic boost, which soon found a vivid expression in the charitable exhibitions

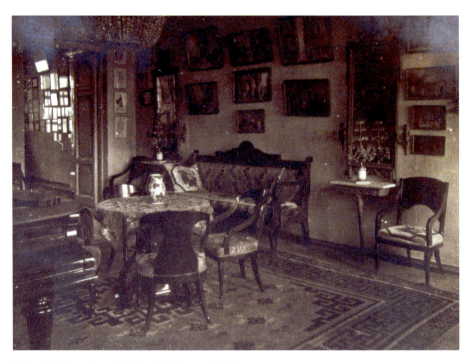

Dobychina's apartment in Adamini House, c.1914.

that united mainstream and Avant-garde artists. The artists on the left, united under the banner of Futurism, who used to be in opposition to the Realist artists on the right, now joined forces with the establishment in order to raise money for the war needs.

The first charitable exhibition in Petrograd was opened in the new premises of the Dobychina Art Bureau, on 26 October 1914. All proceeds raised from the sale of the paintings in this exhibition were donated to the Infirmary for the Art Workers, organised at the beginning of the war by artists, actors, musicians, dancers, architects, writers and poets. One of the main facilitators of the infirmary was Nikolay Kulbin, who probably invited Dobychina to contribute to this worthy course. She also joined the organisers of the infirmary and took part in the first fundraising activity – the auction of paintings by the World of Art group of artists, which took place at the premises of the Society for the Encouragement of the Arts. All the proceedings from the sale of 262 works (around 8,500 roubles) were donated to the infirmary. Two more auctions took place at the beginning of 1915 and in the spring of 1916.

Bringing together works of sixty-six artists from different groups, the exhibition at the Art Bureau followed suit. Avant-garde here was represented by Natan Altman, Nikolay Kulbin, David Burliuk and four women artists – Nadezhda Lermontova, Valentina Khodasevich, Anna Chudovskaia-Zel'manova and Aleksandra Ekster. In his review of the exhibition, critic Rostislavov lamented: 'This exhibition includes good, serious, although often quite modest examples of the most popular nowadays art. Apart from the works by Kulbin, there are hardly any examples of the extreme left. Even Burliuk donated for this exhibition quite realistic landscapes and Ekster – flowers.'

At the time David Burliuk faced financial difficulties and was forced to paint rather conventional and easy-to-sell works. The self-proclaimed head of the Futurists, Kazimir Malevich, who refused to recognise either Nikolay Kulbin or Mikhail Larionov as leaders of the new art, reflected in one of his letters: 'Burliuk is the real betrayer. I have spoken with him at great length but everything is rather sad.' As a result, Malevich refused to invite Burliuk (who was always known as the 'father of the Russian Futurism') to participate in one of the most provocative exhibitions of the 'left' art, *Tramway V*.

The charitable exhibition at Dobychina's new gallery closed on 7 December, and on 9 November 1914 the Infirmary for the Art Workers was officially opened in the premises of the shelter on the Petrogradskaia side (Big Belozerskaia Street, now Voskova Street, 1). It included ten beds for army officers and fifty-eight for the lower ranks. All the beds were decorated by the artists and named after sponsors or famous cultural figures, such as Feodor Chaliapin and Ilya Repin. There were also beds named after the magazine *Satirikon*, the World of Art artists, the

Photograph of David Burliuk, 1914.

Wanderers (*Peredvizhniki*), the Nonpartisan Society of the Artists, the Institute of the History of Art and Dobychina's Art Bureau.

In her letter to the artist Sergey Malutin of 19 December 1914, Dobychina reported that her successful charitable exhibition raised 2,077 roubles and 83 kopeks for the infirmary, of which 1,470 roubles came from the sale of paintings, 418 roubles 12 kopeks from the entry tickets and 189 roubles 71 kopeks from donations. She asked Malutin if he would be content to donate his unsold paintings from the exhibition to the infirmary for subsequent auction.

Following this successful exhibition, a retrospective of the artist Vasily Denisov opened at the bureau in January 1915. The son of a priest, Denisov combined painting with being an orchestra musician and theatre artist at the Italian Opera and the Zimin Opera Theatre. He also collaborated with the Meyerkhold performances. A Symbolist artist, Denisov had already attracted the attention of art critics in 1911 when he participated in the exhibitions at the Izdebsky salon:

> In the first place at the Salon is, without doubts, Vasily Denisov, recently still little known, and nowadays the world-famous artist. His paintings can't be viewed in a rush. It would have been insulting for these divine works. They demand a thoughtful, devout adoration. The artist's works are the fairy tales from the other world. Unlimited fantasy creates crazy nightmares, dazzling myriads of colours in the most fanciful combinations.

His works were also successfully exhibited at Mikhailova's Art Salon in 1912 (see the full description in a previous chapter). A member of the World of Art group

Vasily Denisov, *Bottom of the Sea*, 1907, oil on canvas, 194 × 267 cm. The State Russian Museum, St Petersburg.

of artists, he worked predominantly in the Post-Impressionist style. Like his better-known contemporaries, Čiurlionis and Kandinsky, in his works Denisov strove to combine music and painting. He died in 1922 and was subsequently forgotten.

This retrospective closed in February 1915 and in March a very successful exhibition of the World of Art artists, attended by 10,000 people, opened at the bureau. The founding member of the group was the artist and art critic Alexandre Benois, who played an important role in Dobychina's career. In October 1913, Nadezhda had invited him to become a trustee of her Art Bureau and to stage his retrospective at her gallery:

> By means of this letter, I would like to ask you to allow me to organise with your help an exhibition of your works, as well as to include your paintings into my permanent exhibition, and perhaps participate in the artistic directorship of the bureau as a member of its governing committee.

Although Benois openly criticised Dobychina's amateur approach (he could not quite forgive her for not having an artistic background), he contributed his works

Leon Bakst, *Portrait of Alexandre Benois*, 1898, watercolour on paper, 64.5 × 100.3 cm. The State Russian Museum, St Petersburg.

to numerous exhibitions at the bureau and often consulted Nadezhda and her husband on curatorial issues as well as the framing of works.

In 1916 Benois explained participation of the World of Art artists in Dobychina's exhibitions:

> We were governed not so much by considerations of an 'ideological' nature, but by something of a practical necessity. The whole string of young artists had nowhere to go. They were either not accepted at all at the big exhibitions of academic artists and the Wanderers [*Peredvizhniki*], or they were accepted only at the price of the rejection of all the work in which the artists themselves saw the clearest expression of their search.

In the 1915 exhibition 269 works by fifty-three members of the World of Art movement were included. Next to the paintings by the founders of this group of artists, works by the younger generation of Avant-garde artists, such as Natan Altman, Lev Bruni, David Burliuk and Georgy Yakulov, were displayed. This intervention of the 'left' art was met with criticism:

> The World of Art exhibition has been opened. Just as well, it is not a very big world, and that it won't have much influence on the development of artistic taste and the art of the future. There are many interesting works but also many paintings here are completely useless. Of course, it is not forbidden for

an artist to paint what he wants, to fool around, and to mock the high art, spit at it; however, to include such works in the exhibition and to take it seriously as something meaningful – is to sneer at the public, to mock the public.

Newspapers remarked on the 'street market variegation of the exhibits', as well as lack of standards from the exhibition organisers. Only one newspaper – the *Petrogradsky Kurier* – admitted that World of Art exhibitions clearly reflected the state of contemporary art and culture.

At the same time as Dobychina exhibited works by the more conventional members of the World of Art with only mild avant-garde leanings, the scandalous *First Futurist Exhibition of Painting Tramway V* opened on 3 March 1915 at the premises of the Society for the Encouragement of the Arts in the centre of the capital. Rather like the first wartime exhibition at the Art Bureau, *Tramway V* was raising money for the Infirmary for the Art Workers.

This exhibition was the major showcase of the Russian Avant-garde, at the forefront of which were Kazimir Malevich and Vladimir Tatlin. It was held in the most unlikely of places, the Imperial Society for the Encouragement of the Arts, an academic institution patronised by Tsar Nicholas II, who had no idea what he was getting himself into. It was a great anti-establishment cultural provocation. The artists probably gained the trust of this institution by promising that all proceeds

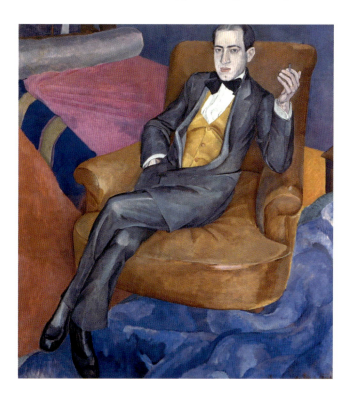

Lev Bruni, *Portrait of Arthur Lourié*, 1915, oil on canvas, 138.5 × 127 cm. The State Russian Museum, St Petersburg.

from the sale of works, as well as ticket sales, would be donated to a charity to help artists who had been wounded while serving as soldiers in the war.

On the day of the opening, minutes before the arrival of the Grand Duke Nicholas, the uncle of the tsar, who had come to view a much more conventional exhibition at the adjoining hall, a large banner was unfurled bearing the mysterious legend 'Tramway V'. In all Petrograd there was no tramway V – it was yet another Futurist provocation. More than 2,000 spectators attended the opening night alone and the scandal was complete. The Imperial Society soon demanded the replacement of the banner on its façade bearing such a nonsensical title, and it was promptly replaced with a new one proclaiming 'The First Futurist Exhibition'.

Despite predominantly negative reviews by the art critics, the exhibition was well attended and all the proceeds from the ticket sales were donated to the Infirmary for the Art Workers, which inaugurated a special 'Officer's bed in the name of the Tramway V exhibition'.

Inspired by the furore caused by this exhibition and strained between the conservative Benois and experimental Kulbin, on 12 April 1915 – ten days after the closure of the *Tramway V* and the bureau's World of Art exhibitions – Dobychina opened the *Exhibition of the Left Streams in Art*.

Unlike the *First Futurist Exhibition* which brought together the most extreme expressions of the new Russian Avant-garde, this exhibition at the Art Bureau was a more moderate affair. The loud, scandalous Malevich and controversial Tatlin had been excluded, but the Burliuk brothers and Wassily Kandinsky, who had recently returned from Germany, were invited. Eighteen paintings by Dobychina's collaborator, Nikolay Kulbin, graced the grand rooms of Adamini House. Women artists were also well represented – Olga Rozanova exhibited seventeen works, along with paintings by such innovative Avant-garde artists as Ksenia Boguslavskaia, Nadezhda Udaltsova and Valentina Khodasevich.

Most art critics stressed similarities between the *Tramway V* and Dobychina's exhibitions, and described the works on display as 'talentless, impudent and stupid' and generally 'a waste of time'. In the review in *Petrogradskaia Gazeta*, the anonymous critic lamented:

> A small exhibition under quite an original title 'Exhibition of the Left Streams in Art' was opened on the Field of Mars. Such political terminology is not accidental; the organisers and participants of this exhibition are really making the 'art politics', claiming to follow the steps of the World of Art, which has already exhausted its potential. … However, there is neither a real 'collective' effort in this display, nor a single ideological rod in the middle of it all.

At the same time as this showcase of the brave new art, the exhibition of the drawings and sketches executed by Evgeny Lancéray at the frontline in the Caucuses

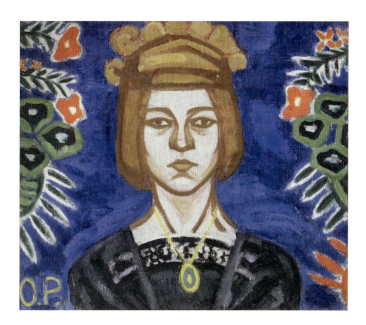

Olga Rozanova, *Self-portrait*, 1912, oil on canvas, 52 × 62 cm. Ivanovo Regional Museum.

and his fellow member of the World of Art, Mstislav Dobuzhinsky, in Galicia and Poland, was opened at the Art Bureau. Such a combination of mainstream wartime art displayed next door to the innovative Avant-garde confused the academic art-buying commission who came to the military exhibition but found themselves at a challenging display of the controversial new art.

Despite the public's interest in the scandalous 'left' art, the exhibition of Lancéray and Dobuzhinsky's art proved to be more successful. It attracted 1,500 visitors in just one month, and resulted in sales amounting to 7,000 roubles. Several works were purchased by the state commission for the summer residence of the tsar in Tsarskoe Selo and one sketch by Lancéray for the collection of the recently opened Russian Museum.

Following a long summer break, the autumn season opened at the Art Bureau with an exhibition of Japanese art. It was the first display of foreign art organised by Dobychina in St Petersburg. We know that in summer 1914 she spent some time in Paris, hoping to organise an exhibition of French art at her bureau. Due to the outbreak of the First World War, this plan never came to fruition. However, the idea of the Japanese exhibition was probably conceived in Paris. It also reflected an interest in Japonaiserie cultivated by the World of Art artists, who collected Japanese prints and reproduced them in their magazines, included them in their exhibitions and published a number of scholarly articles on the subject.

The first exhibition of Japanese art was organised by Sergey Kitaev at the Imperial Academy of Arts in St Petersburg as early as 1896. The Russo-Japanese war slowed down the cultural exchange between the two countries. However, it

Programme de l'Exposition
de l'art Japonais.

Désirant entreprendre l'arrangement d'une exposition de l'art japonais en l'année 1915, nous nous apercevons que le public russe n'a pas eu le moyen de faire connaissance avec le développement artistique du Japon.

Profitant de l'occasion qui s'offre à nous, nous sommes heureux de pouvoir combler cette lacune. Il est indispensable de représenter d'une manière aussi complète que possible l'art japonais.

Nous voudrions surtout attirer l'attention sur les documents rétrospectifs de l'art japonais, qui ont un grand intérêt pour nous.

Nous nous permettons d'énumérer les époques qu'il serait très désirable de représenter d'une manière aussi caractéristique que possible.

Peinture bouddhique, quelques peintures de l'époque antérieure aux Foujiwara, surtout de l'époque de Kwammon. Il serait désirable de donner une idée des peintures de Kanaoka et ses élèves, Kobodanshi. Les écoles de Yamato, Tossa, Kasouga Takouma, leur fondation remonte à l'époque des Foudjiwara et se prolonge durant la période des Kamakoura et Ashikaja. Par exemple: les scènes du Genji-Monogatari (app. au marquis Yoshikira Tokugawa au vic. Sakai Tadevichi) Les Miracles de Kasouga (coll. impériale) Scènes de Heidji-Monogatari (app. au baron Y. Iwasaki) Les œuvres de Sakamitsou, de Takanobou

(portraits). Des peintres de la famille Foujiwara Keion. Légendes du temple Kiijo-mitsou, par Missounobou, au Musée Impériale Toba Sojo. L'école chinoise: Josghen, les œuvres de Joami, Jesson Sofan, Noami, Kenkou.
Portraits de l'époque des Ashikaga comme ceux de Keichoki. Les œuvres de Cho Densu, Soga Jasoku. Les grands Kano.
Peintures de l'époque des Tokugawa. Les œuvres des Kano et de cette époque. Korinn, Kenzan, Hoitsou (les œuvres de Korinn comme la "Cascade de Nunobiki", "La grue" (bar Iwasaki). Sotatsou Itchitsou. L'école de Marouyma, d'Okiyo, de Shidjo, l'école néo-chinoise; les peintures de l'école de l'Ukiyo-yé: les Sumiyoshi.
Quant aux gravures de l'Oukiyo-yé, il semble en avoir une quantité suffisante à Pétrograde.
Les œuvres des peintres modernes du Japon: Hashimoto Gaho, Ogata Gekko, Watanabe Seitei, Kwoggyo Terazaki, Chikupa Otake, Taikwan Yokoyama, K. Kabouragi et autres.

Sculpture
Sculptures correspondant aux époques énumérées ci-dessus.

Art appliqué et industriel
La porcelaine, la poterie, l'ivoire, les objets de laque, les objets métalliques, les armes, la papeterie, les tissus, les masques dramatiques et les nattes tressées.
Nous désirons plusieurs exemplaires de chaque espèce et d'époques différentes des objets

énumérés ci-dessus.
Des livres de l'édition de Chimbichoen, et les reproductions de tableaux et de sculptures de cette même édition.

Programme of the Japanese exhibition, written in French by Petr Dobychin, 1915.

could not prevent artists' interest in the Orient and a major display of woodblock prints owned (and offered for sale) by the Japanese art dealer, Hasegawa, was held in 1905, followed by an exhibition of Chinese and Japanese objects of art, industry and everyday life from Nikolay Kalabashkin's collection in 1906.

One of the artists, whom Dobychina had promoted since the foundation of her bureau, Anna Ostroumova-Lebedeva, was one of the first Russian painters to take advantage of Japanese artistic techniques. She was a great admirer of the classic Japanese woodblock print and applied what she learned in her black-and-white and colour views of St Petersburg (often exhibited at the bureau). In her autobiography, she described her impression of the Japanese art exhibition:

> I would sit at the exhibition for many hours, drawn by the impossible fascination of shapes and colours. The works of art were hung on display boards, covered by glass, in huge numbers, nearly reaching the floor. … I was struck by clear-cut realism side by side with stylisation and generalisation, by the world of fantasy and mysticism, … [by] their ability to commit transient, momentary phenomena of the surrounding nature to paper.

Together with the works for this fascinating display, Dobychina managed to bring to war-torn Russia Japanese musicians who played traditional instruments at the exhibition and attracted the attention of several newspapers, which published their photographs.

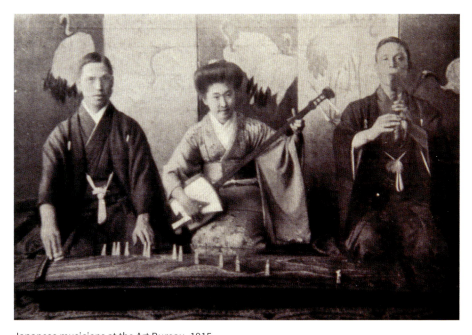

Japanese musicians at the Art Bureau, 1915.

Inspired by the attention of the artists and art critics to this small exhibition, in autumn 1916 Dobychina was hoping to organise a pioneering display of Persian art, but due to complications with the shipment of works from Persia, the exhibition was postponed until April–May 1917 and never materialised because of the change in the political situation in Russia.

Following the Japanese exhibition, Dobychina reinstated her charitable efforts and in October 1915 opened a display of works by Latvian artists. All proceeds from the sale of the tickets and paintings went to the war refugees. One of the highlights of this exhibition were paintings of a young artist from Riga, Aleksandr Drevin, whose family was forced to flee Latvia at the beginning of the war and move to Moscow. This exhibition and his personal experiences during the war inspired Drevin to begin work on a series of paintings called 'The Refugee'. Drevin's life was cut short when he was killed in Stalin's 1937–8 operation against the Poles and Latvians. His name was subsequently deleted from the annals of art history and was only resurrected in the last thirty years.

Big losses on the front in summer 1915 resulted in growing discontent with the tsarist regime. Society was demanding reforms and the general mood was close to the Futurists' aspirations and desire for change. Anarchic tendencies of the 'left'

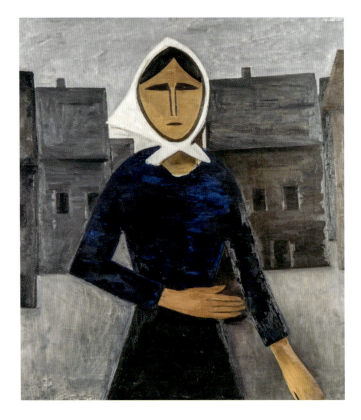

Aleksandr Drevin, *A Refugee*, 1917, oil on canvas, 100 × 89 cm. The State Tretyakov Gallery, Moscow.

artists attracted new devotees and the public's interest in the Avant-garde exhibitions increased.

In his unfinished book, *Art and Revolution*, the leading art-critic Nikolay Punin described this time of uncertainly in Russia: 'Peace could not be expected from anywhere, and nobody was expecting it. We were expecting something else, but nobody could say what exactly – some special way out of war, which was impossible to define.' The city lived on rumours about the upcoming revolution. Punin wrote that those who had made money out of the war were buying art, choosing 'the kitschiest works'. He explained that these people could not buy anything else, since that was what one who 'pops into art like into a café' would buy. Punin concluded: 'Futurism is all that is still worth thinking about.'

Punin's faith in Futurism as the only way forward was reflected in the exhibitions organised at the Dobychina's bureau in November–December 1915. The first one was dedicated to the stage designs from the collection of the famous patron and President of the Union of Youth group of artists, Levkii Zheverzheev. It included 1,289 set and costume designs dating from 1772 to 1915. For the first time, the history of theatre in Russia was traced through visual art. Works on display testified to the remarkable imagination and creative energy of the classical as well as avant-garde theatre, which were now presented on equal grounds.

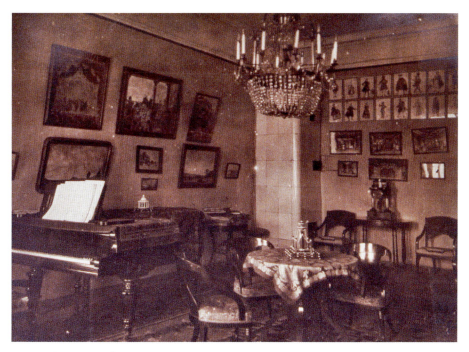

Interior photograph of Dobychina's gallery taken during the exhibition of stage designs from Levkii Zheverzheev's collection, 1915.

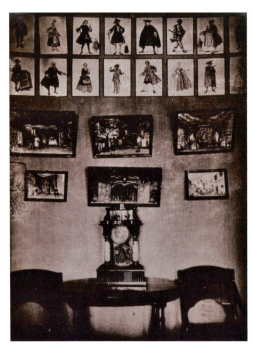
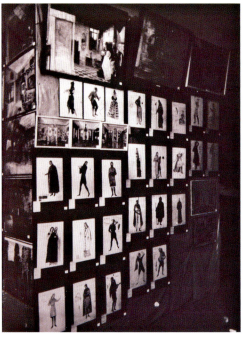
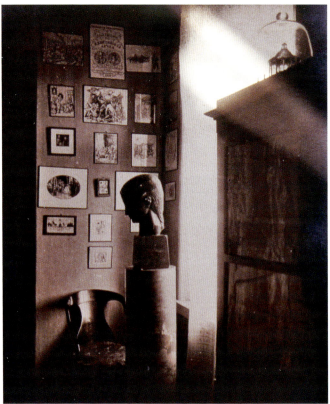

Interior photographs of Dobychina's gallery taken during the exhibition of stage designs from Levkii Zheverzheev's collection, 1915.

In November 1915, the exhibition of the World of Art artists, which had become almost an annual event at Dobychina's bureau, included works by St Petersburg Avant-garde artists Petr Miturich, Nikolay Tyrsa and Lev Bruni. This invasion of the 'left' artists attracted quite a lot of criticism:

> At the previous exhibitions of the World of Art one could have rest and enjoy the truly talented paintings. … And now – there's nothing to be had here; now one is offered nonsensical mess by Lev Bruni in the form of dirty, tearful, coloured with black blots, lace.

Critics remarked on the 'unpleasant flirting' of the World of Art with the Futurists and concluded that this respectable group of artists was dominated by the 'barbarians of colour and line'.

However, the most progressive art critic at the time, Nikolay Punin, believed that the works by the young artists Tyrsa, Miturich and Bruni were the most beautiful and sincere in the whole exhibition. He blamed the established World of Art artists in 'eternal wandering around themselves, inability to move forward, mannerism, and as a result – hopeless boredom and grey spinelessness'.

In his article, 'The drawings of several young artists', Punin described the demands that this controversial time in the history of Russia placed on a young artist, using drawings by Miturich, Bruni and Tyrsa to illustrate his arguments. At the beginning of his article Punin announced:

> The world ceased to be a passing vision (I am talking about the French artists), the sun ceased to be God, as Turner claimed; neither a moment nor the air play any or almost any role now. The reality, but not the reality that

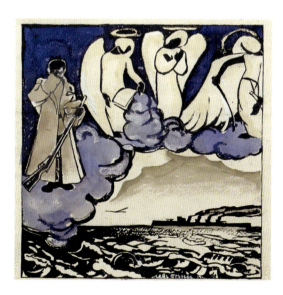

Lev Bruni, *The War. Russia*, 1914, watercolour on paper. State Museum of History, Architecture and Art, Rybinsk.

only exists as an external appearance, but reality as formation, as something that can be experienced with our whole body – that is what I consider to be the context of the new art.

He wrote that Bruni's style could be compared with 'the body in all its tension', for form alone the artist can sacrifice 'the beauty, composition and colour'. Punin concluded that there was a need in the 'new art' – 'powerful and solid' – which could no longer speak 'the vulgar street market language' and which should instead adopt 'more refined, even aristocratic language', which is 'simple and noble, and has more nuances than letters'.

The most important exhibition in the history of the Russian Avant-garde, which opened at the bureau on 19 December 1915, became the answer to Punin's prayers. This exhibition has been celebrated as a watershed moment not only in the history of Russian Avant-garde but also in the history of western art since paintings exhibited here had a profound effect on several generations of twentieth-century artists.

The name of the exhibition was as provocative as *Tramway V* – it was called *0,10* (Zero-Ten), and the subtitle was *The Last Futurist Exhibition of Painting*. The posters for the exhibition announced the participation of the same artists who took part in *Tramway V*; the same ten artists intended to show their works at the *0,10*. Thus, the title of the exhibition may have referred to the number of its participants, but

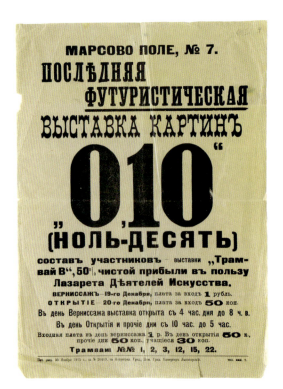

Poster for the opening of the *0,10: The Last Futurist Exhibition of Painting*, 1915.

only eight of the ten artists who took part in the *First Futurist Exhibition* agreed to contribute their works. Aleksandra Ekster and Alexei Morgunov refused to participate at Dobychina's exhibition. Instead, six new participants were added: Natan Altman, Anna Kirillova, Mikhail Menkov, Vera Pestel, the poet Vasily Kamensky and Maria Vasilyeva.

This exhibition became the debut for the Russian-born artist Maria Vasilyeva (better known as Marie Vassilieff) who had lived in Paris since 1905. From 1911 she managed a free art academy – Académie Russe – attended by many Russian Avant-garde artists. In 1912, Marie opened her studio in Montparnasse, where she founded the Académie Vassilieff, which soon became the nexus for those at the cutting-edge of art at the time. Erik Satie, Henri Matisse, Amedeo Modigliani, Ossip Zadkine and Chaïm Soutine used to visit in the evenings for conversation and life-drawing sessions. By 1913 her studio was so widely known that Fernand Léger gave two lectures there on the topic of modern art. Still unknown in St Petersburg, Marie contributed six paintings to *0,10*.

Altogether, the exhibition included works of fourteen artists – seven men and seven women. Although the catalogue lists 154 works, the actual number of exhibits was slightly higher. Like *Tramway V*, this exhibition was financed by a well-off young artist couple who had recently returned from Paris, Ivan Puni and Ksenia Boguslavskaia, who also exhibited seven works here. Their fellow artist, Olga Rozanova, wrote: 'Oksana [another name for Ksenia] is behaving like a stupid cow. She says that she has the right to run everything since the exhibition is on her

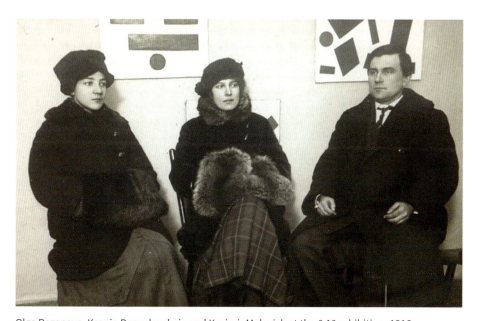

Olga Rozanova, Ksenia Boguslavskaia and Kazimir Malevich at the *0,10* exhibition, 1916.

capital, and so on. All of this is nasty.' None of Boguslavskaia's works exhibited at the bureau have survived – they were probably destroyed when she was forced to flee Russia with her husband in 1919. In a letter, Rozanova sketched one of Ksenia's works on display: 'Here is an exact copy of Oksana's picture. A ring, a wedge, and a partial wedge on a white ground.'

Information on the layout of this legendary exhibition is very scarce, but in July 1915 Puni described his first impressions of the rooms at the bureau in a letter to Malevich: 'The premises are very large. If ten of us each paint twenty-five pictures, then it will only just be enough.'

Kazimir Malevich became a self-proclaimed leader of this ground-breaking exhibition, and the '0' in its title may refer to the title of the magazine which the

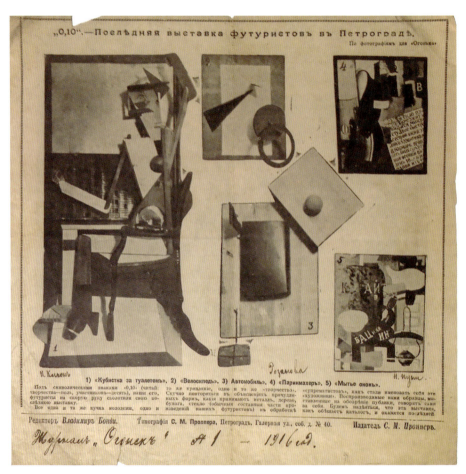

Photographic review of *0,10* in *Ogonyok* magazine, 3 January 1916, with Ivan Kliun's *Cubist Woman at her Toilet (Sculpture)*, Olga Rozanova's *Cyclist (Devil's Footpath) and Automobile*, and Ivan Puni's *Barbershop and Cleaning Windows*. George Costakis collection, MOMus – Museum of Modern Art, Thessaloniki, Greece.

artist planned to publish. Indeed, the previous summer Malevich had written: 'We are planning to issue a journal. … Since in it we intend to reduce everything to zero, we decided to call it *Zero*. Afterwards we ourselves will go beyond zero.' For Malevich and his most radically minded colleagues, '0' referred not to anarchic destruction but to Malevich's aspiration to reduce everything in the history of art to nothing and to develop the new art from scratch. Malevich articulated the sense of limitless possibility offered by his new mode of painting in a leaflet distributed free at the exhibition: 'I transformed myself in the zero of form. … I destroyed the ring of the horizon and escaped from the circle of things, from the horizon-ring that confines the artist and forms of nature.'

Malevich carefully orchestrated this first public unveiling of his new style, Suprematism, through an innovative display and a set of textual commentaries, intended to clarify and reinforce the message of the paintings. He hung thirty-nine canvases, all but one of them unframed, in a collage-like, multi-level arrangement, crowned by the painting he titled *Chetyreugol'nik* (*Quadrilateral*, later renamed *Black Square*). On each gallery wall, underneath the paintings the artist affixed a sheet of paper with the handwritten caption 'Suprematizm Zhivopisi' (Supremacy of painting), and his name on a separate sheet below. He explained the meaning of this inscription in the exhibition leaflet: 'Things have disappeared like smoke

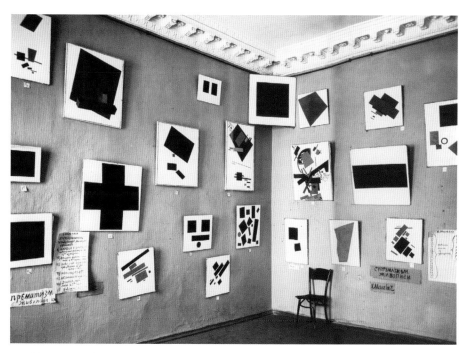

Installation view of *0,10: The Last Futurist Exhibition of Painting*, showing twenty-one works by Kazimir Malevich, 1915–1916.

... art approaches creation as an end in itself and domination over the forms of nature.'

0.10 was Malevich's attempt to hijack the exhibition under his own conceptual umbrella, and most women artists rebelled against this attempt. One of the stars of the Russian Avant-garde, Aleksandra Ekster, refused to participate out of disgust at Malevich's dominance. Liubov Popova declared her independence with a sign separating her works from Malevich, announcing 'Room of professional painters'. Olga Rozanova was also outraged with Malevich's claim that he was the inventor of the new abstract art called Suprematism, since she claimed that she invented it first. She recalled: 'Malevich has a guilty expression when he is with me, he has come down off his high horse, he is ingratiating himself with helpful favours, he is

Liubov Popova, *Portrait of Philosopher* (*0,10*, cat. no. 86), 1915, oil on canvas, 89 × 63 cm. The State Russian Museum, St Petersburg.

TWO WOMEN PATRONS OF THE RUSSIAN AVANT-GARDE

Kazimir Malevich, *Suprematist Painting (with Black Trapezium and Red Square)*, (*0,10*, cat. no. 54), 1915, oil on canvas, 101.5 × 62 cm. Stedelijk Museum, Amsterdam.

unrecognisable, on the first day I demonstratively turned my back on him.' Vera Pestel was kinder to Malevich:

> But then there is this artist Malevich, who drew a simple square and painted it all pink and another one black, and then many more squares and triangles in various colours. His room was elegant, full of colour, and it was pleasant shifting one's eye from one colour to another – all in different geometrical shapes. It was so tranquil gazing at the different squares, thinking about nothing, desiring nothing.

It was here that the most contradictory painting, *Black Square* by Malevich, was exhibited for the first time and placed in the red corner of the room where traditionally the icons were displayed in the peasant houses. It was an embodiment of '0' of form – thus the title of the exhibition. It was also the turning point not only in Malevich's oeuvre but in the history of modern art. At this legendary exhibition at Dobychina's bureau, Malevich proclaimed his new movement Suprematism (from the word 'Supreme' – the highest), and displayed the icon of this new trend – Black Square. He also invited all the participants to give their works the supplementary title 'Suprematism'.

This exhibition marked the turning point in Malevich's career and, according to one of his followers, Ivan Kliun, in summer 1915 he had prepared forty canvases on stretchers for *0,10*. He explained to Kliun that he wanted to fill these canvases

Kazimir Malevich, *Black Square* (*0,10*, cat. no. 39), 1915, oil on canvas, 80 × 80 cm. The State Tretyakov Gallery, Moscow.

Ivan Kliun, *Landscape Rushing By* (*0,10*, cat. no. 23, not exhibited), 1913, oil on wood, wire, metal and porcelain, 77.5 × 61 cm. The State Tretyakov Gallery, Moscow (gift of George Costakis).

with simple geometric forms of different colours, and that there would be no connection between these forms when they were displayed – no harmony between the colours.

On 19 December, the newspaper *Obozrenie Teatrov* published an announcement: 'A group of artists (Kazimir Malevich, Ivan Puni, Ivan Kliun, Ksenia Boguslavskaia and Mikhail Menkov) have united as **Suprematists** [bold type was used in the newspaper].'

One of the artists, who also participated in *0,10*, Nadezhda Udaltsova, later recalled:

> Malevich … wants to scuttle the exhibition, tries to get them to name it the last Futurist one; Ivan Puni and 'Punka' [Boguslavskaia] help him. Tatlin is given draconian conditions, according to which he cannot exhibit his reliefs with them – the Moscow group [Udaltsova, Popova, Ekster] demands that the Petrograd representatives alter these conditions under threat of 'not taking part'. The Peterburgers agree – Tatlin brings his reliefs.

Vladimir Tatlin, *Painterly relief*, 1914, 62 × 53 cm. The State Tretyakov Gallery, Moscow (gift of George Costakis).

Riddled with scandals, arguments and insults, this controversial exhibition became the embodiment of the historic conflict between St Petersburg and Moscow, and a highly articulate presentation of two new models of abstraction developed by the two rivals – Malevich and Tatlin.

Varvara Stepanova recalled the toxic atmosphere of this historic exhibition:

Setting up *0,10* – Tatlin is nervous, he argues with 'Punka' [Boguslavskaia], hangs the 'Muscovites' works, brings his own reliefs at 4.00 pm – the vernissage starts at 5.00 pm – swears at 'Punka' not to try to get a peek at what Tatlin is carrying – finally they partition off the rooms with screens, but when Tatlin walks by, 'Punka' starts screaming. The Suprematists want to disperse Suprematism throughout the exhibition, and definitely hang at least part of their works on the Muscovites' room – to do that they hide works, first Pestel's, then Maria Vasilyeva's, but without success. The Muscovites manage to defend their room. 5.00 pm – the vernissage – Tatlin does hang his reliefs in time – he's up on a stepladder hanging them with the public present; this attracts the public's attention and interest.

Vladimir Tatlin, *Corner Counter-Relief (0,10*, cat. no. 132-a), 1914, sheet metal, copper, wood, string and metal attachment elements, 71 × 118 cm. The State Russian Museum, St Petersburg.

At Dobychina's bureau, Tatlin showed a group of non-representational reliefs. Most had been exhibited previously, but two corner counter-reliefs made their public debut at *0,10*. Like Malevich, Tatlin also integrated a text into his display, pinning a specially published brochure to the gallery wall. Combining a brief text with reproductions of his earlier and current works, this brochure described the formal development of his reliefs from the first painterly reliefs of 1914 to the counter-reliefs of early 1915, which engage more forcefully with the surrounding space, culminating in the corner counter-reliefs, which break away from the two-dimensional picture plane altogether. Suspended on cables in mid-air, they appeared to defy gravity itself.

While Malevich used the mid-tone canvas on the gallery walls as the background for his arrangement of paintings, Tatlin turned the walls into an extension of his works by covering them with large sheets of white paper, emphasising the 'suspended' feel of his reliefs and enhancing the 'sense of natural weightlessness'.

Working in secrecy from one another, Malevich and Tatlin agreed to exhibit together in *0,10* under the strict condition that they were granted separate rooms. Both installed their works at the last minute, with Tatlin finishing his reliefs at the gallery and Malevich arriving a few hours before the opening of the exhibition with

many of his paintings still wet (which explains the craquelure visible on some of the paintings presented at *0,10*).

Both Tatlin and Malevich perceived this exhibition as a manifesto – the most important declaration of their latest achievements. Moreover, the exhibition became a true sensation, attracting over 6,000 visitors in just one month.

Despite its success with the public, the critics were outraged:

> I was planning to write a report on an exhibition of paintings as I headed to N.E. Dobychina's, but upon leaving there, I am sitting down to write … an obituary. … I feel sorry for cheery Futurism – the funniest incongruent colours and merriment in fragments of tin and wire, 'stripped of meaning'. I dip my pen into the most funeral ink and write on the *Catalogue 0,10*: Rest in Peace, Futurism. Best wishes!

Another critic lamented: 'The inventiveness and swiftness of the newest artists is undoubted, but there still remains the question: are their very concepts and perceptions about art, other than its form, in a state of chaotic fermentation?'

The anonymous reporter described his visit to the exhibition in the newspaper *Vecher Petrograda*:

> You feel uncomfortable entering the premises of this exhibition … as if you've ended up in a very bad place. Perhaps because all the people coming in lower their eyes and try not to look at one another. Some ask the doorman in exaggeratedly loud voices and others shyly and softly: 'Where is the exhibition itself?' The doorman smiles ironically and points to the second floor. With the same uncomfortable feeling you get a ticket and catalogue and begin examining the 'paintings'. … Coming down the stairs, I took my ticket from my pocket and looked at the number. 'Fool No. 2215,' I thought, remembering the old joke. I really wanted to stop the two men in civilian dress coming toward me on the stairs and tell them: 'Don't go, gentlemen, or you'll be Fools No. 2216 and 17! You are better off donating your 50 kopeks to a hospital for artists.'

Even Dobychina's friend and supporter of the bureau, Alexandre Benois, published a rather negative review of the exhibition in the newspaper, *Rech*, of 9 January 1916:

> The boredom definitely begins the minute you walk into the exhibition of the 'Futurists' (and not only into this one but all the others, too), as soon as you catch the sight of that inevitable cashier's table piled high with brochures, booklets and posters of various kinds. It's all grey, squalid and petty – and at the same time shrill and snapping, or, more precisely, trying to be shrill and

Yakov Steinberg, *Alexandre Benois at work*. Photograph, 1914.

biting. Right away you get an impression of a pathetic show booth, in front of which hoarse-voiced barkers shout their lungs out to attract attention.

The critic especially criticised Malevich and the new symbol of his new Suprematist style:

The black square in a white setting is not just a joke, not just a challenge, not just a chance little episode occurring in a house on the Field of Mars, it is one of the self-assertive acts of the principle that bears the name of abomination, of desolation, and takes pride in leading everybody to ruin via arrogance and via trampling on everything that is lovable and gentle. This is no longer the rasping cry of the barker but the main 'stunt' in the show booth of ultramodern culture, this is what they promised to show you inside and what you went in to see not really wishing to do so but giving in to the herd instinct.

In May 1916, Kazimir Malevich wrote a long letter to Benois in response to his review. In it the artist explained:

Every half century, our world is enriched by the creativity of an ingenious creator – 'technician'. But what had the world of art enriched contemporary life with? A couple of crinolines and a few Petrine uniforms. That is why I call only to those who, like me, offer their own fruit of art to the present age. And

> I am glad that the face of my square cannot merge with any master or time. … I have one bare icon of my time, without a frame (like my pocket), and it is hard to fight. But the pleasure of being not like you gives me the strength to keep on going further and further into the deserted desert. For only there is the transformation.

Despite occasional positive reviews of *The Last Futurist Exhibition*, which admired the 'inventiveness and swiftness of the newest artists', most critics concluded that the only positive outcome of this outrageous show was that 'nowhere else do people come closer faster or are opinions on things more similar than here. The usually glum Petrograders are unrecognisable here. There are joyous smiles on every face, and everyone tries to top the others in a witty remark about the "art".'

One wonders if Nadezhda Dobychina could possibly have anticipated that *The Last Futurist Exhibition* would become such a scandalous event? However, criticism attracts attention to the exhibitions and brings visitors, so perhaps it was not so bad after all. Moreover, even today the only reason why one may have heard of her Art Bureau is the *0,10* exhibition and Malevich's *Black Square*. This historic display provided a crucial stage from which the two giants of the Russian Avant-garde, Malevich and Tatlin, announced their penetration into the realm of abstraction.

However, following this brave outcry of the 'left' anarchists, Dobychina turned again to established artists, and in February 1916 organised an exhibition of Abram Manevich's art, who in 1913 had a successful one-man show at the Parisian gallery which belonged to the most important art-dealer of the Impressionists, Paul Durand-Ruel.

On 17 February 1916 the newspaper *Den'* published report on the attendance at exhibitions in Petrograd:

> From the start of the season, the space in N.E. Dobychina's Art Bureau has seen a nonstop change of exhibitions, and all the available time is scheduled until the end of April.
>
> Here are some numbers about the exhibitions that have taken place.
>
> The exhibition of Latvian artists garnered more than 3,000 visits, and 25 works were sold for a total of 2,030 rubles.
>
> The largest sum was for a painting by Rozental, sold for 300 rubles.
>
> The exhibition of sketches by Mir Iskusstva attracted more than 4,000 visitors.
>
> The exhibition of Futurists [*0,10*], held at the height of the season, had more that 6,000 visitors. Only one piece was sold, price unknown.
>
> The exhibition of Abraham Manevich is visited more on holidays and less on weekdays. By early February, 5,000 rubles' worth of paintings have been

sold, and the Kuindzhi Society bought works for 900 rubles and the Academy of Arts for 500 rubles.

The next planned exhibition is of Mir Iskusstva, which will continue until the end of March.

Following her brave presentation of the new Futurist art, Dobychina returned to the restrained elegance of the World of Art artists, whose exhibition ran at the bureau from 27 February to 27 March 1916. Sixty-eight artists participated in this exhibition, and apart from the members of the World of Art, two handbags and a pillowcase by Ksenia Boguslavskaia were included, as well as paintings by Petr Konchalovsky, Ilya Mashkov, Petr Miturich, Valentina Khodasevich and Georgy Yakulov.

One of the founders of the World of Art, Alexandre Benois, explained the inclusion of the Avant-garde artists by stating that the World of Art exhibitions could be compared to non-party salons, which strove 'to show all the strands of the Modern Russian Art'. However, most art critics did not accept this statement, blaming the World of Art of 'eloquent flirting with the Futurists'. Nikolay Punin wrote that despite Benois's wishful thinking, the World of Art always remained a closed circle which denied any alternations from its main stylistic inclinations.

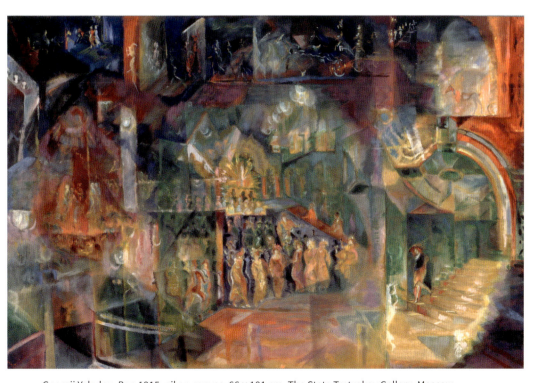

Georgii Yakulov, *Bar*, 1915, oil on canvas, 66 × 101 cm. The State Tretyakov Gallery, Moscow.

Elizaveta Kruglikova, *Silhouette portrait of Nadezhda Dobychina*, c.1915, ink on paper. Collection of Daniil Dobychin, St Petersburg.

Following these debates, such 'left' artists as Konchalovsky, Mashkov, Kruglikova and Goncharova were even accepted as new members of the World of Art.

In 1915, the graphic artist Elizaveta Kruglikova made a silhouette portrait of Dobychina, which depicted Nadezhda scrutinising a painting on an easel, hands in her pockets with a cigarette between her lips. It is a masculinised image focusing on the subject's professional life, which is rendered by means of conventional male props. Such representation was typical for the professional New Woman, Kruglikova, who was openly lesbian and was famous for cross-dressing. Thus, her fellow World of Art artist, Anna Ostroumova-Lebedeva painted Kruglikova in 1925 dressed in work clothes and holding a cigarette. Kruglikova's masculine style included participation in male sports, such as long-distance cycling and mountain climbing. In his diary, Benois described the artist and her girlfriend, Mademoiselle Sellier, cycling from Paris to Brittany around 1905, wearing special cyclist trousers that were still considered to be rather shocking in provincial France.

Avoiding taking sides, in April 1916 Dobychina organised the *Exhibition of Modern Russian Painting*, which united representatives of different, and often conflicting, strands. The whole room was dedicated to works by Marc Chagall, who returned from Paris at the dawn of the First World War and soon became one of Dobychina's favourite artists. She purchased his paintings for her private collection and organised his small solo show in the context of this exhibition, with sixty-three paintings occupying the largest room at her bureau. Another room was dedicated to Mashkov, who exhibited sixty-nine works, and Konchalovsky with twenty-nine paintings on display. Although some members of the World of Art were included,

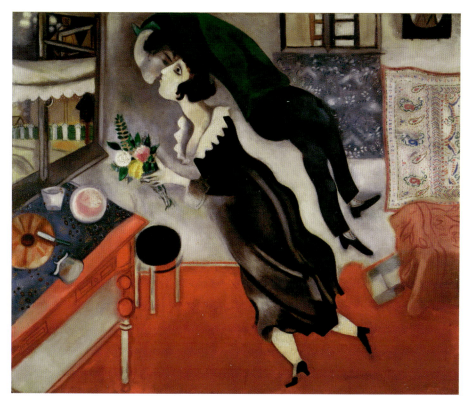

Marc Chagall, *Birthday*, 1915, oil on cardboard, 80.6 × 99.7 cm. MOMA, New York.

the 'left' artists took the decisive lead, represented by Bruni, Boguslavskaia, Khodasevich, Kulbin, Miturich, Rozanova, Altman and Rozhdestvensky.

Most critics remarked that at the time of ongoing war and shortages of canvas and paint, many of the paintings at the exhibition were just a waste of materials. They criticised Chagall's works for being too far removed from the harsh reality of Russian life.

However, this did not discourage Dobychina from her support of the Jewish artists and after the *Exhibition of Modern Russian Painting* moved to Helsinki, she organised an exhibition of the Jewish Society for the Encouragement of the Arts in April 1916.

Dobychina's efforts to promote Chagall had a positive effect on Benois, who wrote in the influential newspaper, *Rech*, on 22 April 1916, that 'he is a true painter, the painter right through to his fingertips, able, in his moments d'élection, to allow himself to be carried away by his inspiration, while submitting to the rules of the craft. ... What is charming in his work is not his exotic character but his capacity for capturing the soul of anything, of revealing the "smile of God" in the most trivial everyday scene.'

Soon after this exhibition Nadezhda Dobychina was diagnosed with tuberculosis and, fearing for her life, left humid Petrograd to spend the next three months at a sanatorium in Finland.

While she was away, in June 1916 the Society of the Independent Artists hired the Art Bureau for their first summer exhibition, which united once again established and Avant-garde artists. On 2 June, the newspaper *Birzhevye Vedomosti* published a review of the exhibition:

> The exhibition opened wide the doors to all art strands – from extreme right to extreme left. They could not do, of course, without Futurists. These guest performers use paints less and less. Why? It takes too much effort to paint with the brush on canvas. It is much easier to take a piece of newspaper, glue it to the board, attach to it an empty cigarette box, a few bits of cloth, and finish it all off with two kopeks note. And suddenly a painting with a special mood is created.

At the same time, during her stay at the sanatorium in Finland, Dobychina attended an exhibition of Wassily Kandinsky at the Strindberg Gallery in Helsinki. Upon her return to St Petersburg, at the end of September 1916, she wrote to the artist:

> … I really enjoyed the exhibition, and most works, apart from two, were unknown to me. I liked the way it was arranged, without being too full, although I wish it was organised chronologically in order to familiarise the viewer with you as an artist; since only one part of your works was on display, one could not get to know your oeuvre. Although one-man shows are so controversial and I was criticised so often for them, I would like to discuss this question with you more seriously. When will your exhibition at Strindberg end? At present I do not have a single day which is not already occupied at the bureau, but something could be arranged between the end of November and 1 January, although this timeslot is also taken up but there are rumours that the exhibition may be cancelled.

Dobychina had begun negotiations with Kandinsky in summer 1913, in the hope of opening an exhibition of his work in her new gallery on Moika Embankment in the autumn, but since there was a big retrospective of Kandinsky in Germany at the time, it was impossible to organise his solo show in St Petersburg. However, at an exhibition of graphic art which opened at the bureau in autumn 1913, Dobychina included six woodcuts by Kandinsky, and seven of his works were offered for sale at the *Permanent Exhibition*. In 1915 she included three drawings by this self-proclaimed father of Abstraction in one of the exhibitions at the bureau, and in April 1916 two of his canvases were shown at the *Exhibition of Modern Russian Painting*.

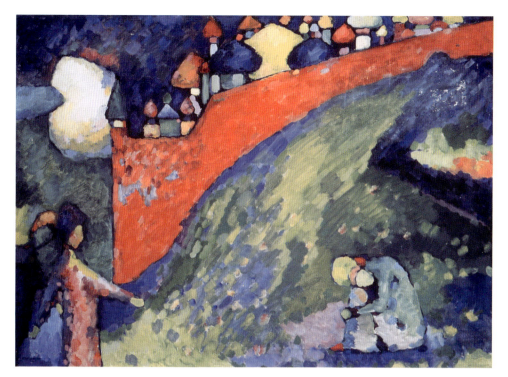

Wassily Kandinsky, *Kupola (Church Domes)*, 1909, oil on canvas, 83 × 116 cm. Dogadin Art Gallery, Astrakhan – one of two paintings by Kandinsky included in the *Exhibition of Modern Russian Painting* at the Art Bureau in April 1916.

Ahead of other gallery owners in Russia, Dobychina started promoting Kandinsky and was the first one to dedicate a whole room to this pioneering artist at the second *Exhibition of Modern Russian Painting* which opened at the bureau on 27 November 1916. Here, Kandinsky wanted to show the works he had previously exhibited in Helsinki, plus two more paintings, which he was hoping to finish just before the show – altogether fifteen paintings and nine watercolours. Although technically it was not a solo show, it was the largest display of the works by Kandinsky in Russia at the time.

This first profound introduction of Kandinsky to the Russian art scene was generally well received. Nikolay Punin wrote in his *Apollon* article, 'In defence of painting': '… I do not only believe in the perfectly deep seriousness of this master, but also admit that this person is very talented, although artistic achievements of Kandinsky are still quite small.' Nevertheless, the art critic admired the artist for leaving the subject matter behind.

At the same time, Punin criticised the exhibition at the bureau for being too eclectic. He wrote that 'in the selection of the exhibits not only one artistic vision is missing, but also a single pronounced taste'. The art critic felt that too many dull

and poorly executed paintings were exhibited next to very skilful and even groundbreaking works. He concluded that even though the exhibition on the whole was rather chaotic, it was full of the 'real, unique, lively and bright paintings'.

Several reviews of this important exhibition were quite negative, stating that by no means did it reflect the full diversity and richness of modern painting in Russia and that it just united under one roof a company of hooligans 'aimlessly misusing canvas and repeating the same thing year after year'. Another review concluded that the exhibition as a whole created a very poor impression and that even the ongoing war was not able to shake up these artists. Most critics felt that the art exhibited at the bureau was rather secondary to French modern art, but Impressionism was just 'a thin coat worn on top of the academic dress', and the moment the coat got worn out, the more conventional underdress was becoming more visible.

All together thirty-five artists took part in this seminal exhibition, and just two weeks after opening forty-five works had been sold and 6,000 roubles raised – quite a respectable sum at the time of war, when even Kandinsky, who came from a wealthy background, was hoping that at least a few works exhibited at the bureau would sell, since, as he wrote to Dobychina in his letter of 23 November 1916, his finances were very tight.

Nikolay Roerich, *Panteleimon – the Curer*, 1916, oil on canvas, 130 × 178.5 cm. The State Tretyakov Gallery, Moscow.

This exhibition was followed by an exhibition of the New Society of Artists, which was attended by Ilya Repin himself, and on 19 February 1917 the final seminal exhibition of the World of Art was opened with great aplomb. Here Petr Konchalovsky and Nikolay Roerich were given whole rooms, and although some critics wrote that the organisers of the exhibition were just mocking the general public, it was quite successful.

The exhibition also marked the end of a series of the World of Art exhibitions at the Art Bureau – a week after it opened, all the newspapers were temporarily discontinued due to political unrest. On 23 February, demonstrators clamouring for bread took to the streets of Petrograd and four days later mutinous Russian Army forces sided with the revolutionaries. On 3 March, Tsar Nicholas II abdicated, ending Romanov dynastic rule and the Russian Empire, and starting the intense period of artistic reforms which would eventually lead to the disappearance of the art market together, along with the Art Bureau and all commercial galleries.

CHAPTER 5

Last act: the beginning of the end

At the dawn of 1917, the Russian economy was rapidly approaching collapse under the strain of the war effort. Paradoxically, the equipment of the Russian army was actually improving in quality, due to the expansion of the war industry, but food shortages in the major urban centres had brought about civil unrest.

The February Revolution was centred on Petrograd, then still the capital (until 1918, when Moscow was named the capital). It broke out on International Women's Day on the last Sunday in February (23 February in the Julian calendar; March 8 in the Gregorian calendar). On this special day, women from several factories across the capital went on strike, demanding the end of the First World War and an end to Russian food shortages.

The strike lasted less than a week, but involved mass demonstrations and armed clashes with police and the gendarmes, the last loyal forces of the Russian

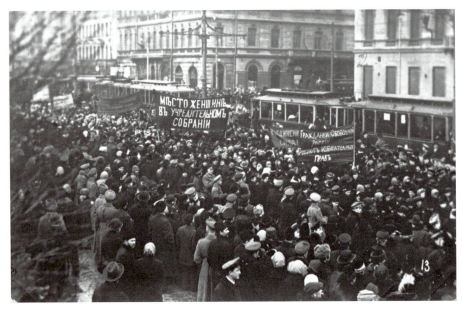

Women's demonstration on Nevsky Prospekt, Petrograd. Photograph, February 1917. State Museum of Political History of Russia, St Petersburg.

monarchy. In the final days, a mutinous Russian army force sided with the revolutionaries. This revolution – seemingly a chaotic affair – appeared to break out spontaneously, without any real leadership or formal planning. Bread rioters and industrial strikers were joined on the streets by disaffected soldiers from the city's garrison. As more and more troops deserted, the city fell into a state of chaos that led finally to the overthrow of the tsar.

The transition to the Provisional Government was not smooth, and in reality fertilised the ground for the revolution in October. However, unlike its predecessors in Imperial Russia, which never had a specific art ministry (although the Imperial Academy of Arts attempted to determine all artistic developments in Russia), the Provisional Government made the first attempt to establish state control over the arts.

Shortly after the February Revolution, on 4 March 1917 the Arts Commission (*Komissya po delam iskusstva*) was established. It included the renowned writer Maxim Gorky and famous World of Art artists Alexandre Benois, Nikolay Roerich and Mstislav Dobuzhinsky, and focused on the pressing need to save palaces and works of art from the threats of war and revolution.

As early as 1912 Benois had expressed the extreme opinion that good taste in art had to be imposed by the state. In March 1917, professors from Count Zubov's Institute of the History of Art sent a petition to the government for the establishment of the Ministry of Arts. They even suggested the candidate for the head of this ministry – Sergey Diaghilev, who was in Rome at the time. Most of the members of the ministry were supposed to be the World of Art artists.

The young critic, Nikolay Punin, described these events in his article 'Academy of Arts in 1917':

> … The question of the establishment of the Ministry of Arts was naturally dictated by the historic developments; it followed the fall of the tsars' regime which practically eliminated the Ministry of the Imperial Court, which almost entirely controlled all artistic institutions and workshops in Imperial Russia.

The report on the establishment of the Ministry of Arts had shaken 'to the roots of their nerves', as one journalist put it, the whole artistic world of Petrograd and Moscow. However, this initiative never came to fruition. Most artists voted for the separation of art from the state, and soon Nikolay Punin, Natan Altman, Lev Bruni, Aleksandr Rodchenko, Vladmir Meyerkhold, Vladimir Tatlin and others founded a new union, The Freedom of Arts (*Svoboda Iskusstv*).

On 12 March 1917, they joined, along with no less than 182 artistic movements and individual artists, The All-Arts Union (*Souz Deiatelei Vsekh Iskusstv*). This overarching organisation united most Russian artists from the Realists to the Futurists. It was a prototype of the Union of Artists but it aimed to be independent from the

state. On 10 April 1917, the Union issued a petition to the Provisional Government, which stated that the development of art in Russia could not be in the hands of a bureaucratic machine (the Ministry of Arts) but needed to be administered by the artists themselves. This was an unprecedented step, which put artists in charge of the whole cultural infrastructure.

Initially, the February Revolution and Tsar Nicholas II's subsequent abdication were welcomed by the majority of Russians. However, the Provisional Government, led by Prince Georgy Lvov, was rapidly losing public support. On 1 September 1917, the art critic Nikolay Punin wrote in his diary referring to Petrograd: 'Here it is – the revolutionary city in the year of disasters – hungry, corrupt, frightened, sprawled out, mighty and absurd. Some confirm that now it strangely reminds one of Paris.' Russia was about to open a completely new chapter of its history.

When the Bolsheviks came to power in October 1917, it was hardly a mass movement, although they did have supporters in many of the key Soviets' and workers' committees: the Bolshevik faction of the Russian Social Democrat party contained at best 350,000 people in a country of 140 million (ironically, the Bolsheviks took their name from the Russian word *bol'she*, or greater part). Their leaders accepted that culture, in all its manifestations, should play a critical part in achieving solidarity and advancement in this new society, but what that culture should comprise was still under debate. When, following the October Revolution, the Bolshevik government decided that art was of the utmost importance for the education of the proletariat, it appointed Anatoly Lunacharsky the Commissar of

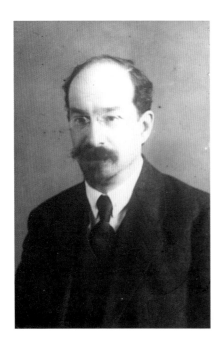

Anatoly Lunacharsky. Photograph, *c.*1917.

Public Enlightenment (or Education) and the head of *Narkompros* (The People's Commissariat of Enlightenment).

Before Lunacharsky was selected, at least two long-established leaders of the Petrograd artistic elite – Sergey Diaghilev and Alexandre Benois – were offered this honorary position. In his diary, Benois described how on 11 November 1917 Lenin asked him 'to take on the portfolio of Minister of Fine Arts', but he refused. Since Diaghilev was already living in Europe and did not plan to return to Bolshevik Russia, Lunacharsky was 'pushed forward'.

On 12 November 1917, Lunacharsky made his first declaration on the new artistic policies. He proclaimed that Soviet governmental institutions had abdicated their powers in the direction of cultural affairs. The majority of the artistic institutions that had formerly been under the jurisdiction of the Palace Ministry would now be under the direction of *Narkompros*, which soon grew into a complex bureaucratic structure with no less than seventeen divisions. Under Lunacharsky, *Narkompros* had control of all state schools and universities, as well as concert halls, theatres, museums and art galleries.

In January 1918, *Narkompros* set up the Department of Visual Arts, known as IZO, in Petrograd. Representatives of the more radical 'leftist' artistic groups gathered around IZO. They were not all Futurists but 'from the time when Futurism first

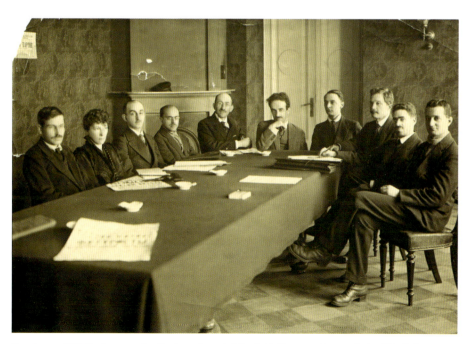

Members of IZO Narkompros' collegium. From left to right: Karev, unknown lady, Shkol'nik, Chekhonin, Il'in, Shterenberg, Punin, Vaulin, Levin and Baranov-Rossine. Photograph, 1918. Family archive of N. Punin, St Petersburg.

emerged in Russia, this concept had quite a wide meaning, and incorporated aesthetics of left art instead of some specific artistic principles'. IZO consisted of two parts: the collegium (or deliberative body) and the executive. The first collegium in Moscow was headed by Vladimir Tatlin and included the painters Kazimir Malevich, Ilya Mashkov, Nadezhda Udaltsova, Olga Rozanova, Aleksandr Rodchenko and Vasıly Kandinsky. The Bolsheviks, reflecting Lenin's extremely conservative tastes in art, would have preferred to work with academic and traditionally inspired artists rather than with these radical left-wing innovators, but established painters were reluctant to reduce their status by talking to the masses.

5.1. A storm approaching: the 1916–17 season at the Art Salon

Autumn 1916 in Moscow was ripe with gloomy foreboding. Two years of war had taken their inevitable toll on the Russian economy. The old capital, as well as many other big cities across the empire, started to experience occasional food and fuel shortages. Essential products were rationed. Big queues formed outside grocery stores and lined the streets. The political situation was no better as the Imperial government's unpopularity grew at high speed, while various political forces were attempting to hijack public discourse and impose their own agendas. Viktor Shklovsky, a Russian and later Soviet literary theorist and critic, recalled the public attitude at the time in his memoirs: '… people in charge of war appeared as not being good for anything. There was no faith in them. No one trusted the government anymore.'

On the eve of 1917, Pavel Milyukov, a liberal politician and prominent member of the opposition party, the Constitutional Democrats (Kadets), warned in his speech at the State Duma – the legislative assembly's lower house – about the forthcoming revolutionary upheaval: 'The atmosphere is saturated with electricity and the approach of a thunderstorm is felt in the air. No one knows when the storm will break.' Some commentators went as far as detecting traces of an impending catastrophe in contemporary art, as it was the case, for instance, with Filipp Malyavin's series of paintings representing large dynamic figures of dancing peasant girls in flame-red twirling dresses: 'The red peasant woman is coming. … It seems she will incinerate and uproot everything on her way. … Horrifying women. … it is for good reason that Malyavin returns to them so persistently. He recognised Russia in them.'

Despite the generally gloomy mood, Moscow's art life nonetheless continued on its course. Moreover, the lingering economic uncertainty enhanced the attractiveness of fine art for the secure investment of capital. As a result, it was not only collectors and connoisseurs, but also the nouveaux-riches with fortunes made during the war, who were now avidly buying works from exhibitions organised by various

Filipp Malyavin, *Whirlwind*, 1906, oil on canvas, 120 × 74 cm. The State Tretyakov Gallery, Moscow.

artistic groups and private galleries. It is unsurprising that the number of events offering this opportunity grew considerably. The art critic, Sergey Glagol, in his overview of art shows taking place in Moscow in January 1917, marvelled at their increased quantity: 'In Moscow there is such an abundance of exhibitions, as if Russian artists were obliged to do pictures instead of military service. There are eleven of them in total. It seems a bit too much for a strenuous year we are going through.'

One of the eleven exhibitions in Moscow mentioned in Glagol's article – the display of works by the World of Art group – was mounted in the Art Salon. Ever since the 1913–14 season, Mikhailova's gallery came to be the place for Moscow's annual shows of this eminent art group from St Petersburg, which became Petrograd from the start of the Great War. The collaboration, fruitful for both sides, was further consolidated once Konstantin Kandaurov was appointed the exhibition organiser for the World of Art. However, his personal curatorial ambitions so clearly articulated during the preparation of the *Painting of the 1915* show, became considerably less pronounced once he assumed the position of responsibility within this society. From that moment on, he acted more as an exhibition manager and administrator than a curator with his own aesthetic conception in mind.

For several years the World of Art ideology, initially based on Symbolist and Neo-Romantic poetics with a special focus on linear approach in painterly techniques, had been slowly but steadily undergoing an important change by adjusting its outlook to incorporate the latest Modernist innovations. This trend was already evident during the World of Art's first exhibition in the Art Salon in

Ilya Mashkov, *Self-portrait and Portrait of Piotr Konchalovsky*, 1910, oil on canvas, 208 × 270 cm. The State Russian Museum, St Petersburg.

December 1913–January 1914, when a small but representative party of Avant-garde artists, including Larionov, Goncharova and Tatlin, were invited to take part in the group show. The season of 1916–17 proved to be a milestone for the World of Art artistic re-orientation, for its membership was reinvigorated by two important newcomers – the Moscow painters Ilya Mashkov and Petr Konchalovsky, both of whom were major figures and founding members of the Jack of Diamonds group.

Remarkably, Konchalovsky and Mashkov's decision to leave their defiant brainchild for the more refined World of Art ultimately served to reinforce the avant-garde tendencies within Russian fine arts. Indeed, in the absence of its founding fathers, the Jack of Diamonds' newly appointed members, headed by the ambitious Kazimir Malevich, seized the opportunity to make the group adopt a far more radical stance. For their part, Mashkov and Konchalovsky, known as the Moscow Cézannists, extended the artistic horizon of the World of Art, introducing into its aesthetic perspective some Modernist techniques, including distortion of form, expressiveness of colour and materiality of pictorial surface. As it happened, both groups had their revamped annual shows one after another in the Art Salon, thus making Mikhailova's gallery the central stage for these momentous developments in the history of early Russian Avant-garde.

Timewise, the Jack of Diamonds show came first and ran from 6 November–11 December 1916, proving to be the most radical event of the 1916–17 season in Moscow. After the departure of Mashkov and Konchalovsky, the society invited Kazimir Malevich and his close associate, Ivan Kliun, to become members, both of whom promptly accepted. Moreover, they were also elected to the group's executive board. Malevich, fresh from his recent clamorous participation in *The Last Futurist Exhibition* in Dobychina's Art Bureau, where he forcefully claimed for himself leadership of the Russian Avant-garde with his latest Suprematism invention, was eager to consolidate his position and further improve his public profile. Out of several avant-garde groups and associations active in Russia at this time, the Jack of Diamonds group managed to achieve the highest artistic status. Therefore, Malevich and Kliun were adamant that they should take full advantage of their new positions and change the balance of power in the art world in their favour.

Malevich insisted on admitting a group of young avant-garde artists from St Peterburg who were close to his own artistic outlook into the society. These included many participants of *The Last Futurist Exhibition*: Olga Rozanova, Ivan Puni, Ksenia Boguslavskaia and Natan Altman. Shortly thereafter, Liubov Popova, Nadezhda Udaltsova, Vera Pestel, David Burliuk and Marc Chagall joined as well. This injection of fresh blood changed the overall make-up of the Jack of Diamonds, transforming it into an avant-garde umbrella association that incorporated a wide spectrum of directions from the Cézannist-style of its oldest members (by then already familiar to general public) to militant radicalism of its rampant newcomers. With all this remodelling, the Jack of Diamonds also became much more representative of female artists, given the gender egalitarianism of the new avant-garde generation.

The 1916 exhibition of the renewed group contained a considerable number of items – 441 in total. The heterogeneity of the participants' artistic orientations was reflected in its layout. The older members – Aristarkh Lentulov, Robert Falk, Aleksandr Kuprin and others – continued to pursue their investigation of painterly texture, colour and volume, toeing the line inherited from the art of Cézanne. This group chose to display their works separately from the new radical members in order to highlight the aesthetic differentiation within the society. Thus, the Suprematist works of Malevich and his followers, as well as paintings by Chagall and Altman, were mounted in other rooms of the Art Salon.

Despite the clear demarcation between moderate and extreme currents of Modernism in the display, some critics labelled the exhibition a 'Futurist' show, which in Russian context denoted all radical ramifications of contemporary art. One commentator marvelled at the considerable popular success of the event, blaming it on the jaded contemporary bourgeoisie:

> I went to the Jack of Diamonds' opening day and was amazed, for none of the art exhibitions that have opened this season attracted such a large audience. The medium-sized halls of the 'Salon' in Dmitrovka Street were cramped with a dense crowd. The Futurists have an audience. And this is a perfectly respectable audience, so to speak. The neatest partings, the most bourgeois 'jackets', the most elegant ladies' outfits stroll through the halls. These are the very bourgeois against whom the Futurists declared a holy war. The Futurists are at war while the bourgeois look around condescendingly. They even buy pictures. How can this be explained? Apparently, the Futurists hit some target. … They managed to oblige the surfeited taste and it paid off.

However, the overwhelming number of other reports were far more insightful and discerning. One observer found that the exhibition 'overwhelmed visitors with colours. At the first moment, upon a cursory viewing the display appears miscellaneous and strange. But the more and closer you look at the paintings, the sooner you endorse the artist-pioneers so that sometimes you even put up with the mannerisms that still remain the hobbyhorse of this group's painters.'

Yet another had to concede:

> The Jack of Diamonds has many sins, but it also has one great advantage: one can hardly point out another group of our artists which gets to grips with and succeeds in special painterly tasks with greater persistence and greater results. No one else gives so much passionate attention to the culture of paint and the colour surface of the canvas.

Some reviewers regretted the departure of Mashkov and Konchalovsky as 'the masters who made the public appreciate them as great artists', since without their paintings 'the exhibition lost much of its flamboyant colour'. Nonetheless, the commonly shared opinion was that the exhibition 'turned out to be viable, for the batch of artists that had united under its banner have remained true to themselves and showed no intention to deviate from the targets once set'.

The verdict referred primarily to the older members of the Jack of Diamonds whose works received nearly unanimous approval, which points to the fact that by 1916 their Cézannesque artistic method had been already digested by the Russian public and stopped being seen as an affront to the art of painting. Particularly praised were 'soft, tranquil and introspective' still lifes of Aleksandr Kuprin, who was also commended as 'an excellent colourist', and Robert Falk's portraits and landscapes, which were admired for their emotional lyricism, elegance and brightness. Less complimentary, but still generally encouraging, was the opinion on Aristarkh Lentulov's idiosyncratic style that combined Cubism with flamboyant colour schemes and the naïvety of folk art. Although his works were harshly

Aristarkh Lentulov, *Portrait of Nita Svedomskaya*, c.1915, oil on canvas, 102 × 88 cm. Savitsky Art Gallery, Penza.

criticised by many commentators, Lentulov was however considered to be an artist of great potential and special decorative gift whose canvases displayed 'a genuine pictorial fun, playfulness and movement'.

Works by Natan Altman and Marc Chagall also received mostly positive critical acclaim. Both men were acknowledged as the painters with 'the authentic artistic temperament'. Altman was appraised as an artist 'eagerly seeking precise form; the one who is cultured, rigorous and sharp'. Particularly appreciated was his sculpture, *Head of the Young Jew*, which several reviewers complimented for its wittiness, craftsmanship and stylishness.

Chagall displayed forty-five works, which filled an entire room. Thus, viewers had a chance to plunge into his art without any external distractions. This was an impressive assemblage and many critics agreed that the painter managed to portray a 'Chagall-invented realm where everything happens exactly as in his pictures … . Chagall conquered us and even his "absurdities", his flying curvilinear figures, green and red, seem now familiar and artistically justified.' His works were commended for 'the beauty of colours … and gracefulness of these clear, sharp and tense lines'. One of the most enthusiastic admirers even wrote that Chagall's distinct propensity to infuse the every-day trivial motifs with a dreamlike quality offered 'inspiring possibilities for depicting "the soul" of the objective world'.

Natan Altman, *Head of a Young Jew (Self-portrait)*, 1916, gypsum, copper and wood, 51 × 31 × 27 cm. The State Russian Museum, St Petersburg.

Far more severe was the critical attitude towards the radical wing of the Jack of Diamonds group represented by Kazimir Malevich and his associates. Malevich placed high hopes on this event, as he aspired to claim the place of an undisputed leader of the Russian Avant-garde, which had remained vacant following Larionov and Goncharova's departure for Switzerland in the summer of 1915. Ever since the presentation of his non-figurative Suprematist paintings in the *0,10* exhibition in Petrograd, his ambition was to champion the spread of this newest radical style among the Russian public and promote himself as its inventor. That was a rather bold task to take on in Moscow – a hotbed of various Russian Modernist movements that were in fierce competition with one another.

Malevich had already made an attempt to test the water in spring 1916 during the exhibition *The Store* (*Magazin*), organised in one of the department stores in the centre of Moscow (hence its name) by his eternal rival Vladimir Tatlin. Although the jealous, over-controlling Tatlin explicitly prohibited any *Suprematist* paintings being on show, Malevich, pretending to obey, invented another method to attract attention to his cherished invention: on the evening of the show's opening, he walked around the exhibition halls with a poster attached to his back that read: 'I am an Apostle for the new concepts in art and a surgeon of the mind. I took the throne of the proud creativity and declare the Academy a stable of the Philistines.'

Unsurprisingly, his escapade cost him dearly, as Tatlin immediately banished Malevich and his loyal friend, Ivan Kliun, from the event. Their paintings were taken off the walls. However, after his election to the Jack of Diamonds' executive board, Malevich must have felt well placed to finally achieve his major goal.

War cast a menacing shadow over this great opportunity, as Malevich was called to arms in August 1916. Although he was never sent to the front and had an occasional chance to visit Moscow and Petrograd, the military service inevitably constrained his artistic activities and liberty of movement, but it did not in the slightest inhibit his determination to achieve his strategic goals. In October 1916 he was granted a short leave and used this time to the full. Upon arriving in Moscow, he took an active role in arranging the display for the radical wing of the Jack of Diamonds in Mikhailova's Art Salon. In view of the imminent exhibition, he also published a brochure, titled, 'From Cubism and Futurism to Suprematism. The New Painterly Realism', which was meant to consolidate his claim on the leadership within the Russian Avant-garde. In his text Malevich made an overview of the preceding Modernist idioms, highlighting their innate faults. Only Suprematism, proclaimed its proud inventor, was the ultimately perfect non-mimetic style, which allowed the artist to create pure and absolute painterly forms without slavish copying of nature. In his view, these pure Suprematist forms possessed the same value and autonomy as all 'living forms of nature'.

Cover for Malevich's brochure 'From Cubism and Futurism to Suprematism. The New painterly realism'. 1916.

LAST ACT: THE BEGINNING OF THE END

Unfortunately, Malevich's attempt to provide Suprematism with theoretical underpinning failed to impress the reviewers. If anything, it had the opposite effect of eliciting sarcasm and hostility. 'Non-figurative creativity, suprematism, colour decentralisation, whitey-blacky-greeny … . Tricky works that express nothing and are totally useless,' was the grumpy reaction from one of the reporters on Malevich's text. While another commentator, in an attempt to proclaim Malevich as an unworthy imposter, even conjured up the authority of Natalia Goncharova, who thus surprisingly became a source of reference *in absentia*:

> The talented Natalia Goncharova once made a very significant statement. 'I affirm,' she wrote, 'that the ingenious artists did not create theories.' Let us add: 'And they did not follow them.' Stencil-like and ready-made theories and techniques can seduce only a banal and insecure artist, the one whose talent is either insignificant or has not yet sufficiently evolved and strengthened.

Suprematism was unanimously dismissed as yet another absurd sham of Futurist rebels in search of cheap success. The review in the popular newspaper, *Early Morning* (*Rannee utro*), exemplifies the viewpoint of many other publications:

> Suprematism replaced Rayism; but when you look at works of this 'new non-objective creativity' such as *The Relative Weight of the Colour Effect*, *Colour Decentralisation*, *Flying Form* and others, you realise that the authors' only goal is to attract the public's attention.

Malevich and Kliun, portrayed as pathetic hoaxers, were the main targets of critical rebuke. The commonly shared attitude was summarised by the Moscow newspaper *Russian Word* (*Russkoie Slovo*):

> A number of coloured geometric shapes, lurid strokes interspersed with eye-tiring lines – the fruits of the 'non-objective creativity' of Mr Malevich and Mr Kliun cannot be taken seriously. … Regrettably, these artists have considerably cluttered the exhibition space with their pretentious works.

Yet, there were a few dissenting voices within this general chorus of negative criticism. Thus, Yakov Tugendkhold, while not exactly approving of Malevich's latest invention and calling it 'coloured geometry', still acknowledged that 'there is a certain movement and bright colour resonance' in 'those combinations of squares, crosses and circles' on Malevich's canvases, while others remarked about interesting potential for the new style, which in their view had not been yet fulfilled by the exhibited works. Thus, an anonymous reporter of the arts newspaper, *News of the Season* (*Novosti Sezona*), regretted that Malevich 'has been unnecessary wasting his talent overreaching himself in an attempt to become a spearhead of new ideas'.

Despite overwhelming negativity towards radical art shown at the exhibition, works by avant-garde women elicited several positive responses. That being so, the *Jack of Diamonds* exhibition in Mikhailova's gallery became one of the first occasions for the oeuvre of the new generation of women artists to receive serious critical acclaim.

The most familiar for contemporary visitors was the name of Aleksandra Ekster, a cosmopolitan artist who in the years preceding the war divided her time between Ukraine, Russia, France and Italy. Networking with the key figures of the international Cubist and Futurist movements (her circle of acquaintances included Picasso, Braque, Metzinger, Gleizes and Ardengo Soffici), Ekster acted as an important emissary in the process of artistic interaction between western European artistic centres and Russia, exchanging information on the latest artistic trends both in Russia and the west. A gifted and determined artist, by the 1910s she had evolved her own style that amalgamated elements of Cubism and Futurism with abstraction and elegant decorativeness. Nikolay Kulbin, who had played such an important role in converting Dobychina to the Avant-garde cause, highly appreciated Ekster's artistic talent, writing in one his articles: 'Her works show convincingly calm strength of form wedded to great virtues of colour and rhythm.'

A few months before the opening of the exhibition in the Art Salon, Ekster began her collaboration with Moscow's pioneering Kamerny Theatre, under the

Aleksandra Ekster, *Bacchante*. Costume design for I. Annensky's tragedy *Thamira Khytharedes* in the Kamerny Theatre, Moscow, 1916, gouache and ink on blue paper, 44.5 × 37 cm. State Museum of Theatre, Music and Cinema of Ukraine, Kiev.

LAST ACT: THE BEGINNING OF THE END

directorship of Aleksandr Tairov. Her first project – the production of sets and costumes for Innokenty Annensky's tragedy *Thamira Khytharedes*, based on a Modernist reinterpretation of the ancient Greek myth – brought her considerable success. *Thamira Khytharedes* was presented to public in autumn 1916 and was called by many observers the 'most significant phenomenon of the Moscow theatre season'. At the *Jack of Diamonds* exhibition, Ekster displayed her costume designs for this production. Colourful and dynamic, her drawings executed in gouache were praised by the critics. Many agreed that Ekster's creations looked even more impressive in the form of graphic works displayed on the gallery walls because the stage tended to extinguish and deaden their flamboyant vividness. Tugendkhold expressed his sincere admiration:

> Against the deep blue and gold background, bodies in hot fiery-crimson fabrics stand out, brilliantly pink and faience-like. Lines look like a bowstring – sharp, nervous. Muscles are outlined with a scarlet – as if bloody – shading. These are excellent drawings. The very soul of theatre reverberates in them.

Liubov Popova, *Painterly Architectonic*, 1916, oil on board, 59.4 × 39.4 cm. Scottish National Gallery of Modern Art, Edinburgh.

Olga Rozanova, *Working Casket*, 1915, oil on board, 58 × 33 cm. The State Tretyakov Gallery, Moscow.

He also signalled out two other women artists, Liubov Popova and Olga Rozanova, whose work, according to the critic, preserved the link to the Cubist method. Popova displayed her new series of paintings, which she called 'Painterly Architectonics' – non-figurative compositions of brightly coloured overlapping squares and rectangles depicted in the state of dynamic interaction. The use of shading created the effect of three-dimensionality and weight, while the thickness of paint and visible brushstrokes underscored the materiality of the canvas's surface. Even though Tugendkhold did not review Popova's work in detail, he still commended her art for special attention to form. He was more eloquent about Rozanova, noting that her compositions display 'life, pattern-based decorativeness and feminine elegance (interior, writing desk, still life etc.)'. He pronounced Rozanova to be 'an artist with a great poetic feeling'.

For a Modernist show, the 1916 *Jack of Diamonds* exhibition was financially successful. It was visited by approximately 3,000 people. During its run the Art Salon organised several music and poetry performances, donating the proceeds from ticket sales for these and the main event to The Society for Assistance of Children of Reservists Called to the Army Service. 7,000 roubles were received from the sale of paintings. For instance, Aristarkh Lentulov recollected later that for him the exhibition was 'extremely lucrative', as he managed to sell all but two of his pictures and 'from that moment, so to speak, I received recognition in the market'. Whether or not Mikhailova had her share from the sale of paintings and what her profit (if any) might have been, remains unclear.

The *Jack of Diamonds* exhibition was without doubt the most lively and controversial show in the Art Salon in the last pre-revolutionary winter of 1916–17. However, it was not the most popular nor the most profitable, given that the annual Moscow exhibition of the World of Art group, which took place in Mikhailova's gallery from 26 December 1916–2 February 1917, was visited by an astonishing 12,000 people and the sum received from the paintings' sale amounted to 60,000 roubles, which was on a completely different level to the *Jack of Diamonds* show.

Critics reviewing the *World of Art* show in the Art Salon did not fail to notice that after the arrival of Ilya Mashkov and Petr Konchalovsky – the two major ex-members of Jack of Diamonds – the overall agenda of Petrograd-based society shifted towards a more pronounced Modernism. The majority of commentators

Petr Konchalovsky, *Agave*. Oil on canvas, 80 × 88 cm. The State Tretyakov Gallery, Moscow.

observed that the artistic orientation of the newcomers cancelled the supremacy of line over colour which had traditionally dominated the World of Art's distinctly 'graphic' style. In the words of one reviewer, the World of Art's traditional 'isms' – i.e. 'retrospectivism, aestheticism, graphism and utilitarianism' – were now replaced by 'the realm of form, volumes and colour appreciation'. Such a shift was generally accepted as a positive development. The other critic concluded that the transformed World of Art became more like a Russian *Salon D'Automne*, 'a kind of an eclectic marketplace for artistic talents' that made no distinction between their relative aesthetic directions. Thus, the group sacrificed its aesthetic unity for the sake of diversity based on a 'generally high level of culture and artistic capability'.

The two consecutive exhibitions of the Jack of Diamonds and the World of Art in Mikhailova's salon underlined the reinforcement of ever-increasing Modernist tendencies within the Russian artistic world. At the same time, the obvious disparity in the number of visitors and the financial outcome for the two exhibitions point to the fact that while the general public and critics were already prepared to

Ilya Mashkov, *Portrait of the Painter Adolf Milman*, 1916, oil on canvas, 167.5 × 142.5 cm. The Volgograd Museum of Fine Arts, Volgograd.

LAST ACT: THE BEGINNING OF THE END

accept and enjoy the art based on a moderate reconsideration of painterly form, space and colour, the most radical wing of the Russian Avant-garde aiming at pure abstraction continued to be relegated to the margins.

Barely had the *World of Art* exhibition closed its display in Mikhailova's gallery when the 1917 February Revolution began. The established course of life in the vast Russian Empire, which had been already severely compromised by three dramatic years of prolonged warfare, fell to pieces. At first, Moscow was less affected by the latest socio-political developments than Petrograd, where the upheaval had first erupted. However, by mid-March 1917, the radical transformations in Moscow were in full swing as well. The artistic treasures that belonged to the Crown were hastily nationalised. These included the whole complex of buildings within the Kremlin walls. Some other properties owned by those who left the country following the Revolution were also expropriated and occupied by various newly established revolutionary bodies. Thus, the elegant building of the Zimin Private Opera House, which neighboured the Art Salon on Bolshaia Dmitrovka Street, was taken over by the Moscow Soviet of Workers' Deputies, who soon re-opened it as the Theatre of the Soviet of Workers' Deputies. The storm was gradually approaching Mikhailova's gallery, but for some time she managed to resist its menacing gusts.

Moscow artists reacted to the ongoing process of socio-political remoulding by founding new artistic unions based – as it was proclaimed – on the progressive democratic values that would sweep aside the autocratic modes of 'the old regime'. These new-born organisations were emerging, splitting and re-combining at such a quick rate that it was almost impossible to follow their complex dynamics. Mikhailova did not seem to take any part in these frenetic activities. However, she could not ignore one union that was established post-revolution. It was the Society of Moscow School of Artists, founded on 15 April 1917 by a congregation of the Moscow School of Painting, Sculpture and Architecture alumni – her esteemed alma mater. The association's declared goal was 'to offer everyone who graduated from the School of Painting, Sculpture and Architecture an ample opportunity to prove his artistic abilities to the fullest extent independently from any directions and outside any group policy'. To achieve this noble target, the society intended to 'organise periodic exhibitions in Moscow and other cities in Russia'.

The Art Salon was an obvious place for arranging the society's events in Moscow. Hence, its first exhibition opened in Mikhailova's gallery on 29 August 1917, heralding the opening of the 1917–18 season. The historical backdrop to the beginning of this new artistic term was rather disturbing. Russia was going through a cataclysmic time. The Provisional Government was quickly losing its credibility and support, while the frontline was approaching Petrograd. Many contemporary commentators were fearing that the country was falling into the abyss of economic disintegration and full collapse.

No wonder, the show of the new society that ran until 26 September was a flop. The display, made up of works by twenty-nine young painters still in search of their distinct artistic style, failed to impress the observers. It was lacking variety and inspiration. Instead of marking a launch for a new exhibition initiative, the event shed negative light on the deteriorating quality of teaching at the Moscow School of Painting, Sculpture and Architecture. The poor quality of the exhibited works was blamed on 'the School's latest dull years of boring routine and endlessly repetitive, as everyday life, monotonous paintings'.

It turned out that the exhibition of the Society of Moscow School of Artists was the last event to take place in the Art Salon before the outbreak of the October Revolution. The establishment of Soviet power would completely reshuffle all aspects of social, political and cultural life in the country, eventually destroying the system of privately financed art activities in which both Mikhailova and Dobychina played such an important role.

5.2. Dobychina's Art Bureau in the revolutionary 1917

In January 1917 Dobychina wrote in a letter to her husband: 'There is a lot of work; sales are going well, thanks God.' This revolutionary year witnessed several remarkable exhibitions at the bureau, although the reality was rapidly unfolding often in front of the windows of Dobychina's gallery. While beautiful and rather decadent paintings by the World of Art artists were still on display, the great ceremony of the Funerals of the Victims of the Revolution was organised on the Field of Mars outside the bureau. That was the first secular outdoor ceremony in Russian history. In his diary, Alexandre Benois described how on 23 March 1917 he managed to get into Dobychina's apartment in spite of the guards by the front door, who would only let in those on the shortlist compiled by Nadezhda.

180 red coffins were carried solemnly across the Palace Bridge to the Field of Mars, where they were placed in a burial ground, which was later adorned with a special monument by Lev Rudnev. Formerly a place for popular fêtes and military manoeuvres, after the February Revolution the Field of Mars had gained a new symbolic meaning – now it became the successor of the Field of Mars in Paris, which had played a central part in the celebrations of the Festival of the Supreme Being after the French Revolution.

What was Dobychina's attitude to these dramatic events of 1917, the year which would change history and the future of Russia so irredeemably? Memoires of Iosif Gurvich held at the manuscript department of the Russian Museum may help to find an answer to this difficult question. Here, the former director of the museum described how in 1916 he told Nadezhda about his plans to join the Bolsheviks. Dobychina replied that the bureau was also in support of the revolutionaries and

that all the proceeds from the poetry recitals and concerts were donated to the good cause of the Bolsheviks.

From its inception, the Art Bureau intended to be much more than the gallery. In the first statement of its purpose, Dobychina had stated that in addition to the display and sale of the works of art, it was supposed to provide assistance 'in the selection and production of theatrical plays, concerts, opera performances and musical-literary evenings'. Hence, in 1912 the bureau took over the Evenings of Contemporary Music, which were first organised in 1901 in order to popularise European and Russian chamber music from the late nineteenth and early twentieth centuries, and were initiated and supported by Alexandre Benois and the World of Art artists.

On 28 November 1912, the first evening of chamber music by Aleksandr Borodin was held at the bureau. In 1913, the famous theatre director Vsevolod Meyerkhold held rehearsals of his studio of pantomime and drama at Dobychina's bureau and the Symbolist poet, Vladimir Soloviev, lectured on the use of masks in Italian comedies.

On 7 February 1914, an Evening of Contemporary Music, held in conjunction with the Tsioglinsky exhibition, attracted a standing-room-only crowd and included a performance of the most recent pieces by Gnesin, Prokofiev and Stravinsky. A

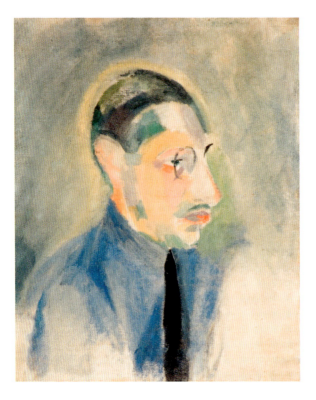

Robert Delaunay, *Portrait of Igor Stravinsky*, 1918, watercolour on paper, 65.5 × 54 cm. The New Art Gallery, Walsall.

review of this remarkable evening, published in the *Peterburgsky Listok*, stated: 'The idea of the music evenings with an interesting programme organised among the works of art, can't not raise everyone's piety. It reminds one of the Parisian salons.' Prokofiev left a note about this concert in his diary:

> The first part consisted of music by various composers: songs by Stravinsky and Sonata by Miaskovsky were quite interesting but badly executed. The second part of the concert was dedicated to me. There was only invited public. I performed the same programme as in Moscow with exceptional success. I had to listen to so many felicitations, adorations and exaltations as never before. … I was introduced to the artist Bakst, who very seriously interviewed me about my attitude to ballet. This conversation had a scent of Paris.

On 30 November 1914, an Evening of Poetry and Dance included readings of the poems by such leading authors as Anna Akhmatova, Mikhail Kuzmin, Georgy Ivanov, Osip Mandelstam, Fedor Sologub and Igor Severianin. The ground-breaking ballet, *The Bride's Choice*, which two years later would be performed at the Comedian's Halt cabaret, was executed at the bureau to great critical acclaim.

Photograph of Sergey Prokofiev, 1918.

Music notes of the song 'Kukushka', dedicated by Viacheslav Karatygin to Nadezhda Donychina, 1916.

On 10 January 1915, music by Rachmaninov followed a lecture 'On contemporary homes in England', organised by the Society of Architectural Knowledge. And on 2 May 1915, the Evening of Contemporary Music included latest pieces by Prokofiev, Skryabin, Liadov and Stravinsky. In his diary, Prokofiev admitted that during the concert he was distracted by rather mundane problems and 'played only a few short pieces and quite badly'.

These musical recitals were often organised by the leading musical critic of the time, composer, pianist and – like Dobychina – biologist by training, Viacheslav Karatygin, who remained Nadezhda's friend until his untimely death in 1925, and dedicated two romantic songs to her, 'Dozhd' and 'Kukushka'. On 20 March 1916, Karatygin's latest songs were performed at the Art Bureau by the greatest opera singer Feodor Chaliapin, who according to Gurvich's memoires, donated all the proceedings from this concert to the revolutionary activities.

Apart from the leading modern composers and opera singers, the most celebrated violinist, Jascha Heifetz, performed music by Chopin and Vivaldi at the bureau on 12 February 1917. It was Heifetz's last concert in Russia before he and his family emigrated to America. His next performance took place on 27 October 1917 at Carnegie Hall in New York, when he became an immediate sensation.

A businesswoman, Nadezhda Dobychina not only promoted young artists to achieve their fame as leading masters of modern art, she also helped to raise to their pedestal such composers and musicians as Scriabin, Prokofiev, Stravinsky and Heifetz. Whether she did so for profit or for political reasons, the impact of the exhibitions and concerts organised at her bureau is hard to overestimate.

On 3 April 1917, in the middle of political unrest, she opened the Exhibition of Finnish Art, by far the most socially conspicuous event of the season. It opened on the day when the leader of the Bolsheviks, Vladimir Lenin, together with twenty-nine revolutionaries, including the future Commissar of the Public Enlightenment, Anatoly Lunacharsky, arrived in Petrograd in a sealed train from Finland, after a decade of exile, to take the reins of the Russian Revolution.

The fact that the Minister of Justice and the future Prime Minister of the Provisional Government, Aleksandr Kerensky, and a foreign minister, Pavel Milyukov, took part in the opening ceremony of Dobychina's exhibition, proves the political significance of this event. The advisory board of the exhibition included the revolutionary writer Maxim Gorky, composers Karatygin and Prokofiev, the singer Chaliapin and the artists Altman, Repin, Grabar and Aleksandr Golovin. Alexandre Benois described in his diary that Dobychina even invited the 'grandmother of the Russian Revolution' herself, one of the founders of the Socialist Revolutionary Party, Ekaterina Breshko-Breshkovskaya, to the opening of the exhibition and asked her to deliver a short speech, in which the old lady thanked Finland for giving a refuge to the Russian revolutionary exiles.

Dobychina's exhibition was certainly not the first show of Finnish Art in Russia. Although Finland had enjoyed autonomy for the greater part of the nineteenth century, the vast majority of the Finnish-speaking areas of Sweden became a Grand

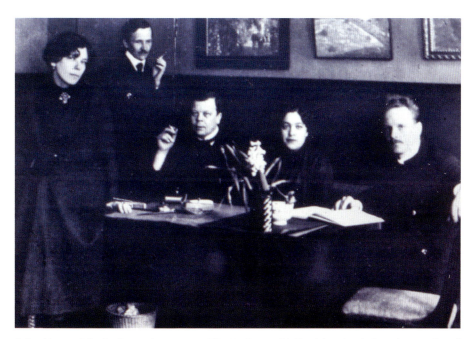

Dobychina and the Art Bureau's secretary, Eliza Radlova, with Finnish artists before the opening of the *Exhibition of Finnish Art*, 1917.

Duchy of the Russian Empire after the Finnish War of 1809. In 1898, the impresario and curator, Sergey Diaghilev, opened with great aplomb the *Exhibition of Russian and Finnish Art* in St Petersburg. He had presented a wide range of artists from Symbolists to Impressionists from the two neighbouring countries in the hope of cross-pollination and mutual reinforcement. The first issue of the progressive artistic journal *World of Art* (*Mir Iskusstva*), published in November 1898, promoted the pluralism embraced by Finnish artists. On 20 October 1897, Diaghilev wrote to his friend and collaborator, Alexandre Benois: 'I am now working on a magazine in which I hope to unite the whole of our artistic life, that is, as illustrations I shall use real painting, the articles will be outspoken, and then in the name of the magazine, I propose to organise a series of annual exhibitions, and finally, to attract to the magazine the new industrial art which is developing in Moscow and Finland.' In 1898 Benois had believed that: 'The joining together of us with the Finns was the means of expressing that "cosmopolitanism" in art which is our group [World of Art].'

In 1899, the most important modern Finnish artists took part in the International Exhibition, organised by the World of Art in St Petersburg, where their work was exhibited next to the French Impressionists. However, the artistic relationship between the Russian Empire and the Grand Duchy of Finland underwent rapid changes at the *fin de siècle*, as a consequence of wider social-political concerns. The February Manifesto of 1899, which required the Finnish parliament's subordination to Russian national laws and the tsar's approval, created further tensions between Finland and Russia, resulting in a halt in cultural exchange between the two countries.

The exhibition of Finnish Art at Dobychina's bureau offered a glimmer of hope for the resumption of vibrant dialogue between the artistic circles in Petrograd and its close neighbours. However, the closing borders and proclamation of Finland's independence in December 1917 put a stop to this initiative.

Prior to this, in April 1917 Benois, Gorky and Karatygin spoke at the opening of the exhibition about the great accomplishments of the Finnish artists and the spirit of brotherhood between the two countries encouraged by the changing political climate. An air of optimism and great hopes for the future which followed the February Revolution resulted in general excitement at the Art Bureau.

Due to the political significance of this exhibition, it was well covered in the press and diaries of cultural and political leaders. Benois described his conversations with the Cubo-Futurists Mayakovsky, Zdanevich and Burliuk. He understood Zdanevich's arguments for the reduction of the state control over artistic production but could not comprehend Mayakovsky's plea for the 'democratisation of the arts'. He admitted that their argument could have lasted for ten hours if Dobychina had not come to his rescue, leading him away from the ambitious youth.

After the official opening of the exhibition, a grand dinner took place in the most fashionable restaurant in Petrograd at the time, Donon. In his diary Benois complained that although the restaurant was renowned for its exquisite cuisine, the price of 15 roubles per person for a three-course dinner was too high. Furthermore, although a bottle of Champagne was 45 roubles and a bottle of vodka 60 roubles, the Finnish artists managed to get drunk rather quickly and offered several long toasts, much to the amusement of the Russian guests. The lavish dinner was followed by a dance and continued until 2.00 am, although most artists moved to the Comedians' Halt cabaret – the celebrated neighbour of the Art Bureau. According to David Burliuk, around midnight when most guests decided to move to the Comedians' Halt, Maxim Gorky was supposed to go to the railway station to meet Lenin off the train from Finland. However, at the last minute he opted to stay at the party and joined the artists at the cabaret.

Despite the grand opening and all the political intrigues, the exhibition was characterised by Benois as 'grey and sluggish'. He concluded that the Finnish display was opened in 'the inconvenient moment' when life was more about survival than the enjoyment of art. 273 paintings by twenty-seven artists and nineteen sculptures were included in the exhibition, the only international show in Russia during the First World War. Due to the ongoing war, works by the most renowned Finnish artists – Magnus Enckell, Pekka Halonen and Ville Vallgren – were trapped in Europe and the United States, and were never shipped to Russia. Paintings by the famous Akseli Gallen-Kallela were stranded in Sweden, although the artist attended the exhibition opening at the Art Bureau with his son.

The Nobel prize-winning Russian author, Ivan Bunin, agreed with Benois that the timing of the exhibition was rather unfortunate. In his celebrated book, *Cursed Days*, he wrote:

> We thought that we didn't care about paintings at the time, but it turned out that we did. We were hoping to have as many people as possible at the opening. And the whole of St Petersburg came … . And everyone just begged the Finns to send Russia to hell and live freely.

Maxim Gorky was full of praise for the exhibition. He lamented: 'Now, when Finland is free from the Russian Tsarist power, as unwilling participant of this imperial oppression, I would like to exclaim "Long Live Finland!"' In the works displayed at the bureau the writer encountered 'the greatness of the human spirit and the all-conquering power of intelligent labour'. The artist Konstantin Somov called the day of the opening of the Finnish exhibition 'fantastic'.

In Dobychina's archive at the Manuscript Division of the National Library in Moscow, there is a handwritten translation of the review of the exhibition, written by the curator of the gallery of the Finnish Art Association, architect Gustaf

Strengell, and entitled 'What and Why is Lacking at the Finnish Art Exhibition?' Here the author criticised the show at the bureau for lack of retrospective approach, which prevented visitors from understanding the history of Finnish art. Strengell explained that the exhibition had many gaps which could only be filled by works from the private collections in Finland. However, due to ongoing war the collectors were too scared to send their works for an exhibition in Petrograd. The author was hoping that this could be rectified in another exhibition in the near future.

Despite a mixed reception, the Finnish exhibition became a real highlight in the calendar of one of the most challenging years in Russian history. Following its closure on 10 May 1917, Dobychina was hoping that it would travel to Finland, but these plans never came to fruition. Due to ongoing political unrests, the bureau remained closed until an exhibition of sketches by contemporary artists opened on 11 November 1917. Rather surprisingly, it was attended by 1,500 people striving to find refuge from the rapidly unfolding chaos and anarchy on the streets of the beautiful Imperial city. Since sketches were quite cheap, many were sold and a respectable sum of 23,000 roubles was raised.

5.3. The Art Salon after the October Revolution: the closing chapter

Despite the revolutionary upheaval, the Art Salon offered the Moscow public two noteworthy exhibitions in the course of the winter 1917–18. One was the fifth and – as it happened – last exhibition of the Jack of Diamonds group that ran from 21 November–3 December 1917. The process of the radicalisation of this society's aesthetic direction, initiated by Malevich and his fellows in the spring of the previous year, continued its course. In autumn 1917, Malevich was elected its chair while some old members, including Lentulov, Falk, Kuprin and Rozhdestvensky, followed in the steps of Mashkov and Konchalovsky and left the Jack of Diamonds for the World of Art. Moreover, conflicts of interest within the Jack of Diamonds' radical wing prompted Popova, Udaltsova, Tatlin (who had joined the association only a short while earlier) and their allies to surrender their membership as well. This important change in in the composition of the society dramatically transformed the Jack of Diamonds' profile: Malevich received carte blanche to rule as he pleased. The cover of the fifth *Jack of Diamonds* exhibition catalogue defiantly displayed the image of the *Black Square* – Malevich's notorious masterpiece proclaiming the end of the old figurative art and the onset of the new era of Suprematism. By some cruel, ironic coincidence, this messianic assertion represented a perfect visual symbol of the historical events unfolding in the real life of the vast country.

The fifth *Jack of Diamonds* exhibition ran for only two weeks. Such a short timespan, unusual for an annual display of an important art society, was most

Catalogue of the fifth Jack of Diamonds exhibition. 1917.

likely due to the historical events rather than any other reason. In fact, less than a month before the opening of the show, the October Revolution took place. The Provisional Government was deposed and Russia entered an era of profound reshuffling of all its ideological, social and economic foundations. The grim predictions of Alexandre Benois, who dreaded that the eventual Bolshevik seizure of power would 'directly uproot the entire culture, scattering its keepers and ruining everything that had been accumulated and educated' came true. The end of 1917 and the following two years proved to be a traumatic time of rapidly deepening economic crisis, during which Moscow experienced sky-high inflation and serious supplies shortages, including electricity and fuel. The major Moscow museums were shut. The established lifestyle had to be re-adapted to the harsh post-revolutionary reality.

According to the majority of commentators, the Jack of Diamonds display showed beyond doubt that after a farewell of its founding fathers, the society

Olga Rozanova, *Green Stripe*, 1917, oil on canvas, 71.5 × 49 cm. Rostov-Yaroslavl Museum of Architecture and Art, Rostov.

had become an empty shell 'with no meaningful content which filled-in its vacant space with all sorts of bits and bobs'. The exhibition, in the words of *Apollon*'s critic Rosstsy (pen name of Abram Efros), looked like a 'good old patchwork blanket' stitched out of disparate pieces, some of which were of really poor quality, chosen only to 'cover available walls'. Yet, some other reviewers conceded that abstract compositions of the reformed Jack of Diamonds had a certain value for the overall development of contemporary art, due to their strong focus on colour tonality, surface texture and quality of brushstrokes. History proved their opinion right and not only in relation to Suprematist canvases by Malevich, Kliun and their followers but also regarding the talented Olga Rozanova. Her seventeen non-figurative canvases offered another original version of abstract painting. Based on valorisation of colour as the major autonomous feature in painting, Rozanova's experimental works, fittingly called 'Colour', created a startling visual effect of an utmost luminosity as in her now celebrated work, simply called *Green Stripe*.

However, the best reviews landed with Aleksandra Ekster. Indeed, out of the 314 items exhibited at the show, more than one hundred works belonged to her.

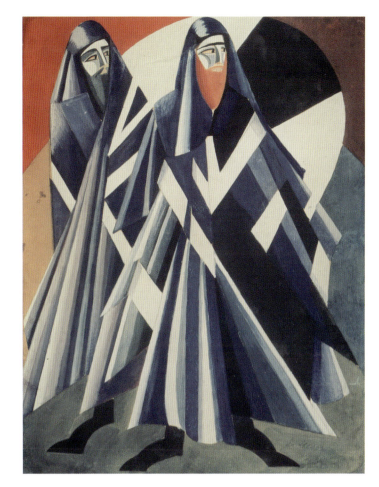

Aleksandra Ekster, *Two Jews*. Costume design for Oscar Wilde's *Salomé* in the Kamerny Theatre, Moscow, 1917, gouache and bronze pigment on cardboard, 67 × 52 cm. State Bakhrushin Theatre Museum, Moscow.

Twenty-six were designs for her recent theatrical project, *Salomé*, for Tairov's Kamerny Theatre, sixty-seven canvases titled 'Painting 1907–1917' represented Ekster's oeuvre of the previous ten years, and the rest illustrated her engagement with decorative arts. Rosstsy called the arrangement of Ekster's work 'the most attractive part at the whole exhibition'. He praised her as 'a woman artist of huge temperament, one of the most clever and consistent followers of Cubism … who now demonstrated her talent in full extent'. As Malevich's scholar, Aleksandra Shatzskikh, rightly observed:

That was a large-scale solo exhibition within the framework of the *Jack of Diamonds* show. Such an extensive monographic display remained the first and the last in the earthly life of this outstanding woman artist.

The exhibition's closing day was marked by a debate, with a puzzling title, 'Painting on fences and literature'. Weird as it might seem at first sight, such a subject was actually in tune with the latest developments in the field of visual arts

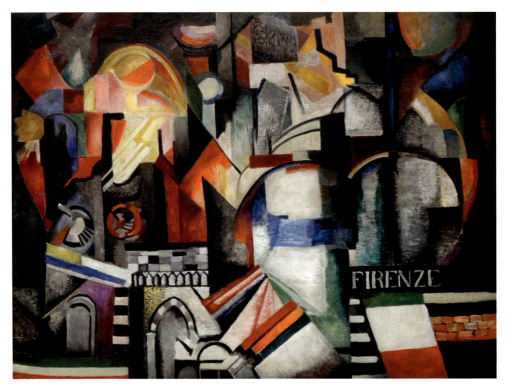

Aleksandra Ekster, *Florence*, 1914–1915, oil on canvas, 100 × 146 cm. The State Tretyakov Gallery, Moscow.

conjured up by revolutionary events. It coincided with the Bolshevik government's campaign for visual propaganda, which invited artists, writers and poets to forcefully promote the new Bolshevik ideology in their works. Following the logic of agitprop, the new revolutionary slogans should have been omnipresent, occupying as much public space as possible. Kazimir Malevich, David Burliuk and Vasily Kamensky – the debate's main organisers and participants – essentially took the same line, calling upon the artistic intelligentsia to actively engage with revolutionary themes, applying their creations to street walls, fences and any other available surface to make their messages easily accessible to the general public.

There is no evidence that Mikhailova was in any way involved with organising the *Jack of Diamonds* exhibition and dispute. Like many times in the past, she must have acted on this occasion as a landlady simply renting her gallery space to rebellious radicals. Certainly, her relations with Malevich were never as close and collaborative as they were with Larionov or Kandaurov. That said, Mikhailova seemed to have established a solid link with the Suprematist wing of the Russian Avant-garde, as its next important event, the *Second Exhibition of Modern Decorative Art*, took place in her gallery from 6–19 December 1917. The display featured

Oliver Seiler, *Fragment of the display of 'The Second Exhibition of Modern Decorative Art' in the Art Salon*. Malevich's design for embroidered cushion (centre). Photograph, 1917.

approximately 400 embroidered items executed by craftsmen and women of the Verbovka art colony owned by the art patron and painter Natalia Davydova. She had founded her arts and crafts colony in 1900, near Kiev, for the purpose of providing the local population with a secure means of income. In 1915–16 Davydova, who was always attentive to the latest development in visual arts, employed a group of Avant-garde artists, including Kazimir Malevich, Aleksandra Ekster, Ekaterina Vasilyeva, Georgy Yakulov, Ksenia Boguslavskaya and Ivan Puni, to supply their Modernist designs for her colony's artisan production. In November 1915, Davydova and Ekster organised the *Exhibition of Modern Decorative Art* at the Lemercier Gallery in Moscow. The event had a considerable critical and financial success, introducing the Russian public to proto-Suprematist non-figurative experiments by means of applied art. Apparently Davydova, who by then had adopted Malevich's Suprematism for her own artistic practice, felt more at home in Mikhailova's salon, thus choosing it as a venue for the second exhibition of her flourishing enterprise.

Severe hardship of everyday life in the post-Revolutionary Moscow impinged on the public success of the *Second Exhibition of Modern Decorative Art*. No

catalogue of the event has survived, if indeed one ever existed. A number of contemporary photographs and some sparse remarks in memoir literature remain the only sources of information. However scarce, that material still allows one to assume that stylistically the show was dominated by Suprematism-based geometric designs. The painters who had already participated in the first decorative exhibition in the Lemercier Gallery were joined by others whom zealous Malevich managed to convert to his artistic method. These included Liubov Popova, Olga Rozanova, Vera Pestel and Nadezhda Udaltsova. Verbovka's embroideries and other decorative items displayed in the exhibition bore close affinity to the Suprematist paintings produced by participating artists at around the same time. There were no full-scale reviews of the exhibition. A short two-line mention in the newspaper *Early Morning* (*Rannee Utro*) reported that the visitors were struck by 'the jubilant shining of dazzlingly coloured silks arranged together in the boldest combinations in works by A. Ekster, N. Davydova, K. Boguslavskaya and others'.

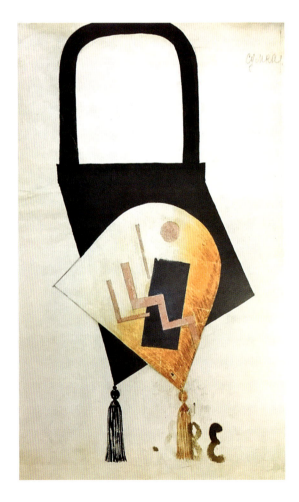

Olga Rozanova, *Purse Design*, 1917, watercolour on paper, 45 × 33 cm. State Kustodiev Picture Gallery, Astrakhan.

The *Second Exhibition of Modern Decorative Art* was the last big show in Mikhailova's gallery. Her final rent payment dates to 1 March 1918. Soon thereafter, the building on Bolshaia Dmitrovka 11, where the Art Salon resided, was nationalised and came under the control of the People's Commissariat for Education, best known as *Narkompros*. The gallery kept its original name – the Art Salon. Its halls continued to be used by the new authorities as a popular exhibition space until 1924, when it was finally closed and rearranged to serve other needs of the Soviet State.

After the expropriation of her venture, Klavdia Mikhailova went back to her main professional vocation and spent the rest of her life working as an artist. Her natural propensity for fairy tale subjects was not particularly in tune with the ideology of the new proletarian culture, so she had to gradually adapt her art to much more realist themes, producing landscapes and scenes of Soviet life. However, even as late as the 1930s she continued to cherish the idea of organising a solo exhibition of her Symbolist and fairy tale paintings. She even outlined her plans in a written statement, under the eloquently bitter title 'Notes to the catalogue of my future, most probably posthumous exhibition'. In this text she described her canvases as 'the result of tenacious endeavours and arduous explorations of all my not-so-short life. Until now I have always put on exhibition display only few selected works, but I firmly believe that it was meaningless to show them separately from the rest of my oeuvre. I always thought that in order to appreciate them in full

Klavdia Mikhailova, *Kolkhoz Farm Herd*. Oil on canvas, size and whereabouts unknown, 1930s.

the viewer must stop in front of them, must delve into them and into the world in which they exist, the world that excites by its depth of colour and meaning, the world of the ancient folk tale of which many people think superciliously if at all.' Evidently, various sharp vicissitudes of fortune did nothing to change the inner romanticism of Mikhailova's personality. Even in the twilight of her years she 'still remained the same good idealist, may God bless you', as one of her oldest friends put it tenderly in their correspondence.

Fate dealt Mikhailova a cruel hand. In the harsh winter of 1918–19 her apartment became uninhabitable for the absence of heating. The situation was so desperate that her closest acquaintance, the celebrated sculptor, Anna Golubkina, who enjoyed special treatment from the Soviet powers due to her revolutionary background, offered Klavdia's family her studio and her own ration of fuel to save them from the risk of peril. In 1921 Mikhailova's sister, Olga, died, and her own health quickly deteriorated. In the early 1920s her arthritis became so bad that one of her legs had to be amputated and she had to walk on crutches for the rest of her life.

There was some consolation in the fact that people who had known her previously – her old friends, colleagues and acquaintances – did not forget her and gave a helping hand from time to time. Thus, as early as 1918 she was accepted as a full member of the Professional Union of Moscow Painters, which confirmed her professional status and gave her access to exhibitions and other activities organised by the society. In 1932, she joined the Moscow Regional Union of Soviet Painters which in 1938 was renamed as the Moscow Union of Soviet Painters. In 1927 she was granted a personal state pension, following the petition of a group of some influential figures in Soviet culture, who included her good contacts from the time

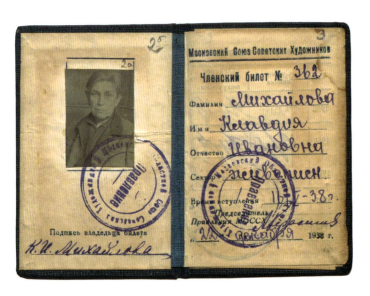

Mikhailova's Membership Card for the Moscow Regional Union of Soviet Painters. 1930s. Russian State Archive of Literature and Art RGALI, Moscow.

TWO WOMEN PATRONS OF THE RUSSIAN AVANT-GARDE

of the Art Salon – Yakov Tugendkhold, Abram Efros, Vitold Belianitsky-Birulia, Igor Grabar, Vasily Rozhdestvensky and Aleksandr Gerasimov. In their recommendation letters they particularly highlighted Mikhailova's 'exceptional contribution to national culture', both as an organiser of one of the most important exhibition centres in Moscow and as a gifted artist.

Mikhailova's only child – a daughter, Natalia – married the artist Vasily Rozhdesvensky in 1920. Rozhdesvensky had been one of the founding members of the Jack of Diamonds group. Despite a twenty-year age difference, they were a happy and devoted couple. Natalia became a scholar of Russian folklore and also acted as Mikhailova's artistic agent, managing her mother's participation in various art exhibitions. Undeterred by her poor health, Mikhailova continued to take on commissions and produce paintings until at least the spring of 1941. She died in 1942, in Moscow, of peritoneum cancer at the age of sixty-six.

Five years spent at the head of the Art Salon might seem but a short fraction of Klavdia Mikhailova's 'not-so-short life', yet her endeavours left an important and memorable imprint on Russian artistic life of the early twentieth century. There was a reason as to why a decade after her gallery had been expropriated, Yakov Tugendkhold in his letter to Soviet authorities wrote: 'For a number of years the Mikhailova's Art Salon was almost the only place in Moscow where it was possible to conduct cultural and educational activities for the popularisation of art … and where the developments of artistic youth were shown to the public.' His statement was endorsed by the two of Mikhailova's ex-employees who declared: 'We worked in her gallery and confirm that she did not seek profit, but worked for the benefit of art.' These words make a fitting epitaph to Klavdia Mikhailova's remarkable life story.

Klavdia Mikhailova. Photograph, late 1930s.

5.4. Facing up to new realities: Dobychina

After the October Revolution, Benois's Arts Commission for the preservation of palaces and works of art held regular meetings at Dobychina's Art Bureau. The troublesome season of 1916–17 closed with an auction of one of the most notable collections of old Russian masters in Petrograd, which belonged to the banker Nikolay Smirnov. He was hoping to open a public gallery dedicated to his collection, but following the revolution decided to sell it to the Russian Museum. Faced with rejection, he hired the bureau for a short exhibition (21 December 1917–3 January 1918) and a public auction.

Following the closure of this brief exhibition, the spacious rooms of the Art Bureau were occupied by the annual *Contemporary Painting and Drawing* show. According to the catalogue, there were 212 works by thirty-five artists from the stars of the Russian Avant-garde, including Marc Chagall, Liubov Popova and Aleksandra Ekster, to the World of Art artists, including Alexandre Benois. Unlike previous exhibitions at the bureau which attracted the attention of the most progressive art critics, this show received little attention in the press, largely due to political turmoil and the fact that most non-Bolshevik newspapers had already closed down. In its last issue, the prestigious journal *Apollon* published a short review by Nikolay Radlov on this exhibition, who remarked on the 'archaic combinations of triangles' by Popova and 'unnecessary' stage designs for Oscar Wilde's *Salomé* by Ekster. Apart from paintings and drawings, a handbag, teapot cover and a cushion by Ksenia Boguslavskaia – recently shown at Mikhailova's exhibition of decorative arts, *Verbovka* – were on display.

On 17 February 1918, Benois wrote in his diary: 'At our exhibition there are lots of people but no sales. Only the Academy of Arts is bargaining for four works.'

Following this exhibition, in June 1918 the posthumous retrospective of Dobychina's best friend and mentor, Nikolay Kulbin, who had died on 6 March 1917, opened its doors to the public. It was the second solo show of 'the crazy doctor' (this nickname was given to him by the artists). The first exhibition of Kulbin's work took place in 1912 at the Society for the Encouragement of the Arts. The exhibition attracted quite a lot of attention from the critics, who remarked that Kulbin had obviously inherited a psychiatric disorder from some of his patients which found expression in his art.

If in 1912 critics mainly laughed at the paintings by Kulbin, which looked too amateur to most visitors to his exhibition, in 1918 they largely ignored his retrospective due to ongoing political unrest and the rapidly changing situation on the art front. Moreover, it was quite symbolic that the Art Bureau, which was largely inspired by Nikolay Kulbin, was closed down shortly after his solo show.

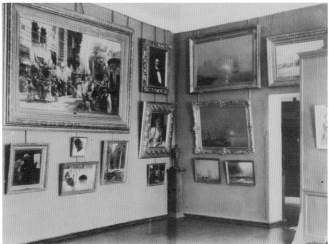

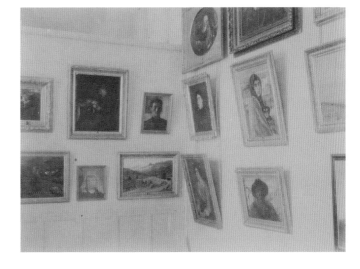

Photographs from the exhibition at the Art Bureau which preceded the auction of paintings from the collection of Nikolay Smirnov, December 1917.

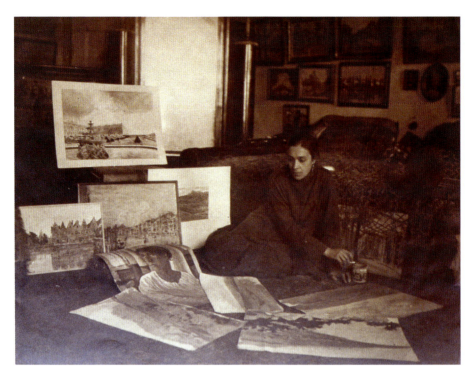
Dobychina sitting on the floor of the bureau, selecting works for the annual *Contemporary Painting and Drawing Exhibition*, 1917.

1918 witnessed state nationalisation and the crash of the art market. In autumn 1918, the All-Russian Central Exhibitions Bureau was formed at the Moscow Branch of the Visual Art Department of the *Narkompros* and a 'Decree on the Exhibitions' was shortly issued. This document, which was ironically written by the same Avant-garde artists who Dobychina had exhibited at her bureau, stated that all the exhibitions in Russia should be organised by the state in order 'to free the artists from the exploitation' and 'to create the people's culture'.

Following the October Revolution, Bolsheviks proclaimed, 'Art belongs to the People'. The nationalisation of works of art soon followed this plausible statement. In early 1918, the Hermitage Museum had offered to 'accept for temporary conservation' the works of western European art from private collections. This was a time when starvation and theft were rife, so quite a number of people entrusted their precious treasured paintings, sculptures and jewellery to the museum. Most of them knew they might never see their collections again, but were hoping that by donating their works of art they would secure a place in the new 'society of workers and peasants'. On 14 November 1918, a new decree was announced. From now on, none of the works of art which had been given to the Hermitage for restoration, valuation or temporary conservation could be taken out

of the museum under any circumstances. 'Expropriation of the expropriated' had started.

On 2 October 1918, Nadezhda Dobychina wrote bitterly in her diary:

> How can I express in words – I have just closed down the Art Bureau! I have just lost a child! My poor heart! Why are you beating so rapidly and occasionally stop completely, what is going on? You should understand, my silly heart, that all the best in life is dying, but something new, perhaps even better, comes round instead. But you refuse to accept it and you would prefer to lead the old life instead. One must think of the new ways of life and live on.

Dobychina refused to give up and decided instead to fight against the almighty state machine. On 20 November, she organised a meeting at her apartment (which was still referred to as the Art Bureau by the artists) to discuss the recently announced 'Decree on the Registration and Conservation of the Works of Art in the Possession of the Private Individuals, Societies and Institutions'. Dobychina still owned a large collection of paintings, purchased or left from her exhibitions, and she had no intention of giving them away.

This meeting was attended by the leading artists of the World of Art – Benois, Somov, Dobuzhinsky and Sergey Chekhonin, as well as private collectors and museum curators. Benois wrote in his diary that 'several collectors and artists

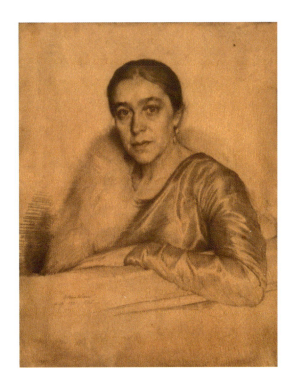

Petr Neradovsky, *Portrait of Nadezhda Dobychina*, 1921, pencil and sanguine on paper. Collection of Daniil Dobychin.

expressed their concerns that neurotic losers would visit the artists' studios and private collectors, disguised as state officials, demanding full disclosure of the artworks in their possession'. In her letter to her husband of 21 November 1918, Dobychina wrote that at the meeting it was decided to send a delegation to Moscow, and Nadezhda was asking her husband to help them, via Rykov, to meet Lenin at home.

Instead of fighting against the challenging reality, Dobychina decided to live with it. After the state monopolisation of the art market and the closure of the Art Bureau, she became one of the organisers of the *First State Exhibition of the Works of Art*, which opened in April 1919 in seventeen grand rooms of the Winter Palace (which was renamed the Palace of the Arts after the revolution). Formed on the same principle as Dobychina's exhibitions of contemporary art, it included over 1,800 works by 359 artists from all the artistic movements active in Petrograd at the time.

The collection of the works for this extraordinary exhibition, which was accessible and open to everyone (participation was free, as was entrance) was announced on 27 November 1918. In her letter to her husband written on the same day, Dobychina described her meeting with Lunacharsky in the presence of Benois. She stated that the Minister of Public Enlightenment spoke to her in a very insulting manner. He offered her 2,000 roubles for her curatorial work but she refused to accept. She wrote that Lunacharsky was very biased against her, hoping that she would calm down and retreat.

The decree establishing the exhibition proclaimed that the state would only pay for the organisation of this exhibition, but would not participate in the selection of works of art for it. Thus, each participant, rather than the state, was responsible for the success of this exhibition. Apart from professional artists, workers were especially encouraged to participate in this 'free exhibition'. An article, published in the first issue of the newspaper *Art of the Commune*, announced:

> The Department of Visual Arts is taking every possible measure to show at the exhibition some paintings by workers. With this in mind the Department decided to get in touch with the Unions of Workers. The Department is also planning to issue an appeal to all workers, asking them to bring their paintings to the Palace of the Arts, where they will be very welcome.

Organisation of the exhibition on this scale must have seemed like complete madness at a time when the electricity supply in Petrograd was intermittent and strictly rationed food coupons replaced money. New posters calling people to fight fleas and ticks decorated most houses in the centre of this beautiful city at the time of this disaster. Political posters filled the empty shop windows. To make matters worse, starving, desperate people were not allowed to leave Petrograd.

The only chance to desert a sinking ship was to join the Red Army (mobilisation began in February 1918).

Nevertheless, in January 1919, the exhibition started being assembled. However, since it was mid-winter and the rooms of the Palace of the Arts were very draughty and the heating non-existent (temperatures were often -12C), work on this grand showcase of contemporary art took more than three months.

In spite of all these obstacles, this amazing exhibition opened on 13 April 1919. Despite all the obstacles, it was attended by nearly 40,000 visitors and had a mainly positive response in the media.

The only artist who attracted seriously negative criticism was Ivan Puni – the frequent participant of the exhibitions at Dobychina's Art Bureau. In the newspaper, *Northern Commune* (*Severnaya kommuna*), one of the critics wrote about Puni's plate on a wooden board: 'The Public is stopping by Puni's work in bewilderment. And it is really impossible to understand how his plate on a wooden board is related to art. Not a painting, not a drawing of a plate, but an ordinary plate, attached to a wooden board …'

Despite Dobychina's efforts to educate art critics and exhibition-goers in the new art, non-figurative works still proved to be a challenge to most of them.

Following this successful exhibition, Dobychina became the head of the exhibitions department of the Petrograd branch of *Narkompros*. She was also in charge of exhibitions at the House of Arts, which was founded by Maxim Gorky on 19 November 1919, in order to help artists, writers, actors and theatre directors survive the challenging conditions of frozen, starving Petrograd at the time of the Civil War. Here they could get food rations and fire logs, as well as attend an exhibition or a lecture.

Despite the challenging and rapidly changing political situation, Dobychina was still actively involved in the artistic life of Petrograd. In 1920–21 she even commissioned the most prominent members of the World of Art, Konstantin Somov and Aleksandr Golovin, to paint her portraits. Her efforts to support artists did not stop with the closure of the Art Bureau; during the 'hungry years' which followed the October Revolution she remained at the forefront of artistic activity and continued to support the artists by exhibiting their works.

At the same time, her private life also reflected the new Soviet reality in which marriage was no longer seen as a sacred union between one man and one woman. The new Code on Marriage and the Family (1918) established a legislative framework that clearly aimed to facilitate the breakdown of the traditional family. It removed the influence of the Church from marriage and divorce, making both a process of simple registration with the state. At a time when marriage lost its spiritual and religious foundations and the commitment to the Communist party and its collectivist values was regarded more highly than the commitment to your

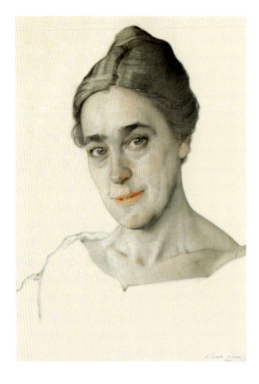

Konstantin Somov, *Portrait of Nadezhda Dobychina*, 1921, lead and coloured pencils, sanguine on paper, 41 × 29 cm. KGallery, St Petersburg.

spouse and children, multiple relationships became a norm rather than an exception. 'People can come together, and then part. This depends upon circumstance and upon temperament,' wrote Anatoly Lunacharsky in 1927.

In their diaries, both Benois and Somov describe meeting 'Dobychina accompanied by her two husbands'. In the 1920s, Nadezhda combined life with her husband Petr and their son Daniil with an open affair with Ruben Drampian, a law graduate of St Petersburg University and a close friend of Benois and the World of Art artists. In 1923, Drampian received an invitation to return to his native Erevan in order to organise the new National Art Museum in Armenia. His departure signalled the end of this short-lived affair for Dobychina, although their friendship remained strong and in 1928 he helped his former lover sell a painting by Goncharova from her private collection to the State Museum of Armenia.

After Drampian's departure, Nadezhda started another affair with the former deputy of the First Duma (1906), Mikhail Vinaver. On 7 November 1924, she sent him a beautiful photograph of herself with a handwritten dedication on the back: 'To the most beautiful person, Mikhail L'vovich Vinaver, from the frivolous but deeply loving Nadezhda Dobychina.' Under this dedication, she wrote: 'My beloved. Please do not tell anyone.'

In 1921 they had both worked for the Political Red Cross – the organisation which was founded in St Petersburg in 1874–5 to help political prisoners. In 1921,

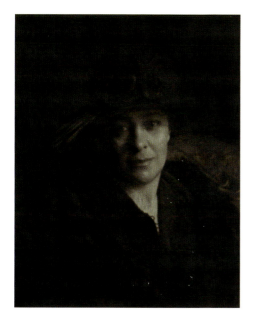

Photograph of Nadezhda Dobychina, given by her to Mikhail Vinaver, 1924.

Verso inscription on a photograph of Nadezhda Dobychina, given by her to Mikhail Vinaver, which reads 'To the most beautiful person, Mikhail L'vovich Vinaver, from the frivolous but deeply loving Nadezhda Dobychina. Petersburg, 7 November 1924. Darling, please do not tell anyone.'

ambitious and fearless Dobychina was elected the vice-president of the Political Red Cross.

Although the Civil War was drawing to a close, the Bolsheviks faced yet another counter-revolutionary revolt from within. The Communist free-market economy had left the country in ruins. In 1920–21, many factories in Petrograd had closed due to a lack of fuel; there were almost no street lights and the population of the city was reduced from 2 million at the beginning of 1918 to 722,000 in 1920. In March 1921, 20,000 deeply dissatisfied seamen held a mutiny at Russia's largest naval base, Kronshtadt, which was put down very brutally.

This uprising on Petrograd's doorstep had many resonances, resulting in a wave of arrests which directly affected members of cultural elite in the Imperial capital. In connection with the fabricated 'Case of the Petrograd Military Organisation,' around 200 people were imprisoned. Their main crime was that at some point they had met (in some cases without knowing it) Vladimir Tagantsev, who was a reader in Economic Geography at St Petersburg University. He was incriminated as a leader of the Petrograd Military Organisation and was accused of terrorism. Seventy-one years later, in 1992 the State Office of Public Prosecutor made

an official statement confirming that the Petrograd Military Organisation never existed but was artificially created by the committee of inquiry out of several groups which were, or might have been, concerned with sending money, jewellery and emigrants abroad.

At the end of June 1921 Tagantsev was arrested for the illegal possession of a large amount of money, and on 1 July his wife was also arrested. Thereafter, events began to move rapidly. A few other political groups were rounded up at the same time, and soon sixty, and then another thirty-four people were shot without any explanation or investigation.

Among those arrested were the most prominent art critic Nikolay Punin, the famous poet Nikolay Gumilev (who was shortly thereafter shot) and the brother of Alexandre Benois, Mikhail.

On 6 August 1921, Benois recorded in his diary that 'today at 5.00 am my brother Mishen'ka [diminutive form of Mikhail] was arrested. It was done so quickly and quietly that even the neighbours have not noticed anything.' Early in the morning he went to Dobychina, asking her for help. She promised to do everything she could to try to apply for his immediate release.

A day later, on 7 August, one of the greatest Russian poets, Aleksandr Blok, died at the age of forty-one. Shortly before his death, Blok, who had welcomed the Bolshevik Revolution and supported it wholeheartedly, would give speeches with his eyes closed, 'so as not to see those apes'. His faith in the Bolshevik Revolution was first shaken by his arrest in 1919 on suspicion of conspiracy. By 1921 Blok was mentally and physically exhausted. He developed inflammations of the inner lining of his heart and of his brain. Gorky and Lunacharsky appealed to Lenin to let the poet go to Finland for treatment, but the Politburo initially refused to let him go and when it finally did change its mind, it was too late. The jaded Lunacharsky wrote in a secret letter to the Central Committee of the Bolshevik Party: 'There will be no doubt and no refutation of the fact that we killed Russia's most talented poet.'

The cultural elite of the old capital, including Nadezhda Dobychina, gathered to bid farewell to one of the leading lights of the Russian Symbolist Movement. His death signalled a time of disillusionment for the members of intelligentsia, exacerbated by the Civil War, rooted as this was in the distress caused by way the Bolsheviks had seized power. Along with many famous artists, major writers and poets started heading west, including Ivan Bunin, Aleksandr Kuprin and Konstantin Balmont. In 1922, the most famous Russian opera singer, Feodor Chaliapin, had also left Russia, following his belief in 1921 that in the Bolshevik state 'liberty had been turned into tyranny, fraternity into civil war, and equality meant stomping down anyone who dared raise his head above the level of the swamp'.

Shocked by the tragic and untimely death of his friend Blok, the disillusioned Maxim Gorky left Russia in October 1921, and lived in Italy until 1929.

Funeral of Aleksandr Blok, Petrograd, 7 August 1921.

Another star of Russian literature, Anna Akhmatova wrote in 1921:

> … What had happened to the capital?
> Who had lowered the sun to the earth?
> The black eagle on its standard
> Seemed like a bird in flight.
> This city of splendid vistas
> Began to resemble a savage camp,
> The eyes of the strollers were dazzled
> By the glint of bayonet and lance.

Nadezhda Dobychina took a conscious decision to stay in Russia. In 1922, the Political Red Cross was closed down and she was hoping to re-open the Art Bureau.

At the time, in response to the rising tensions in society, the New Economic Policy (NEP) was launched to replace the failed policy of post-revolutionary war communism. While Lenin saw the NEP as an interim measure, he justified it by insisting that it was 'state capitalism', thus different in kind from all other capitalism. The market economy was resurrected, and private trade and the leasing of enterprises were permitted again. The shelves in the shops were full once more,

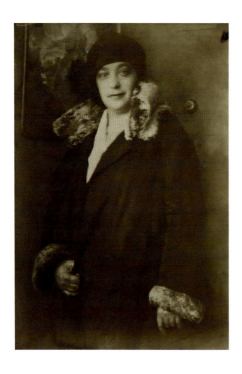
Nadezhda Dobychina, c.1920.

restaurants re-opened and city life regained its vibrancy. This freedom did not last long – in 1928 Stalin replaced the NEP by Central Planning and the first Five-Year Plan was announced. However, for a few years for many, including Dobychina, it felt that there was hope for resurrection of the art market, commercial exhibitions and private art acquisitions.

On 19 May 1923, Benois remarked in his diary that he was desperately trying to persuade Dobychina that it was the wrong time to resurrect the bureau. Nadezhda was rather concerned that the powerful Union of Art Workers (SORABIS) blamed her for exploiting artists before the revolution. Benois commented in his diary that this accusation was completely groundless, since through her exhibitions and acquisitions she had saved, rather than exploited, many artists.

The headstrong Dobychina was planning to travel to Moscow to persuade the authorities that she was innocent in her pre-revolutionary activities and to acquire permission to re-open the Art Bureau as an art shop, where she would work as a director. Rather predictably, this ambitious plan was never realised.

In 1922–4, Dobychina worked as head of the exhibitions department at the Society of Encouragement of the Arts. She was striving to open an art shop at the society as well, but this project was doomed to fail. Instead, she organised art auctions at the society, although according to Benois, 'paintings and drawings sold for next to nothing, even if they were framed and glazed', and often the frame was more expensive than the final price achieved at auction.

Osip Braz, *Portrait of Anton Chekhov*, 1898, oil on canvas, 102 × 80 cm. The State Tretyakov Gallery, Moscow.

Although Dobychina tried to stay away from political affairs, when the leading World of Art artist, Osip Braz, was suddenly arrested in 1924, she tried to use all her contacts to help his release. Braz was sentenced for buying paintings in order to sell them abroad, as well as espionage, and was sent to the recently set up Solovki special camp (later the Solovki Special Prison). In July 1924, Dobychina tried to help him, since she believed he was completely innocent. She organised a meeting with the leader of the Soviet state security and intelligence, Stanislav Messing, which is described in detail in Benois's diary. However, she soon realised that all her efforts were in vain when Messing declared: 'His case is very serious. He has confessed to most of his crimes already and we will make sure that we soon get his full confession.' It was the beginning of the new era, when punishment was no longer linked to a crime, and the question 'why?' became increasingly pointless. Braz was released only in 1926 after a petition from the leading artists from Leningrad was sent to Stalin himself.

According to Benois, at their meeting with Messing, Dobychina had a list of requests from people whom she tried to help – from children who tried to re-unite with their grandmother in Finland to sons and daughters of political prisoners who had been refused admission in all universities. Although the Political Red Cross

had ceased to exist in 1922, Dobychina was still trying to fight for justice on behalf of many innocent victims of the merciless Soviet regime.

She was also trying to help Benois and his family to emigrate. In 1925 they went to Paris and stayed there permanently from 1926.

Exhausted by her fruitless fight for justice and the resurrection of the Art Bureau, Dobychina managed to spend a few months abroad in 1925. She spent August and September in the private hospital in Wiesbaden, having operations on her ears, nose and throat. In her letters to Petr, she complained of feeling very lonely and accused him for not writing to her for two months. At the time he lived with their son at the apartment in the Adamini House.

Having lost any hope of re-opening the Art Bureau in Russia, Dobychina considered launching an art salon in Paris, but she was not sure if she would be able to get a French visa. She felt 'absolutely helpless and broken'.

In October 1925, Dobychina managed to travel to Paris from Wiesbaden after diplomatic relationships between France and the USSR were established. She

Photographs of Alexandre Benois with his family in Paris, sent to Dobychina in 1922.

described Paris in her letters as the most beautiful city, where 'every corner is filled with the grandeur of human genius'. She wrote: 'You just want to stand still here and look around and feel that your heart stops beating and tears fill your eyes out of awe of this city. On the outside Paris is a crazy city. Thousands of automobiles rush through the streets. I can't fully express all the noises and colours of this city.' However, she also noticed that the main difference between Paris in 1925 and Paris in 1914 were people's faces, which were now lacking the expression of careless joy – 'the fight for a slice of bread left its trace'.

While in Paris, Dobychina unexpectedly met Konstantin Somov, who had left Russia in December 1923 and who happened to be staying at the same hotel. She wrote in her letters that they were very happy to see each other, that he had lost weight and that 'he was even more grumpy and withdrawn than before, but he was still a soulful aristocrat'.

Dobychina went to Versailles to see Alexandre Benois, who had come to Paris to take part in the Exposition Internationale des Arts Décoratifs et Industriels Modernes, which opened on 25 October 1925. 'I will never forget how Aleksandr Nikolaevich greeted me – for several minutes he could not say a word, was all shaking of excitement and would not stop hugging me. Anna Karlovna [his wife]

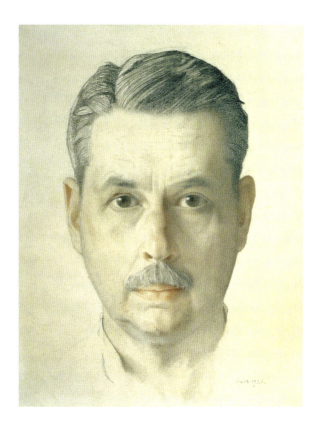

Konstantin Somov, *Self-portrait*, 1921, pencil and sanguine on paper, 26 × 20.3 cm. Pushkin Museum of Fine Arts, Moscow.

gone all pale and cried. For the first time I could witness their true attitude towards me.' They had dinner at the restaurant and Nadezhda had oysters for the first time in her life.

Feeling homesick and missing her family, Dobychina returned to Leningrad. She would never be allowed to leave Russia again. She struggled to find work; in a letter to Benois she admitted: 'The only thing that I really want now is a job, but I want to work rather than serve – something I could never do in the past and refuse to aspire to now. I would like to find a job which would use my brain, energy and temperament. I would like to create again with all my heart and soul.' For the next five years she worked for free as the chair of the Society of Chamber Music, relying on financial support from her husband. She managed to find at least one source of inspiration and used all her endless energy in organising concerts and giving musicians and composers who had starred at her celebrated music evenings at the bureau before the revolution a chance to perform.

Nevertheless, lack of paid work and the increasingly challenging reality of life in the Soviet Union led to a nervous breakdown, from which Dobychina took two years to recover. What probably saved her life was an offer of the curatorial position at the State Russian Museum. Here, her aspiration to help contemporary artists found fulfilment in the biggest showcase of post-revolutionary art, the exhibition *Fifteen Years of Artists of the RSFSR* (Khudozhniki RSFSR za 15 let), which was held at the museum from November 1932–January 1933. It was initially supposed to take place in Moscow, but as a suitable exhibition space was not available, the Leningrad Soviet offered to host it in the main galleries of the State Russian Museum.

In line with the growing Soviet bureaucracy, the exhibition had three tiers of organisers: a Government Committee, headed by the Commissar of Enlightenment Andrei Bubnov, which provided the general ideological direction and a budget; an Exhibition Committee, which included a broad range of artists, museum curators and scholars, who decided on the choice of works; and finally an on-site working group, which consisted of the Russian Museum director Iosif Gurvich and two twentieth-century curators, Nikolay Punin and Nadezhda Dobychina, who had both championed the Russian Avant-garde in the past.

A massive display of post-revolutionary artistic production – 2,640 works (1,050 paintings, 1,500 graphic works and 90 sculptures) by 423 artists were on view in thirty-five galleries. It offered an unprecedented opportunity for artists, critics and the general public to get a first-hand overview of past and present Soviet art, with an eye on its future development.

Its immediate goal was stated bluntly in major Soviet newspapers: to demonstrate the sheer scale and amplitude of Soviet pictorial achievement and to present this as an illustration of the advantages of the Soviet system of artistic production over that of the capitalist west.

Nikolay Punin with Petr Neradovsky and Nadezhda Dobychina at the State Russian Museum during the assembly of the *Fifteen Years of Artists of the RSFSR* exhibition, 1932. Nikolay Punin Archive, St Petersburg.

The exhibition in Leningrad embodied Dobychina's last attempt to showcase the full development of contemporary art in Russia. However, the clouds were already gathering. On 23 April 1932, a party decree had been passed which was to change Soviet policy on art and re-structure literary and artistic organisations. Two years later, Avant-garde works were no longer exhibited in any Soviet museum.

When this massive review of Soviet art opened its doors at the State Russian Museum on 13 November 1932, only two galleries in the exhibition were dedicated to artists perceived as 'leftist' – the Analytical painter, Pavel Filonov, and the founder of Suprematism, Kazimir Malevich. Their exceptional inclusion was most likely due to the bravery and support of the exhibition curators, Dobychina and Punin. It was also enabled by the direct patronage of the museum director, Iosif Gurvich, who in turn relied on the support of the Leningrad Communist Party leader, Sergey Kirov. Thanks to Kirov's direct intervention on the eve of the exhibition's opening, the works by the Avant-garde artists were allowed to remain on the walls, despite the Government Committee's last minute request to remove them.

When the exhibition moved to Moscow at the end of its showing in Leningrad, most of the 'left art' was excluded. After this exhibition, Socialist Realism became

the only style which all the artists had to adopt if they wanted to ever exhibit or sell their works.

Dobychina followed her last exhibition of contemporary art and in December 1935 moved to Moscow to work first at Russia's largest film studio, Mosfilm, as a consultant for the film *Queen of Spades*, and from 1936 she was head of the art department at the Museum of the Revolution. In a letter to her son (who stayed in his native city and became a professor of chemistry), Dobychina explained that she had not been able to find a decent job in Leningrad, since the only sphere where her expertise and experience could be in demand was fashion, furniture sales and antique shops. She added that most people who worked in these areas were dealers from the past who were mainly crooks, and that she did not want to become one of them.

The remarkable life of this unstoppable and insuppressible woman could not end among the dubious objects glorifying the revolution, which took away from her the Art Bureau – her pride and joy and main source of inspiration. During evacuation in Alma-Ata (in what is now Kazakhstan), at the time of the Second World War, Dobychina became one of the organisers of the Second Republican Art Exhibition, and in April 1944 was awarded a special Charter of the Supreme Soviet of the Kazakh Republic for her contribution to the promotion of the local artists.

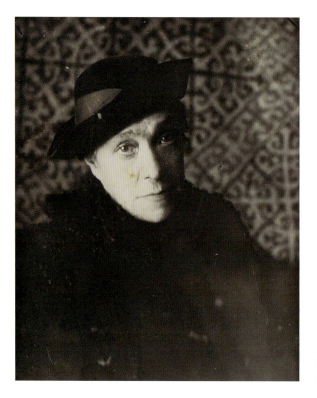

Nadezhda Dobychina during the evacuation to Alma-Ata, 5 March 1942.

Nadezhda Dobychina died in Moscow on 1 February 1950 and was buried at the Jewish Cemetery. Her grave was adorned with a copy of her portrait by Konstantin Somov, which depicts a young, smiling woman who dedicated her life to Russian and Jewish art and artists.

Nadezhda Dobychina's grave adorned with her portrait by Somov at the Vostriakovskoe Jewish Cemetery in Moscow.

Picture Credits

© ADAGP, Paris and DACS, London 2021: 62, 75 (left), 150

AKG Images: 176; Mondadori Portfolio/Walter Mori: 165; SNA: 75 (left)

Alamy/Active Museum: 96 (top); Album: 7, 32, 40 (top), 67 (bottom), 76, 96 (bottom), 97, 106, 111, 127, 129 (bottom), 140, 143, 149, 167; Godong: 200; Heritage Image Partnership: 31, 40 (bottom), 163, 199; Sputnik: 98

Bridgeman Images: 39 (top), 87, 88, 102, 150, 151, 158, 159, 219; © Peter Willi: 62

© DACS 2021: 43, 75 (right), 180

Dallas Museum of Art: 181

Encyclopedia of the Russian Avant-Garde: 22

Family Archive of Nikolay Punin, St Petersburg: 173, 221

KGallery, St Petersburg: 212

© Petr Konchalovsky Foundation: 186

Library of Congress, Washington DC: 28, 29, 191

MOMus: 152

Thea Polancic: viii (right), 17, 24, 33, 72, 78, 79 (left), 136, 145, 147, 148, 164, 192, 193, 208, 209

Rostov-Iaroslavl Museum of Architecture and Art, Rostov: 126

Russian State Archive of Literature and Art, Moscow, RGALI: viii (left), 9, 12, 14, 16, 42, 59, 90, 92, 93, 117 (top), 203, 204, 205, 213 (left), 213 (right)

Savitsky Art Gallery, Penza: 179

State History, Art and Natural Museum Reserve Polenovo: 6 (top), 121, 122

The State National Library, Moscow. Manuscript Department: 18, 71 (left), 71 (right), 77, 105, 144, 207, 216, 218, 222

Tretyakov Gallery Magazine: 75 (right)

© UPRAVIS/DACS 2021: 67 (top), 67 (bottom), 70, 87, 88, 96 (top), 102, 103, 107

Wikimedia Commons/Надежда Пивоварова: 134; Shakko: 180

Anna Zakharova: 223

Index

Page numbers in *italics* refer to paintings and photographs. Names are indexed in English, except where the Russian is predominantly used in the text, in which case both entries are indexed.

Ainalov, Dmitry 27
Akhmatova, Anna 135, 191, 215
Aleksandr, Archimandrite 103
All-Arts Union (*Souz Deiatelei Vsekh Iskusstv*) 171
Altman, Natan 171, 177, 193
 in exhibitions 73, 95, 126, 132, 137, 140, 151, 165, 179
 works *75*, *180*
Apollinaire, Guillaume 111
Arapova, Yulia 108
Arkhipov, Abram 10
Art Bureau, St Petersburg / Petrograd *33*, *134*
 see also Dobychina, Nadezhda Evseevna
 establishment of 25, 28, 33–6
 early exhibitions (1913–14)
 Exhibition of Three 105
 Graphic Arts 75, 76, 77
 Goncharova 91, 99, 100–104
 Novyi Satirikon journal 77–8, *78*
 Sapunov 97–9
 Sherling 78
 Tsioglinsky 79–80
 wartime exhibitions (1915–17) 109–10, 142, 162–3, 169, 189
 0,10 130, 150–62, *150*, *151*, *152*, 177
 charitable 137–8, 146, 165
 Denisov, Vasily 138–9
 Exhibition of the Left Streams in Art 142
 Finnish Art 193–6, *193*
 Japanese Art 143–6, *144*, *145*
 Lancéray and Dobuzhinsky 142–3
 Latvian Artists 146
 Modern Russian Painting 164–5, 166–8
 Nikolay Kulbin 206
 Persian art 146
 World of Art 139–41, 149–50, 163–4
 Zheverzheev 147, *147*, *148*

other artistic showcases 73, 190–92, *192*
Permanent Exhibition of Paintings 71, 72, 73, 74
 during revolution 196
 post revolution and closure 206, *207*, *208*
 Contemporary Paintings and Drawings 206
 attempted re-opening 215–16, 218
Art Salon (*Khudozhestvenny Salon*), Moscow 44
 see also Mikhailova, Klavdia Ivanovna
 establishment of 11, 12, 28, 41–9
 opening season exhibitions (1912–13) 50–51
 Contemporary Art 59–61
 Denisov and Riuss 52–3, *52*, 59
 Target 52, 62, 64, *69*, 80, 81
 Vrubel 53–5, 58–9
 second season exhibitions (1913–14) 80–82
 Goncharova 82, 83–9, *86*
 French Art 91–2, 110
 Serov posthumous 92–4, *92*, *93*
 World of Art 95–7, *96*
 unrealised and cancelled exhibitions (1913–14)
 German Art 110
 Picasso-Picabia 112–14
 African Art 113–15
 Exposition Franco-Russe 115–21, *117*, *118*
 wartime exhibitions (1914–17) 109–10, 124–5, 133, 187–8
 Jack of Diamonds 177–80, 182–3
 Painting of the 1915 125–32, 175
 Polenov 121–4, *121*, *122*, 125
 Society of Moscow School of Artists 188–9
 World of Art 175, 186–8
 during and post revolution exhibitions (1917–19)
 Jack of Diamonds 196–200, *197*
 Modern Decorative Art 200–203
 nationalisation and closure 203
Arts Commission (*Komissya po delam iskusstva*) 171, 206

Bakst, Léon 32, *133*, *140*, 191
Ballet Russes 94, 111, 133, *133*

Baranov-Rossiné, Wladimir 118, *173*
Bart, Viktor 65
Belzen, Yakov 105
Benois, Alexandre 139–40, *140*, *161*, 173, 218, *218*, 219
　Arts Commission 171, 206
　in exhibitions 20, 94, 206
　political views 142, 197, 216
　writings 34, 72, 160–62, 163, 164, 165, 189, 193, 194–5, 209–10, 214, 217
Bernstein, Lina 73
Blok, Aleksandr 135, 214, *215*
Blue Rose group 97
Bogdanov-Bel'sky, Nikolay 20
Boguslavskaia, Ksenia 142, 163, 165, 177, 201, 202, 206
　at *0,10* exhibition 151–2, *151*, 157, 158
Braz, Osip 217, *217*
Briusov, Valery 45
Brummer, Joseph 113–14
Bruni, Lev 140, *141*, 149, *149*, 165, 171
Bunin, Ivan 195, 214
Burliuk, David 20–22, 25, 35, 108, 109, 132, 177, 194, 195
　in exhibitions 20, 53, 73, 126, 137, 140, 142, 200
　photographs of *36*, *127*, *138*
　Portrait of the Poet Vasily Kamensky *129*
Burliuk, Vladimir 25, 53, 73, 126, 142
Byalynitsky-Birulya, Olga née Suvirova 8, 9, 11, 204
Byalynitsky-Birulya, Vitold 10–11, 205

Chagall, Marc 18–19, 38, 118, *165*
　in exhibitions 64, 65, 126, 132, 164–5, 177, 179, 206
Chaliapin, Fiodor 78, *79*, 128, 137, 192, 193, 214
Chekhonin, Sergey *173*, 209
Chernetsov, Nikanor, *Interior view of the Dmitry Naryshkin's house…* *31*
Chernyshevsky, Nikolai 4, 5
Chudovskaia-Zel'manova, Anna 137
Comedians' Halt (*Priut Komedianta*) 135–6, 191, 195
Contemporary Art Salon, St Petersburg 31–2

Davydova, Natalia 201, 202
Delaunay, Robert, *Portrait of Igor Stravinsky* *190*
Denisov, Vasily 52–3, *52*, 59, 72, 78, 138–9, *139*
Diaghilev, Sergey 31, 94, 111, 133, 171, 173, 194
Dobuzhinsky, Mstislav 35, 143, 171, 209
Dobychin, Daniil 212, 222
Dobychin, Petr 18, 35, 70, *71*, 210, 212

Dobychina, Nadezhda Evseevna née Fishman
　see also Art Bureau, St Petersburg / Petrograd
　early life and studies 16–19, 25
　　works for Kulbin 22, 25, 8–16
　family life 70, 105, 212
　health 166, 218, 220
　intersection with Art Salon 91, 113
　political views 189–90, 193, 209–10, 217
　portraits of
　　by Altman *75*
　　by Kruglikova 164, *164*
　　by Sherling (photograph) *79*
　reputation 72–3, 77
　post-bureau appointments 216, 220, 222
　　curator of *First State Exhibition* 210–11
　　curator of State Russian Museum 220–21, *221*
　　Head of Exhibitions Department, *Narkompros* 211
　　with Political Red Cross 213, 217–18
　later years and death 218–20, 222–3, *222*, *223*
Donkey's Tail group 62, 63–4, 66, 104
Drampian, Ruben 212
Drevin, Aleksandr 146, *146*
Durand-Ruel, Paul 60, 72, 73–4, 162

Efros, Abram (Rosstsy) 92, 198, 199, 205
Ekster, Aleksandra 151, 154, 157, 183
　in exhibitions 20, 137, 183–4, 198–9, 201, 202, 206
　works *154*, *183*, *199*, *200*
Erikhson, Adolf 45, 47
Evreinov, Nikolay 25, 135, *135*, 136

Falk, Robert 126, 132, 177, 178, 196
Filonov, Pavel 221
First State Exhibition of the Works of Art 210–11
Fishman, Ginda-Neka Shyevna see Dobychina, Nadezhda Evseevna
Free Creativity (*Svobodnoe Tvorchestvo*) 124
Freedom of Arts, The (*Svoboda Iskusstv*) 171–2

Galérie Paul Guillaume, Paris 111, 112
Gaush, Aleksandr 99
Gerasimov, Aleksandr 205
Girshman, Vladimir and Henrietta 94, 130
Glagol, Sergey (Goloushev, Sergey) 61, 175
Golden Fleece, Moscow 46, 50, 63
Golovin, Aleksandr 193, 211
Golubkina, Anna 204
Goncharova, Natalia 13–14, 38, *69*, *84*, 99–100, *100*, 182
　see also Larionov, Mikhail
　Donkey's Tail group 63–4

in exhibitions 21, 46, 53, 80, 126, 132
 solo 82, 83–9, *86*, 91, 99, 100–104
 Target 64, 66, 69, *69*
 World of Art 95, 164, 176
 relationship with Larionov 13, 82, *111*, 115, 133
 scandals and censorship of works 101–4
 works 67, *84*, *102*, *103*, *107*
 in Ballet Russes 94, 110–11, *111*, 115, 133, *133*
 Bunch of Flowers and a Bottle of Paints 86, *87*
 The Evangelists 88, *88*, 91, 104
 Zdanevich lecture on 89–91, *90*, 104
Gorky, Maxim 15, 171, 193, 194, 195, 211, 214
Grabar, Igor 43, 94, 193, 205
Grigoriev, Boris 73, *74*
Guro, Elena 35
Gurvich, Iosif 189, 192, 220, 221

Hermitage Museum 208
House of Arts 211

Imperial Academy of Arts, St Petersburg 5, 13, 29, 30, 50, *51*, 54, 79, 94, 102, 143
Imperial Society for the Encouragement of the Arts 30–31, 141–2
 see also Society for the Encouragement of Artists
Independent Ones (*Nezavisimye*) 13, 14, 15, 16, 53
Infirmary for the Art Workers 137, 141, 142
Institute of the History of Art 138, 171
Izdebsky, Salon of, Moscow 33, 46, 53, 115, 138

Jack of Diamonds (*Bubnovy Valet*) group 27, 62, 63, 70, 108, 124, 176–7
 exhibitions of 50, 64, 115, 177–80, 182–3, 184–6, 196–200
Jawlensky, Alexey 53
Jourdain, Frantz 116

Kahnweiler, Daniel-Henry 112–13
Kalabashkin, Nikolay 145
Kamensky, Vasily 108, 128, *129*, 132, 136, 151, 200
Kamerny Theatre, Moscow 183–4, *183*, 199, *199*
Kandaurov, Konstantin 125–7, 128–31, 132, 175
 as curator for Art Salon 125–7, 128–31, 132
Kandinsky, Wassily 25, 80, *167*
 in exhibitions 46, 53, 73, 126, 132, 142, 166–7, 168, 174
Karatygin, Viacheslav 192, 193, 194

Khlebnikov, Velimir *36*, 94
Khodasevich, Valentina 128, 130, 132, 137, 142, 163, 165
Kirillova, Anna 151
Kirov, Sergey 221
Kitaev, Sergey 143
Kliun, Ivan 108, *152*, 156–7, *157*, 177, 181, 182, 198
Koiransky, Aleksandr 45, 59
Konchalovsky, Petr 46, 126, 132, 163, 164, 169, *176*, 186, *186*
 in Jack of Diamonds group 108, 176–7, 178
Kruchenykh, Aleksei 94
Kruglikova, Elizaveta 118, 164, *164*
Kulbin, Nikolay *20*, *22*, *24*, 99, 137
 as critic 135–6, 183
 in exhibitions 22, 23–5, 142, 165, 206
 friendship with Dobychina 19–21, 34, 73, 80
 works *21*, *135*
Kuprin, Aleksandr 63, 177, 178, 196, 214

Lancéray, Evgeny 142–3
Lansere, Evgeny 71, 75, 95–7
Larionov, Mikhail 13–14, *69*, 70, *84*, 85, 137
 see also Goncharova, Natalia
 correspondence with Mikhailova 111–15
 in exhibitions 46, 53, 63, 66–69, 81–2, 95, 111–12, 126–8, 176
 as curator for Art Salon 81–2, 85–87, 94, 112–15
 as curator for Goncharova 83, 85, 87, 88, 89, 91, 101
 Target exhibition 62, 63–70, 81
 military service 108, 115, 125, 126
 relationship with Goncharova 13, 82, *111*, 115, 133
 works 67, *70*
 Boulevard Venus 95, *96*
 in Ballet Russes 94, 110–11, *111*, 115, *133*
 views on other artists 21, 99–100
L'dov, Konstantin 21
Lebedev, Ivan 118
Le Dantiu, Mikhail 64, *69*, 81, 82, 95, 108
Léger, Fernand 61, *62*, 111, 112, 151
 Woman in Blue 61, *62*
Lemercier Gallery, Moscow 26, 45, 59, 201, 202
Lenin, Vladimir 173, 174, 193, 195, 210, 214, 215
Leningrad see St Petersburg (Petrograd from 1914, Leningrad from 1924)
Lentulov, Aristarkh 73, 126, 128, 177, 178–9, *179*, 186, 196
Lermontova, Nadezhda 132, 137
Lesgaft, Peter 18, 19
Levisson, Rafail 45
Levitan, Isaak 10, 11, 38

Livshitz, Benedikt 35, 73
Lunacharsky, Anatoly 135, 172–3, *172*, 193, 210, 212, 214

Magula, Gerasim 34
Makovsky, Sergey 32, 94
Makovsky, Vladimir 10
Malevich, Kazimir 25, 81, 108, 137, 142, *153*, 181, 200
 artistic style 27, 64, 65, 181–2, 198, 202
 in exhibitions 99, 126, 128, 131, 141, 174, 196, 201, *201*, 221
 0,10 exhibition *151*, 152, 153–7, 158, 159–60, 161–2, 180
 Jack of Diamonds group 176–7, 180–81, 196
 works 129
 Black Square 153, 156, *156*
 Suprematist Painting 153, *155*
Malutin, Sergey 138
Malyavin, Filipp 174, *175*
Mamontov, Savva 5, *7*, 11, 36–7, *37*, 55, 56–7
Mamontov, Sergey 15–16, 61–2
Mamontova, Elizaveta 5–7, *6*
Manevich, Abram 162
Maria Pavlovna of Russia, Grand Princess 79
Marinetti, Filippo Tommaso 25, 99–100, 105
Mashkov, Ilya 46, 126, 132, 163, 164, 174, 176–7, 178, 186
 works *176*, *187*
Mate, Vladimir 71
Matyushin, Mikhail 25, 35
Mayakovsky, Vladimir 35, *36*, 126, *127*, 128, 135, 194
Melnikov, Dmitry, *Portrait of Sergey Shchukin* 39
Menkov, Mikhail 151, 157
Messing, Stanislav 217
Meyerkhold, Vsevolod 25, 78, 135, 136, 138, 171, 190
Miasoedov, Grigory 50
Mikhailov, Ivan 10, 11, 42, 47, 60, 124
Mikhailova, Klavdia Ivanovna née Suvirova *9*, *12*, *42*, *205*
 see also Art Salon (*Khudozhestvenny Salon*), Moscow
 artistic career 11–16, 203
 The Golden Kingdom 15
 Kolkhoz Farm Herd 203
 Lilac 124
 Rose bush 14
 The Silver Kingdom 15, *16*
 early life and studies 8–10
 finances 42, 43
 health 133
 intersection with Art Bureau 91, 113
 later years and death 204–5

Mikhailova, Natalia *see* Rozhdestvenskaia, Natalia
Milashevsky, Vladimir 35
Milyukov, Pavel 174, 193
Ministry of Arts 171–2
 see also Narkompros (The People's Commissariat of Enlightenment)
Miturich, Petr 149, 163, 165
Morgunov, Aleksey 128, 131, 151
Morozov, Ivan 36, 37–8, *39*, 41, 45, 60, 61, 94
Moscow 29–30, *29*, 36–41, 174
 artistic life in 50, 80, 83–5, *84*, 174–5
 during revolution 188, 197
Moscow Association of Artists (*Moskovskoie Tovarishchestvo Khudozhnikov*) 12–13
Moscow Regional Union of Soviet Painters (*Moskovskii Soiuz Sovetskikh Khudozhnikov*) 204, *204*
Moscow School of Painting, Sculpture and Architecture 9–10, 12, 41, *51*, 82, 188–9
Moscow Society of Friends of Fine Arts (*Moskovskoe Obshchestvo Liubitelei Khudozhestv*) 45
Moscow Society of People's Universities (*Moskovskoe Obshchestvo Narodnykh Universitetov*) 124

Nakhman, Magda 132
Narkompros (The People's Commissariat of Enlightenment) 49, 173, 203, 208, 211
 IZO (Department of Visual Arts) 173–4, *173*, 210
Neradovsky, Petr 94, *209*, *221*
New Society of Artists (*Novoye Obshchestvo Khudozhnikov*) 54, 169
Nicholas II, Tsar 49, 141, 169, 172
Nonpartisan Society of the Artists (*Vnepartiinoe Obshchestvo Khudozhnikov*) 104, 105, 138
Nosova, Evfimia 130–31, *131*
Novyi Satirikon (*New Satire*) journal 77, 78, *78*

Obolenskaia, Yulia 132
Ostroumova-Lebedeva, Anna 71, 75–6, *76*, 145, 164

People's Commissariat for Education (*Narkompros*) 49, 173, 203, 208, 211
 IZO (Department of Visual Arts) 173–4, *173*, 210
Peredvizhniki (the Wanderers group) 10–11, 13, 16, 30, 37, 42, 50, 56, 78, 123, 128, 138, 140
Pestel, Vera 151, 155, 158, 177, 202
Petrograd (St Petersburg from 1914, Leningrad from 1924) 20, 28–9, *28*, 30, 133–4
Petrov-Vodkin, Kuz'ma 41

Picabia, Francis 114, 115
Pini, Irvin 110
Pirosmani, Niko 65–6, *65*
Pisakhov, Stepan 105, *106*
Polenov, Vasily 10, 11, 121–4, *121*, 125
Polenova, Elena 5, *6*, 7
Political Red Cross 212–13, 215
Popova, Liubov 154, 157, 177, *184*, 185, 196, 202, 206
Prokofiev, Sergey 73, 190–91, *191*, 192, 193
Puni, Ivan 151, 152, *152*, 157, 177, 201, 211
Punin, Nikolay 133–4, 147, 172, *173*, 214, 220, 221, *221*
 as critic 149–50, 163, 167, 171

Radlov, Nikolay 206
Radlova, Eliza 71, *193*
Re-Mi (Nikolay Remizov) 71, 75, 77
Repin, Ilya *6*, 11, 24–5, *38*, 75, 105, 133, 137, 169, 193
Riuss, Rosa 52, *52*, 53
Rodchenko, Aleksandr 171, 174
Roerich, Nikolay 32, 78, 133, *168*, 169, 171
Romanovich, Sergey *69*, 80
Rosstsy (Abram Efros) 92, 198, 199, 205
Rostislavov, Aleksandr 72, 77, 104, 137
Rozanova, Olga 25, 142, 151–2, *151*, 154, 165, 174, 177, 185, 198, 202
 works *143*, *152*, *185*, *198*, *202*
Rozhdestvenskaia, Natalia née Mikhailova 11, *12*, 205
Rozhdestvensky, Vasily 108, 165, 196, 205
Rykov, Arkady 136, 210

Sagaidachnyi, Evgeniy 65
St Petersburg (Petrograd from 1914, Leningrad from 1924) 20, 28–9, *28*, 30, 133–4
 Imperial Academy of Arts 5, 13, 29, 30, 50, *51*, 54, 79, 94, 102, 143
Sapunov, Nikolai 97–9, *97*, *98*
Sarian, Martiros 73, 126
Satirikon magazine 77, 78, *78*, 137
Schoenberg, Arnold 25
Serov, Valentin 38, *39*, *44*, 92–4, *93*
Shcherbatov, Prince Nikolai 43–4
Shchukin, Sergey 36, 38–41, *39*, *40*, 60, 61, 113, 114, 116
Shemshurin, Andrei 126–7, *127*
Sherling, Miron 78, *79*
Shevchenko, Aleksandr 65, 81, 82, 95, 108
Shklovsky, Viktor 174
Shor, Evsei 80
Shukhaeva, Elena 71
Sibiriakov, Innokenty 19
Smirnov, Nikolay 206, *207*

Society for the Encouragement of Artists 30, *31*, 34, 137, 141, 206, 216
 see also Imperial Society for the Encouragement of Artists
Society of Chamber Music (*Obshchestvo Kamernoi Musiki*) 220
Society of Moscow School of Artists (*Obshchestvo Khudozhnikov Moskovskoi Shkoly*) 188–9
Society of People's Universities (*Obshchestvo Narodnykh Universitetov*) 25, 124
Society of the Independent Artists 166
Somov, Konstantin *131*, 195, 209, 219, *219*
 Portrait of Nadezhda Dobychina 211, *212*, 223, *223*
State Russian Museum 134, 220–21
Stepanova, Varvara 158
Stravinsky, Igor 73, *133*, 190, *190*, 191, 192
Stray Dog Café, St Petersburg / Petrograd 25, 34, 99, 135, 136
Strengell, Gustaf 196
Suvirov, Ivan 9, 41
Suvirova, Klavdia Ivanovna *see* Mikhailova, Klavdia Ivanovna
Suvirova, Olga *see* Byalynitsky-Birulya, Olga

Tairov, Aleksandr 184, 199
Tatlin, Vladimir 27, 64, 171, 174, 180–81, 196
 in exhibitions 95, 99, 126, 141, 142, 176
 0,10 157, 158–60, 162
 works *96*, 130–31, *132*, *158*, *159*
Tauride Palace, St Petersburg 31, *32*
Tenisheva, Princess Maria 54
Teper, Iosif 116, 118–21
Tiutcheva, Anna 30
Tramway V 141–2, 151
Tretyakov Gallery, Moscow 10, 35, 36, 37
Triangle group (*Treugol'nik*) 20, 22, 23, 25
Tsioglinsky, Ian 79
Tugendkhold, Yakov 115–16, *116*, 118, 205
 as critic 43, 48, 90, 98, 182, 184–5
Tyrsa, Nikolay 149

Udaltsova, Nadezhda 142, 157, 174, 177, 196, 202
Union of Russian Artists (*Soiuz Russkikh Khudozhnikov*) 45, 50, 72, 78, 124, 171
Union of Youth (*Soiuz Molodezhi*) 99, 100–101, 104–5, 147
Uspensky, Gleb 4

Vasilyeva, Ekaterina 201
Vasilyeva, Maria (Marie Vassilieff) 151, 158
Vaulin, Petr *58*, *173*
Vignier, Charles 113–14
Vinaver, Mikhail 212, *213*

Vollard, Ambroise 60
Vrubel, Mikhail 37, *37*, 38, 53–9, *55*, *58*

Wanderers group (*Peredvizhniki*) 10–11, 13, 16, 30, 37, 42, 50, 56, 78, 123, 128, 138, 140
World of Art group (*Mir Iskusstva*) 50, 95, 118, 132, 137, 138–40, 163–4, 169, 175
Wrangel, Nikolay 102–3

Yakulov, Georgy 53, 95, 140, 163, *163*, 201
Yakunchikova, Maria 94
Yasensky, Alexei 105

Zdanevich, Ilia *65*, 68, 81, 91, 194
　Goncharova lecture 89–91, *90*, 104
Zheverzheev, Levky 99, 147, *147*, *148*